Seeing is Forgetting the Name of the Thing One Sees

a life of
Contemporary Artist

ROBERT IRWIN

BY LAWRENCE WESCHLER

UNIVERSITY OF CALIFORNIA PRESS
Berkeley Los Angeles London

Portions of this work appeared in *The New Yorker.*
University of California Press

University of California Press
Berkeley and Los Angeles, California

University of California Press, Ltd.
London, England

Library of Congress Cataloging in Publication Data

Weschler, Lawrence.
 Seeing is forgetting the name of the thing one
sees.

 Includes interviews with Robert Irwin and others
taped between 1976 and 1979.
 Includes bibliographical references and index.
 1. Irwin, Robert, 1928– . 2. Artists—United
States—Biography. I. Irwin, Robert, 1928–
II. Title.
N6537.164W4 7098.284 [B] 81-16176
ISBN 978-0-520-04920-8 AACR2

Printed in the United States of America

13 12 11 10 09 08

20 19 18 17 16

The paper used in this publication meets the minimum
requirements of ANSI/NISO Z39.48-1992 (R 1997)
(*Permanence of Paper*). ♾

In memory of
my father
IRW

During the early seventies, when Robert Irwin was on the road a lot, visiting art schools and chatting with students, he was proffered an honorary doctorate by the San Francisco Art Institute. The school's graduation ceremony that year took place in an outdoor courtyard on a sunny, breezy afternoon, sparkling clear. Irwin approached the podium, and began, "I wasn't going to accept this degree, except it occurred to me that unless I did I wasn't going to be able to say that." He paused, waiting as the mild laughter eddied. "All I want to say," he continued, "is that the wonder is still there." Whereupon, he simply walked away.

CONTENTS

A NOTE ON
THE ILLUSTRATIONS

NOTE: For many years Robert Irwin forbade photographic reproduction of his paintings. An early intuition in this regard hardened into an absolute conviction during the time he was creating his line, dot, and disc paintings. As will be seen in the text that follows, Irwin felt that a photograph would capture none of what the painting was about and everything that it was not about. That is, a photograph could convey image but not presence. Furthermore, many of the works of Irwin's middle years, particularly the late lines and the dot paintings, are virtually unreproducible: not even the "image" of the original, as it were, finds its way to the contact sheet. Therefore this book includes no photographs of Irwin's work from 1957 through 1969.

Around the time of his column installations, however, in the late sixties, Irwin began to allow some photographic documentation. Although still dubious about the value of such documentation, he felt that the photos themselves were often sufficiently ambiguous as to prevent the work's reduction to mere image. Furthermore, in many cases, photographic reproduction afforded the only ongoing record of pieces that seldom existed, in physical reality, more than a few weeks. For that reason, Irwin has allowed the inclusion of some photographs of his more recent work in this volume.

ACKNOWLEDGMENTS

Research on this book was undertaken with the support of grants from the National Endowment for the Humanities (Youthgrant program) and the Ludwig Vogelstein Foundation.

The vast majority of the quoted material derives from interviews which I taped with Robert Irwin and others between 1976 and 1979. Some of the material is extracted from the University of California, Los Angeles Oral History Program's 1976 interview with Irwin (the interviewer was Frederick Wight, although I edited the transcript) and is reprinted with permission of the university. Copies of all the tapes and transcripts developed for this project have been deposited with the Oral History Program, a research unit of the UCLA Library's Department of Special Collections.

Throughout the course of my work, Joan Tewkesbury, Dennis Phillips, Leonard Durso, Dorothy Semenow, and Henry and Maria Feiwel have been especially supportive. Alice Sachs and Bob Bingham were very helpful during the editing phase of the work. As I was reviewing the galleys of this book, I received word of the tragically sudden death of Fred Mathieson, my old high school composition teacher; it's extraordinary for me to realize how much he lives in these pages. The final text also bears the firm imprint of my studies, many years ago, with Maurice

Natanson, a master phenomenologist. Perhaps most important in this book's realization was the ongoing enthusiasm and support of its subject, and for those many months of good natured encouragement, I thank Robert Irwin.

L. W.

INTRODUCTION

"What is the poet?" mused a great philosopher during the last
century. "An unhappy man who in his heart harbors a deep an-
guish, but whose lips are so fashioned that the moans and cries
which pass over them are transformed into ravishing music."*
This romantic conception still characterizes many popular im-
ages of the artist—that he is usually the survivor of an unhappy
childhood and a pilloried adolescence, that his heightened sensi-
tivity entails a heightened vulnerability, that his psyche dips
slightly askew (either tipped toward the melancholic or tottering
along the manic-depressive)—and none of it has anything to do
with the life and person of Los Angeles artist Robert Irwin, whom
you can meet most any afternoon of the week, basking in the sun
at his neighborhood falafel stand, palming his perennial Coke,
and watching the world go by.

Indeed, for a long stretch recently, Irwin had not precisely
done anything, or at any rate, he had little to show for his labors. A
robust young abstract expressionist during the late fifties, he'd
gradually pared back his painterly activities during the sixties,
systematically dispensing, step by step, with the usual artistic re-
quirements of image, line, frame, focus, permanence, and even
signature, until by 1970 he abandoned his studio altogether.
Throughout this trajectory, Irwin was beset by critics who lam-
basted his project as a descending spiral into pure negation, and
the work *was* at all times lean, austere, reticent, sometimes almost
mute. From the work, you might have expected to meet a stark,
obsessively cerebral creator. The artist you do meet, however, is

*Sören Kierkegaard, in his guise as "A," the young poet, in the first of the
"Diapsalmata," *Either/Or,* trans. David and Lillian Swanson (New York: Double-
day Anchor, 1959), 1:19.

anything but dour. Indeed, his sunny, jovial disposition would be almost off-putting if it weren't so infectious. For a long time you have trouble squaring the man's personal presence with his production. But it's precisely through such encounters that you begin to understand that far from constituting an exercise in nihilist reduction, Irwin's minimalist passion arises in a spirit of zestful affirmation of human possibility, and that his ambitions are as vast as his gestures are spare.

But the paradox of that presence turns back on itself. For no matter how carefree he behaves in public, no matter how antic the tales he weaves concerning his youth and his early years as an artist, the fact is that this man is also one of the most vigorously self-disciplined figures on the contemporary American art scene, a man capable of spending months on end without any human contact. How then does one square this dynamic sociability, the ease, grace, and delight with which he mingles among friends and students, with this extraordinary capacity for solitude? How can someone so carefree be simultaneously so driven? How did a young man who had never particularly fancied an artistic career suddenly become possessed, in his late twenties, by such an overwhelming aesthetic curiosity? For months as I was first getting to know him, during the many interviews we conducted concerning his life and attitudes, these dichotomies seemed unbridgeable. Only gradually did I begin to see them as twin emanations from a single source, his social ease as grounded in his self-sufficiency, his anarchistic whimsy as contained by his fierce sense of discipline and integrity.

LIFESOURCE

The search is what everyone would undertake if he were not stuck in the everydayness of his own life. To be aware of the possibility of the search is to be onto something. Not to be onto something is to be in despair.

Walker Percy, *The Moviegoer*

CHAPTER 1

High School
(1943–46)

"And then when I came back"—Robert Irwin was recalling some time he'd spent in Japan about ten years ago—"I'd taken one of those seventeen-hour flights from the Orient which really wipe you out. Anyway, I got home about midnight and went immediately to bed, thinking I'd probably sleep for two days. But I was so jazzed and hyper that I couldn't fall asleep. So I got in my car and put the top back and put my tape deck on and was just driving along in the middle of nowhere. Actually I first went over to Fatburger and bought a Coke from Jay, and then I set out cruising the freeways. I was driving over Mulholland Pass on the San Diego freeway, you know, middle of nowhere at about two o'clock

in the morning, when I just got like these waves—literally, I mean I never had a feeling quite like it—just waves of well-being. Just tingling. It's like I really knew who I was, who I am. Not that you can't change it or whatever. But that's who I am: that's my pleasure and that's my place in life. To ride around in a car in Los Angeles has become like one of my great pleasures. I'd almost rather be doing that than anything else I can think of."

Robert Irwin and I were sitting outside Mè & Mè, talking about him and his life. Mè & Mè is a falafel stand in the middle of the busiest section of Westwood, a fairly new stand, which means it has a fairly new Coke machine, which means it gives slightly better cola than some of its more established competitors. When they were new, Irwin used to frequent them—as it happened, the Coke fountain here was a bit past its prime, and for some days now Irwin had been restless (or as restless as he lets himself get), on the lookout for a new stand.

"In terms of just day-to-day life," he was continuing, "basically I can have a terrific time doing nothing. I'm quite at ease, and always on the plus side. I can come down here and sit on the corner, and, I mean, nothing's happening where I could say I'm having a hilarious time, but I'm feeling real good and the world's fine.

"I don't know how to explain it exactly. I guess I'm as confused by other people's insecurity as they are by my security. And my security is probably no more substantiated than their insecurity!"

Irwin is in his early fifties, but he gives the appearance of someone considerably younger, perhaps because he has something of a baby face—or, more precisely, a baby head, for his head is strikingly large, with soft benevolent features, and sits perched atop a comparatively thin neck, which in turn opens out onto a solid, almost hefty frame. There is a touch of elfin mischievousness in the delight that is usually transporting him, even in his serious moods. His forehead is high and broad, his hair thinning on top and greying to the sides. His body is still in very good shape; he downs a fistful of vitamins every morning and ritually jogs five miles in the afternoon.

I asked him if he had any notion what that sense of well-being grew out of, and without hesitation he replied, "High school. Or more generally, just the experience of growing up in southwest Los Angeles, which was a fairly unique experience—obviously

turns out it must have been a *very* unique experience, because it produced a fairly interesting, rich activity. All of us at Ferus grew up basically with that same background." (He was referring to the extraordinary group of artists who ranged themselves around L.A.'s funky, pioneering, avant-garde Ferus Gallery during the late fifties and the early sixties.) "For example, conversation was a continually running sarcasm; you never gave anybody a straight answer. You played games all the time, and where that comes from, I don't know. But, man, I can talk to somebody in Michigan, and I can spot a southern California person—West L. A. especially—in Europe or anywhere; I can spot them a mile away. We start a conversation, and it's like I've been talking to this person all my life, and I've never met him! There was just a whole freewheeling attitude about the world, very footloose, and everybody in southwest Los Angeles had it. From the time you were fifteen, you were just an independent operator, and the world was your oyster. Maybe you didn't have that much, but the world was just always on the up side. And that's what that script is about, or at least I hope it's in there. It was just really a rich place to grow up."

For the past several years, Irwin has been living with Joan Tewkesbury, the celebrated scenarist whose credits include screenplays for Robert Altman's *Nashville* and *Thieves Like Us*. Partly at her instigation, Irwin composed *The Green and the White*, an unproduced screenplay about life at Los Angeles's Dorsey High School during the early forties (the school's team colors account for the title). This wistful memoir abounds with boisterous characters—Spider, Cannonball, Cat, Mole, Blinky, and others—but the protagonist Eddie Black ("his hair in a pompadour with a slight duck tail") is none other than Irwin himself. The screenplay's tone is raucously vital throughout, the incessant banter somehow simultaneously glib and heartfelt.

I asked Irwin if he'd be willing to take me on a drive around his old haunts, and he said, "Sure." The sun was shining, a warm breeze rustling through the high palm stalks—a perfect afternoon for a drive. We dispensed with our Cokes and headed back toward his house.

As we were walking the few blocks back into the Westwood hills, out of the bookshop-record-store-and-movie-house glut of the village, past fraternities and densely packed student apartments, then turning right onto a slightly less frantic sidestreet,

Irwin continued speculating on his L.A. youth. "I mean, people talk about growing up Jewish in Brooklyn, know what I mean? And they always dwell on the dark side. I hear all of that, and I grant that it makes for good drama, makes good writing, and it makes good intellects, in a sense. Well, apparently this made for good artists, 'cause we didn't have nothing to do with all of that— no dark side, none of that struggle—everything was just a flow."

We just flowed into his carport and climbed into his car, a sleek, silver 1973 Cadillac Coupe de Ville, one of the few luxuries he allows himself within an otherwise Spartan life style. In one fluid motion, he selected a cassette from the box on the floor, popped it into the tape deck (Benny Goodman filled the car's interior), slid back the sunroof, slipped the key into the ignition and the car out of the driveway, and eased us into the midafternoon surge of L.A. traffic.

A few moments later we were barreling down the San Diego freeway, southbound, toward one of those amorphous undifferentiated communities that make up the mid-Los Angeles sprawl—not really a suburb, but not the central city either; not really poor, but by no means well-to-do. Bob spent his adolescence on the southeastern edge of Baldwin Hills, just north of Inglewood. (If you were to draw a line between the Hollywood Park Race Track to the south and the present site of the Los Angeles County Museum of Art to the north, Leimert Park, one of the main staging areas of Bob's youth, would constitute the midpoint.)

"I don't remember particularly much about my early childhood," Irwin was saying, "but it was never sad that I can think of. Kind of floating and suspended, maybe, but that's something I still do. The high school period I remember very well, however, and it was an unmitigated joy, even though it was in some ways minimal, because of my parents not having any money or anything. I had a job and worked the entire time, made all my own money. From the time I was very young, my mother had a lot to say about that sort of independence, which was nice for me. At age seven, I was selling *Liberty* magazine door to door, and within a few years I won this little award for being the magazine's top salesman in the county. To this day I'm a sucker for any kid along the street hawking flowers or newspapers or a shine. I had jobs in a movie theater, in coffee shops, at garages. During the summer

I'd lifeguard up at Arrowhead or out on Catalina. All those jobs involved a lot of action, a lot of involvement. They were really part of my pleasure. And they were very important, because they gave me total independence from very early on. I never had to ask my parents for anything, and they never in a sense really stopped me from doing anything. They were real open to me in that sense."

As we threaded in and out of traffic, the warm air swirling about us, I flipped through the box of cassettes: Stan Kenton, Artie Shaw, Bing Crosby, Frank Sinatra, Count Basie, Al Hibbler, and Erskine Hawkins. "*That* of course was also a big part of those years," Bob volunteered, anticipating my question, "the incredible music and the dancing. In fact, dancing even became an important part of my financial picture.

"At first, when I was thirteen or so, I just had no sense of rhythm at all. But I taught myself to dance by using the doorknob in the living room as my partner, and I got to be a pretty good dancer, good enough so that I could contest-dance. For a period I was entering contests almost every night of the week. There was a whole circuit: Monday was the Jungle Club in Inglewood, Tuesday was the Dollhouse out in the Valley, Wednesday was in Compton, Thursday in Torrance, Friday in Huntington Park.

"You contest-danced with a partner, of course. So you always had one regular partner and a few maybe that you were building up. Because a good partner was crucial: she could make or break you. Interestingly, you weren't usually romantically involved with your dance partner. That was the thing about dancers, especially in terms of sex: got it all out dancing, that was their whole gig. It was just such a goddamned pleasure.

"Everybody at the school I went to, Dorsey, everybody was really into dancing. We used to dance at lunchtime and then after school. The big step at the time was called the Lindy, which was kind of like the New Yorker, only smoother. The key movement was the shoulder twist, where the girl came directly at you and then you spun each other around and she went on out. When you got it going real smooth, you could literally get to the point where you were almost floating off the ground, acting as counterweights for each other. It was absolutely like flying, just a natural high.

"At these contests there were maybe a half dozen regular couples who made the circuit, and they'd alternate winning, de-

pending on who the judges were. You'd come out one couple at a time. You'd sort of be standing to the side, and they'd say, 'The next couple is Bob Irwin and Ginger Snap,' or whatever, and you'd take her and throw her in the air, she'd come down, you'd come boogieing out on the side, and then you'd start your routine. And you could make a lot of money doing that. At my peak, I was bringing in upwards of a hundred a week!"

About ten minutes out of Westwood, we swung off the freeway onto Slauson, a wide boulevard that skirts the southern flank of the Baldwin Hills, and proceeded east about two miles.

"By the way, this here was the big drive-in," Bob indicated, turning off Slauson onto Overhill and then pulling into a parking lot. "Used to be called the Wich Stand—still is, I guess." In the broad daylight, the pink thrusting roof, the jagged stone pillars, the dusty palm trees flanking a garish, orange Union 76 signpost in the distance, the virtually empty asphalt lot: it seemed the most commonplace of Los Angeles vistas. But years ago, this had been the hub of teenage nightlife in the region. *The Green and the White* offers a vivid evocation: "A round drive-in set in the center with cars parked three and four deep radial around it: the show and pussy wagons with a few family irons. There is a parking area to the side where the more radical looking rods are neatly parked side by side with walk-around space. A lot of boys stand around eyeballing."

We negotiated a lazy arc around the lot, and just as we were about to ease back onto Overhill, Bob pointed toward one corner of the drive-in and commented offhandedly, "Over there's where I almost got shot once." He paused for effect.

"Yeah, I used to come over here after work most nights when I was working at one of the nearby garages. I'd come over for fries and a coke, and. . . . By the way, this used to be the race-strip right along here." (We were heading south on a wide stretch of Overhill, which indeed was beginning to take a decided downhill dip.) "For a while anyway, that is, until the cops succeeded in stopping us. That signal wasn't there.

"Anyway, I used to go there after work, all greasy and everything, and this real pretty girl started working there. Pretty soon I noticed that she was taking my car every time, and she started playing jokes, like putting roses on my tray, that kind of stuff. So we started having a kind of dialogue. I asked a couple of other

drive-in ladies what the story was, and they said she'd just gotten married, so I didn't make a run on her or anything. But one night she asked if I'd take her home, so I said okay. Had to wait till she got off at two A.M. and then drive her all the way out to Gardena, so I was kind of regretting it. But then she invited me to come in and—all this time I wasn't really thinking. But I went in, and the point is that we began to have this casual love affair. She was sensational, so all that was very great. She told me her husband was a real bad-ass and so forth and that they were getting divorced. He was a bandleader.

"Anyway, so one night I'm sitting in the drive-in with a friend of mine, and she comes up to the car and says, 'Don't say anything, my husband's in the very next car.'

"This, by the way, is Verdun, the street on which I lived in high school, and this here was my house—6221." We'd veered off Overhill down a very steep Sixty-third Street a few hundred yards to the corner of Verdun. The modest stucco house, slightly smaller than its neighbors was perched atop a slight hill, the carport level with the street, the living room above it, a brick stair path leading up from the driveway to the front porch. The street was lined with trees, and we parked in the shade. Bob killed the engine—and Benny Goodman. "That window on the right was my bedroom. This house was one my parents got. I mean, my mother was the instigator of getting it. That was late in the depression, so it was a big stretch for them. Boy, it took every cent they had. They had to get $600 together for the down payment. But they made it, and then they lived here for a long time, only moved out about ten years back.

"But anyway, so this guy got out of his car, and he comes over to my car, and he says, 'I know everything. My wife told me everything,' and blah blah blah. I felt like a rat. 'I love her,' he says, and blah blah blah. I said, 'Listen, you know, I'll stay out of it,' because I never wanted to get involved in that sense anyway. So he said, 'God bless you,' which really made me nervous, because those kind of guys are very weird. So that was the end of that, I thought.

"Then I came in the drive-in one night like three months later, and there he was. He comes up to the car—he was real pissed off, just enraged—and he says that he wants to talk to me. So we walked over to the back of the drive-in, where I showed you. He

pulls out a gun and sticks it right up against my forehead and hisses, 'You went all the way with her. She told me how you made her do it.' His eyes were bulging. All I said was, 'I never *made* her do anything.'

"By the way, that slope there was all ivy instead of lawn the way it is now. That was the bane of my existence, having to weed the ivy.

"Anyway, so he was shaking, nervous, sweating, and when I said that I never made her do anything, he broke down and started crying. He was leaning on my shoulder. At the time I didn't get scared, because I guess you just don't have time to put it all together. But he'd had four of Babe Pillsbury's boys in the back seat of that car with him. What he was originally going to do was just pull me off the side of the road and have them stomp me, which they could have done very well, because they were real bad-ass motherfuckers. But anyway, instead he broke down crying and everything, you know, 'God bless you' and all that again, and then he split. A few minutes afterwards I really got shook up, because he really had the gun and he had been dead serious thinking about using it. I mean, he really was shaking and all upset, and those kind of guys can do that sort of thing. So, anyway, that was a bizarre side tale."

He started up the engine again, Benny Goodman resurged, and we rolled out of the shade. We began climbing back toward Slauson, and the neighborhood steadily improved. "Over there's where I used to catch the bus before I had any car. See, our school was kind of schizophrenic. We were like 35 percent black; the blacks lived down in the flatlands, where we're heading now, and they had no money. (By the way, John Altoon, who later became one of the top Ferus artists, he lived down there, too, and also went to Dorsey, just a little bit ahead of me.) Then there were the kids who lived in the hills, and they had some money, although this was still the depression and nobody had much. But back there where I was living was 'over the hill,' so I always looked like I was coming from the hills, but actually I was from the other side of the tracks, too. I mean, one block further out and we'd have been in Inglewood.

"By the way, the whole stretch here we're driving now" (we had crossed Slauson and were continuing northeast on Angeles Vista, a wide, but lightly traveled thoroughfare flanked on either

side by residential streets lined with incongruously tall palms), "this was the distance I'd run home each night after closing up the theater, where I was usher and then assistant manager. It was about a two-, three-mile run each night, leaving there at about one A. M. when the buses had ceased running and traffic was too light to hitchhike. The job was a pleasure, the run was wonderfully invigorating, and the next morning I always had to be up early for school."

I asked Bob about race relations at Dorsey High. "Well, maybe I'm a bad source for that, because, like the black thing, the feminist thing, those were just never issues with me. I never thought of women as being different or blacks as being lesser.

"For instance, girls. I used to chase girls—radically: every night was chasing girls. When I worked in the theater, I always had a girl stashed in the back row all the time I was an usher there. A girl was involved with everything I did. But I used to be amazed: I'd sit down with some of the guys, who were all doing this, just chasing anything that moved, and they'd all be talking about marrying virgins. I'd never particularly thought about it, but even at that time—I was fifteen, sixteen—I remember thinking, that's weird. They were going to marry virgins, and the chicks they were balling were all whores. I never thought like that. When a girl turned on to me, I never thought less of her, I always thought she was terrific, that she was doing something special for me. I mean, their attitude made no sense to me, it was just bare-ass backwards. For starters, it was self-defeating, because if you knock all the girls that put out, then if a chick's smart at all she don't put out. Any girls with any brains just don't put out to that kind of guy."

From the hills we had eased down to the flatlands and into the town center. We passed a skinny wedge of a park—crab grass, restrooms, asphalt, a dry fountain—across from which loomed an old art-deco-style movie house, now recast as a Jehovah's Witnesses Assembly Hall. The letters W-A-T-C-H-T-O-W-E-R streamed down its ornate tower.

"So this here's Leimert Park," Bob continued, "and it was kind of the center of our social life, this and the drive-in. Here's the theater I worked at for several years. Next door there was a little restaurant called Tip's, and I'd work there occasionally, too. That parking lot back there, which they shared, is where me and my

buddies used to siphon gas out of unsuspecting vehicles. We'd take out the garbage and shift the hoses and cannisters. They were of course rationing in those days."

This was the first time the war had impinged on Bob's recollections. I wondered whether it had had any more significance for him then.

"Oh, no," Bob responded immediately. "We were just oblivious. We conducted ourselves like the war wasn't on in any way. Not having gas and all that was simply a challenge. I didn't have any older brothers, and come to think of it, none of my friends in that group did either. Maybe that was part of it. But basically we didn't pay any attention."

I asked him if the obliviousness of the local youth had bothered the older members of the community, whether he and his friends were criticized as irresponsible.

"I don't know. I mean, if I was oblivious to the war, I was certainly oblivious to any criticism!"

Irwin was thirteen at the time of the Japanese attack on Pearl Harbor, just graduating high school as the war ended. I asked him where he had been December 7, 1941.

"I don't know," he replied.

I asked him about the day the war ended.

"Haven't the slightest idea."

Hiroshima?

"Nope. *Hiroshima Mon Amour* was the story of a fairy tale."

I wondered if part of the reason he and his friends were having such a fiercely good time was because they all realized they were presently going to be shuttled off to the war.

"Oh, no," Bob dismissed the notion with a sweep of his hand. "Look. Look at it here. Look at how it is: calm, sunny, the palm trees. What is there to get all fucking upset about?" He laughed. "This is reality. In other words, the war was not reality. The war wasn't here. The war was someplace else. So any ideas you had about the war were all things you manufactured in your head from newspapers and that. To me, this was reality; this was my reality right here."

We had in the meantime swung out of the shopping district and were cruising along a pleasant residential street on our way back toward Baldwin Hills. "Right there is where one of my favorite girlfriends lived," he pointed, and then paused. "She was the

champion. World Champion. She would get so knocked out, she would literally. . . . I could hardly get her out of the car afterwards; she would be absolutely unable to walk. That was my introduction: she was my first real major sexual experience. So what I got was this total fantasy of what it was like, because she would literally pass out cold right in the middle of it. We'd be lying there in the back seat, and she'd be out, like 'bang!' "

How old were they?

"Sixteen. *Bang!* I mean, just out cold. No other girl has ever passed out on me since, you know. I used to have to walk her. . . . I'd park over in this alley and walk her up and down the block just to get her legs going so that she could walk into the house!"

Was that where one generally made out, in cars?

"Sure. The car was the key, the pivotal item in the whole ballgame. Everything was wrapped around the car. The car was your home away from home. And you put months and months into getting it just right. Everything was thought out in terms of who you were, how you saw yourself, what your identity was."

I asked him how his cars expressed his self, as opposed to how others expressed their owners.

"Well, first of all," he began, "there were three, maybe four categories. One was like 'go.' You built the thing—like the Cat and the Mole, they built things that were just rat-assed, but, boy, they went like a son of a bitch. The body could be almost falling off, you'd be sitting in an egg crate, but everything was in the engine, and *that* was very sanitary. Then there was 'go-and-show,' which was like a car that went real good but wasn't necessarily going to be in a class with the Cat and the Mole, but it would look fine. It was a question of taking a car that was a classic model and then just doing the few right things with it to accentuate why it was a classic model, building it up to absolutely cherry condition. Then there was 'show,' and then there were like 'pussy wagons,' which were strictly kind of like Chicano cars are now: lowered way down, everything exaggerated, blue lights under the fenders, Angora socks bobbing in the window, seats that tilt back, all that sort of bad taste, which has now achieved almost the level of a profession.

"Well, I was category two, go-and-show. Sort of a little bit of both. I mean, the car had to be real good, because it had to have an edge on it, but on the other hand, it had much more to do with its

being an absolute classic model, with everything set up just right. I had a very hard time getting one in that condition, because they cost a lot of money, but that was my ambition."

How many cars had he worked his way through as an adolescent?

"Oh, not that many; about half a dozen. A little '32 roadster, a '34 five-window coupe. . . . The first car I wanted was a '32 B roadster. It was Fred Gledhill's car, and he was selling it. I didn't have enough money, and that was the only time I ever asked my father for some money. I asked him for $100, just as a loan, so I could make the down. And he wouldn't or couldn't loan it to me, I don't know which. That was the biggest disappointment of my life up till that point. It may be till this day the biggest disappointment. I don't think I ever had a bigger one. I mean, we won the war and what have you. . . ."

Several plotlines dovetail across the expanse of Irwin's screenplay, but perhaps the most involving concerns the loving devotion with which the protagonist, Bob's stand-in Eddie Black, nurses a beat-up '39 Ford back into "cherry" shape. Throughout the script, Eddie confers with his buddies prior to each decision.

CAT
Hey, Eddie-O, you got the '39 running?

EDDIE
[*startled*]
Huh? Oh, yeah. Yeah, it runs good, Cat. I've got it with me. After school I'm going over to get a set of mufflers.

CAT
Yeah, what kind?

[*Mole walks up hearing Cat's conversation.*]

MOLE
Get yourself a set of Sandys for a '39.

EDDIE
I was thinking of a set of 15-inch Porters.

CAT
Mole's right. Sandys have a real bark.

CANNONBALL
[*approaching*]
What's up, Eddie-O?

EDDIE
Got the '39 here. I'm getting a set of mufflers.

CANNONBALL

Oh, yeah. Hey, get some fine 18-inch Rileys with those down tips like I got on the '36.

EDDIE

Yeah, they're good.

MOLE

They got no bite.

CANNONBALL

They're real mellow.

CAT

They're for sneaking up on chicks.

EDDIE

I like when you back off the Porters. They have that nice deep throaty roll. No flat and no pop. Too much pop on Sandys.

And so forth. A few scenes later, the Porters installed, the car nearly completed, the script floats into a lyrical reminiscence of the late nights of a Southland youth.

The box office is closed. The theater is semi-dark waiting for the last show to be over. We see Black exiting. He says goodnight to the manager in a black tux. He exits toward us and turns left to his car which is parked almost in front of the theater. The '39 is looking very sharp now. It's sitting at just the right angle, lowered in the rear, the new chrome bright against the grey primer. The car is almost finished. Black sits for a moment letting the '39 idle and dialing the radio until he hits on a station, Bobby Sherwood's "Elks Parade."

He idles away from the curb. The car is driven with more than care. Each time he winds up just so before he shifts; then with a short rev of the engine between gears he gives the mufflers a slight rap. Once in a while, for no seeming reason, except plea- sure, Eddie lets the '39 hang longer in first and second. Some- times he snaps off the shift between the two, letting it back all the way down to a stop at the corner.

We follow Eddie through the now familiar neighborhood. He pauses in front of Susy Stewart's and Anna Grace's houses, each dark, and each time he raps the mufflers lightly.

We idle on to a main street. Crenshaw. It is wide and well lit. There is very little traffic. The radio is playing "I've Got A Crush on You," by Tommy Dorsey and Frank Sinatra. Black has a Coke and idles along. The lights pass in patterns.

We pass down Hollywood Boulevard, also well lit with no traffic. There are a few people walking.

Eddie idles through a drive-in. He does this twice and chips a little rubber as he leaves.

He heads for home. "Skylark" by Earl Hines and Billy Eckstine plays as he idles down the dark tree-lined street letting the mufflers back way down. He pulls into his driveway and the lights go out.

As we wheeled out of Baldwin Hills, back down many of the same streets Eddie Black had often cruised, Bob recalled that particular '39: "Well, I finally got that car finished. I had twenty coats of ruby-red maroon on the dash, and I had this great finish outside. The car was absolutely hunky-dory. Twenty coats of ruby-red maroon, let me tell you, to paint the dash: that means taking everything out, all the instruments and everything, painting it, building up these coats very slowly, spraying the lacquer. It was just a very exaggerated thing. So it took a lot of work, but I finally got it into that condition.

"That was just in time for Easter week in Balboa. Everybody'd go down to Balboa for Easter week. All the girls' sororities and clubs had their houses there, and we used to go down and hang out in various situations there. Maybe you'd do some work for them, but mostly you just played around and slept in your car or out on the beach. My friend Keith went with me one time, and we'd been sleeping on the beach, so we went over to the girls' house the next morning to shower and brush our teeth. I had a fairly good gig going, 'cause the car was in very cherry shape, which of course was very important to the whole scene."

Did girls really respond to the cars?

"Well, you at least thought they did. It gave you a sense of identity, and your identity was what you wanted it to be, sure. I don't know how much, but. . . .

"Anyway, so we'd gone over to this girls' house, and we were just shooting the breeze, and I asked if we could wash up, and they said sure. So I went in and showered, 'cause I had my stuff with me. Then Keith came in the bathroom, and I thought to myself, 'How the hell did he get his stuff?' 'cause his toothbrush and all were locked in the glove compartment. So I went down immediately and took a look. Instead of coming up and asking me for a key, Keith had just pried the glove compartment open with a screwdriver, which is unbelievable. I still can't believe it to this day. He'd broken the lock and also slipped the screwdriver and put

this big gash across the dash right through my twenty coats of ruby-red maroon. Well, I just absolutely came on him. I mean, I just bounded up those stairs, blood in my eyes. He'd locked the door. The girls were yelling, 'Don't, don't!' I was tearing down the door, just kicking it in. And he, realizing that I was really going to tear him limb from limb, he leaped out of that second-story window, broke his ankle on the cement pavement, and still managed to scamper off. I didn't see him for another month after that. By that time I'd slowed down a bit, although I don't think I ever forgave him. Can *you* believe that? I can't."

We had come full circle back to Leimert Park and were idling by the crab grass. I asked Bob whether his work on cars, more than any particular art classes he subsequently took, might be seen as one origin of his artistic vocation. He concurred.

"Of course, what's going on in such situations is precisely an artistic activity. A lot of art critics, especially New York *Artforum* types, have a lot of trouble seeing the validity of such a contention. I once had a run-in with one of them about this — this was years later, in the middle of the Ferus period. This guy was out here, one of the head honchos, and he was upset — what was it? — oh, yeah — because Billy Al Bengston was racing motorcycles at the time. This critic just dismissed that out of hand as a superficial, suicidal self-indulgence. And I said you can't do that. We got going and ended up arguing about folk art. He was one of those Marxist critics who like to think they're real involved with the people, making great gestures and so forth, but they're hardly in the world at all. Anyway, he was talking about pot-making and weaving and everything, and my feeling was that that was all historical art but not folk art. As far as I'm concerned, a folk art is when you take a utilitarian object, something you use everyday, and you give it overlays of your own personality, what it is you feel and so forth. You enhance it with your life. And a folk art in the current period of time would more appropriately be in the area of something like a motorcycle. I mean, a motorcycle can be a lot more than just a machine that runs along; it can be a whole description of a personality and an aesthetic.

"Anyway, so I looked in the paper, and I found this ad of a guy who was selling a hot rod and a motorcycle. And I took the critic out to this place. It was really fortunate, because it was exactly what I wanted. We arrived at this place in the Valley, in the middle

of nowhere, and here's this kid: he's selling a hot rod and he's got another he's working on. He's selling a '32 coupe, and he's got a '29 roadster in the garage. The '32 he was getting rid of was an absolute cherry. But what was more interesting, and which I was able to show this critic, was that here was this '29, absolutely dismantled, I mean, completely apart, and the kid was making decisions about the frame, whether or not he was going to cad plate certain bolts or whether he was going to buff grind them, or whether he was just going to leave them raw as they were. He was insulating and soundproofing the doors, all kinds of things that no one would ever know or see unless they were truly a sophisticate in the area. But, I mean, real aesthetic decisions, truly aesthetic decisions. Here was a fifteen-year-old kid who wouldn't know art from schmart, but you couldn't talk about a more real aesthetic activity than what he was doing, how he was carefully weighing: what was the attitude of this whole thing? What exactly? How should it look? What was the relationship in terms of its machinery, its social bearing, everything? I mean, all these things were being weighed in terms of the aesthetics of how the thing should *look*. It was a perfect example.

"The critic simply denied it. Simply denied it: not important, unreal, untrue, doesn't happen, doesn't exist. See, he comes from a world in New York where the automobile. . . . I mean, automobiles are 'What? Automobile? Nothing.' Right? I mean, no awareness, no sensitivity, no involvement. So he simply denied it: 'It doesn't exist.' Like that: 'Not an issue.' Which we argued about a little on the way back over the Sepulveda pass.

"I said, 'How can you deny it? You may not be interested, but how can you deny it? I mean, there it is, full blown, right in front of you, and it's obviously a folk art!'

"Anyway, he, 'No, no.'

"So I finally just stopped the car and made him get out. I just flat left him there by the road, man, and just drove off. Said, 'See you later, Max.' "

Bob was laughing uproariously by now, relishing the memory of the incident. Calming himself, he continued, "And that was basically the last conversation we two have ever had."

We started moving once again. "Well," Bob sighed, "I suppose all that's left to show you is the high school."

We cruised through a flat business district for several blocks. I

observed that for all his tales of teenage life that afternoon, the school itself had cropped up only rarely in his recollections.

"Well," he explained, "from the tenth grade on I didn't even take a notebook. That shows how seriously I took school. If there was an assignment, I'd scribble it on some scrap of paper. School was essentially a place to go and meet. I went to school, and I went every day, because I really was having a good time: that's where all the action was."

Had any particular subjects interested him?

"Well, I took art classes, and I had an art teacher who thought I was very talented; I guess I had a natural facility and it was easy. There were only two required classes that I ever took. My father definitely wanted me to take algebra, and my mother definitely wanted me to take Latin. I flunked them both, which shows you. My father really wanted me to take algebra, for the discipline. So I tried real hard, took it three times, beginning algebra, and flunked all three times."

"Did that matter at all to you, flunking classes?"

"Nope."

"Did it matter to your father?"

"Finally, I guess not."

We rounded a corner and confronted the school's sign, Dorsey High ("Registration, September 11 — See you soon!"). Bob was pointing: "Over there, past the main entrance, there's like a large circle, which is where we all danced during lunch and after school. And over here" — we sidled round toward the playing field, where squadrons of green-and-white-jerseyed jocks (most of them black) were friskily sacking each other in the late afternoon sun — "this was the football field, scene of my many. . . whatever. I played end. We had a very good team, made the city finals. I was a good, solid participant, but hardly the star or anything."

I wondered how on earth Bob had time for all of this; it sounded like he had lived eighteen adolescences, rather than one. "Well," he explained, "we are talking about *three years* of high school," as if that explained anything. He went on to describe how he'd been a floater. "I wasn't really a member of any particular clique, although I floated between several. There were the guys who were into cars, others who were into girls, others into dancing, others into gambling — I just drifted between them, partaking of everything."

I asked him about the gambling. "Well, as you know, Hollywood Park Race Track is just a few miles back that way. And there was one group of guys—they hung out over at this pool hall on Adams—and they were into dressing up, wearing suits and porkpie hats, the whole dude routine. They were heavily into gambling, and I hovered around them. Starting around tenth grade, we began going to the ninth race each day, because after the eighth race they just opened the gates and let you in free (otherwise, we couldn't have gotten tickets, because we were still too young). But all day we'd be listening to the races, getting to know the horses, trying to pick 'em."

Was he making any money?

"Well, in the very beginning I wasn't making much. It was like two-dollar bets. I didn't really begin to make money gambling until I turned professional, which was years later. No, I'd win sometimes, lose sometimes. I don't know whether in the long run I came out ahead or behind, because I didn't keep track. If I came out behind, it was not very far behind, because *(a)* I could not afford to lose and *(b)* I never liked losing. I mean, losing is something I never took kindly to at all.

"It's funny. You know the theory about gamblers really being in it for the losing? Well, that's something that never entered my psyche. Losing, forgetting the money, just was no fun. To me, losing was not interesting. So if I'm losing, I don't play. That's why I never gamble in Las Vegas. I mean, I love to shoot craps. It's a great game, one of the great gambling games of all time, but basically you can't win. You're playing against the house, and it's strictly percentages, strictly mathematics. You can be a better gambler, have a few winning streaks, but basically you can't beat mathematics.

"You *can* beat other people, by playing better than they do. So any game where it's man-on-man, me-against-you, or me-against-the-crowd-at-the-race-track: that's my kind of gambling game. It's my skill and your skill, and if I'm better than you are, I'll beat you. Over the long run, you might beat me here, you might beat me there. In fact, in small nickel-and-dime games, I'd be inclined to let you win, but to play loosely enough so that it makes no difference, on the basis that you may eventually end up in a real game with me, at which point the investment will have proven worthwhile.

"But back in high school, this was still embryonic, just nickel-and-diming around. It was more just part of the pleasure."

The sun was low in the sky now, and we were meandering lazily toward it, back toward the freeway and home. Our conversation was drifting casually—curious associations. One thing led to another, gambling to . . . birth control. I asked Bob if kids in his circle worried much about pregnancy.

"Well, we thought about it," Bob reflected, "but not a hell of a lot. You did one thing or another. Sometimes you just kept your fingers crossed. It just depended what the occasion was, who you were with. Got very lucky, I guess. Just plain lucky. Joan sometimes talks about all the girls at her high school, how half of them got knocked up and had to get married before they even graduated. In my high school I don't remember anybody getting married . . . or knocked up. No abortions that I can remember. So sure, it was a concern, but not one that stopped you. Everybody was just lucky or something. We lived a sainted life or whatever you call it—a charmed life."

We had passed his junior high, and I asked him if that had been a similarly blessed time for him. He said not especially. "I have just a total blank in terms of memories before high school. Since that's come up a few times, I've wondered why. And part of it, I think, is that I never delve into it. I mean, people like Joan, with whom there are traumas in their youth, one thing about why there are traumas is that they dwell on them a little, they remember them and think back on them and use them as reference. I never think about that stuff at all, and I never go back. It's not so much a question of not having a memory as not having an interest in going back to think about those things"

CHAPTER 2

Childhood
(1928 – 43)

"Bob doesn't like to think about things that are unpleasant," the white-haired woman was explaining, "so he doesn't. That's all. He's just got incredible self-discipline." Doubtful about getting any substantial information from Bob about his childhood, I had driven down to Leisure World, a sprawling retirement community halfway between Los Angeles and San Diego, to talk with his mother.

Actually, Bob had divulged some sparse details about his parents. His father, Overton Ernest Irwin, grew up in Cripple Creek, Colorado, working in the gold mines as early as his twelfth year in order to help support his widowed mother. Around the time of

World War I, he moved out to Long Beach, California, to work in the shipyards. There he met Goldie Florence Anderberg, a devout young Mormon from Provo, Utah, whom he presently wed. Several years later, in 1928, they bore their first child, Robert. (A daughter, Pat, would complete the family a year later.)

During the twenties, Bob's father founded and ran a thriving contracting business (these were boom years for construction in southern California). He was stylish, even flamboyant—wore spats, sported a cane, affected a monocle. Years later, Bob's aunts regaled him with tales of how they used to cross the street whenever they saw his father coming, so embarrassed were they by the young man's cocky strut. But Bob would only hear tell of this side of his father. The construction industry was one of the first to be devastated by the depression, and Bob's father lost everything. Unlike many of his competitors, however, Overton Irwin refused to declare bankruptcy, and over the years, slowly, painfully, he paid off all his debts. But, in Bob's words, "He had no style whatsoever after that." Through a family connection he secured employment with the municipal Department of Water and Power (or, as Bob tellingly miscasts it, "the bureau of power and light"), where he logged a regular nine-to-five shift for the rest of his working life.

"My relationship to my father was very simple," Bob told me once. "We had one thing in common, and that was sports." Bob and his father used to frequent the boxing matches at the Olympic Auditorium and the football matches at the local junior colleges. For years, indeed right up until his father's death in 1975, Bob used to accompany his parents to all the University of Southern California home games; they had season tickets. Aside from those enthusiasms, however, there was apparently little substantive relationship between father and son. Bob speaks fondly of his father as "a gentle man of few words—but whenever he laid down the law, that was it; there was no appeal; that was just how it was going to be."

His mother, by contrast, Bob describes as the thinker and the worrier of the two. "My father wasn't much of a worrier at all. I think it's rather from her that I gained a lot of the need to endure, to accomplish something. She had a lot of that in her, was very strong in that way. He was, as I say, much lighter. He was very happy to do just what he was doing." Bob feels there was a real

spark of vitality, of creative curiosity to his mother—he cites her very decision to marry the kind of man his father was when she married him—but he feels that spark was continually being dimmed by her unwavering devotion to her religion. During the early years she carted her two youngsters to Mormon Sunday school every week, until one day, around age ten, Bob simply said he wasn't going to go anymore. His father, prodded into the fray, remained essentially neutral: "There's probably some good in it, son," he said. "But *you* never go," countered Bob, who, although he seldom rebelled, could be as unflinching as his father whenever he did. "Well," insisted his father, "*that's* different." But Bob didn't go that Sunday and never went again. Over the years, mother and son gradually achieved an equilibrium on the issue, an impasse that disguised itself as peace, but to this day, each time she sees him, Mrs. Irwin quizzes her son on his luck at the horse races. "And when I tell her I've been doing terrific, she's visibly disappointed," Bob comments with a smile. "It's like she's just waiting for me to get clobbered, as if that would vindicate something very important in her life. She can't stand the thought that she may not have had to be so righteous all these years."

Aside from such general intimations, however, one doesn't get much from Bob regarding his earliest years and even less regarding the genesis of his artistic vocation. "Actually it's almost without event," Bob hazarded one afternoon. "Not unlike many children, I did a lot of drawing. My mother encouraged me, but that was really casual. You know, your mother likes them, so to please your mother you do a lot of drawings. You can sort of say that was the root of it, but it wasn't very clear and it wasn't very complicated. My family and my life at that time had no aesthetic qualities at all, no input, no awareness, nobody I looked at. There was no interest on the part of any of my friends. Our family lived near the museum, but we hardly ever went, except for maybe a picnic once in a while. How I decided to become an artist, I really don't know. It was something I decided even before I went to high school. And yet I didn't pursue it in high school.

"The only thing I really remember about my early life — and it's almost *too* correct now—is just the way things looked: the way a particular street looked or the time of day, or the way a hallway looked in the evening, things of that sort. It's almost a purely visual memory, with no sense of events at all up until I reached high school.

"You want that kind of thing," he smiled at me, "maybe you'd better go talk to Goldie."

Which is what I was now doing.

Mrs. Irwin's home is neat, full, indeed overbrimming, the kind of thing that happens with older people as they shoehorn their lives into successively smaller quarters. There is little to distinguish this pleasant duplex from the dozens of others that dot the rolling hills of this retirement community wedged between the freeway and the sea. Neighbors putter in gardens, putt on greens. The sun shines benignly—people put their best face on.

Mrs. Irwin's living room teems with California kitsch, narrow paintings of bouquets and Mexican street scenes (sombrero pastorals), statuettes on counters, clusters of family photographs. Everything is of a piece except for the strikingly robust, abstract, green canvas hanging on the wall by the entrance. I paused to look at it for a moment.

"Bob did that when he was just out of art school," Mrs. Irwin volunteered. "He thinks it's terrible now and wishes I'd get rid of it, but I like it, and I'm not going to. I think it's very pretty; you can look and never tire of it, not like some of these other things here. I use it as a test, too; you can tell about people. Sometimes visitors just can't stand it; they actually avoid it! And sometimes they get caught up in it for a long time. Yesterday there was a neighbor here, and she was talking about how she saw birds and waves in it, and I had to explain to her that this is modern art, and you're not *supposed* to see things like that; it's just abstract."

I asked her what she says when visitors ask her what her son does. She laughed. "Yes, that's a problem. I say, 'Well, he's an artist.' And they say, 'Oh, really? A commercial artist?' So I say no. 'What type of art does he do?' 'Well, it isn't anything that you would probably understand, but let's just say he's had shows probably in most of the states of the United States and in many foreign countries. The type of thing he does you wouldn't buy to use in a home for decorative purposes. It would only be bought by museums or collectors.' And of course, by that time they lose me, or I lose them. As the years have gone by, it's gotten more and more difficult, especially since Bob really lost me a long time ago.

"About ten years ago there was a show at the L. A. County Museum of Art, and a group of us from the neighborhood went down, and everybody was very complimentary, but I knew that

deep down they were going, 'Oh, dear.' Around that time a friend of mine from church said, 'You know, Goldie, I'd give anything if your son would paint me a pretty seascape.' And I said, 'Margaret, Bob wouldn't paint you a seascape if you paid him a million dollars — *no way!*' But later on she heard about this show, and she said, 'I want to go see that.' So I said okay and told her where it was and everything, but I thought, oh-oh. So she went to see it with a friend, and she told me later, she said, 'We went in, Goldie, and we didn't see *anything!*' And I said, 'Yes, I understand.' She said, 'We spoke with the guard there, said, 'We came to see the Robert Irwin show.' And he said, 'Yes, it's right there.' *'Goldie,'* she said, *'Goldie, there wasn't anything there!'* I said, 'Margaret, you have to be committed to this, you have to understand it, you can't just go in there cold and expect to understand something like that.' I didn't have the foggiest notion, and here I was explaining it to her!

"But, you know, even though I don't understand it, I still see the beauty in it. Bob's never done anything unpleasant to look at."

I asked her how she accounted for the dawning of her son's artistic vocation, how she saw it relating to his family upbringing. She really didn't have a clue. "How he developed the way he did is a complete mystery to me. You could talk to my next-door neighbor and get as good an insight." She offered a few glimpses— Bob's initial passion was copying cartoon strips, and he was the cartoonist for his school paper; also, by high school his talent was so pronounced that his art teacher, Miss Jones, gave him an easel and paints while everyone else worked in pencil and pad—but she seemed to prefer to talk about the genesis of his character. He was, apparently, a very curious child.

To begin with, "He was born cautious. You know how most mothers are petrified of leaving their babies alone on high places—tables, chests, and so forth. Well, when he was an infant, I could leave Bob on top of a high bed, for instance, and even leave the room, I was so sure he wouldn't move. It wasn't that he was scared: he was just exceedingly careful. He wouldn't make a move until he'd felt all around—his little hands and feet extending— and was absolutely sure of where he was. He seemed to be fascinated just feeling about like that.

"In subsequent years," she continued, "he was incredibly independent. He insisted on learning everything by himself. It was no use, for instance, trying to teach him how to ride a bicycle. He

couldn't stand for anyone to see him falling down. Instead he'd take the bike off in a corner or out back in the alley and struggle with it by himself until one day he'd emerge, riding the bike.

"The first day of school—in kindergarten, imagine!—I went to meet him, because he had to cross a couple busy streets. As I approached the school, I saw all the other little kids, clinging to the fence, crying for their mommies. But Bob was already out, starting on his way home; and when he saw me he went clear across the street so he wouldn't have to walk with me. He couldn't stand to be that dependent. That hurt me so much," Mrs. Irwin smiled in retrospect, "but it was typical."

Or how he dealt with pain: "One day our puppy died and we all wept, but not Bob. This was when he was about fourteen. He just went off by himself for a while. A few days later I asked him, 'Didn't you feel bad when Penny died?' And he said, 'Yes, but I went away by myself.' He came to his own terms. It was the same way when his father died a few years ago. He just masters the sadness.

"But I can count the times on one hand that he ever said something unkind or unpleasant to me," she continued. "If he didn't like something, he just shut it out and said nothing. Bob always obeyed, although we seldom had need to order him. He was greatly loved at home; his aunts adored him, spoiled him. He was just a nice person to raise. As my husband used to say, 'That boy has never caused me one moment's worry.' "

I asked her what her husband had thought of Bob's art, and she laughed. "Ah, my poor husband. Well, he was a man with a calm disposition, very easygoing. Their main tie was sports. He didn't really understand the art at all, and he just about died when Bob started refusing some of those big job offers that began coming his way, art directorships and university positions. But he never said anything, and he was proud of Bob. In 1961, Bob gave us some money and sent us off to Europe for the first time, and we went to all the museums, and I remember how my husband used to go up to the guards and ask where the Vermeers were. They'd direct him, and then he'd boast, 'My son's an artist, and he says that guy's okay.' It tickled the guards, I think."

Our conversation turned to Bob's education. "You know," she said, "Bob seemed to acquire knowledge by osmosis. When he was just a little kid, people would be talking about this or that, baseball

averages, car models, and so forth, and he just knew it all, and I had no idea where or when he'd picked it up. It was kind of spooky. He seemed to retain things with only the slightest exposure."

I asked her about books in the house when Bob was growing up, and she said Bob read the standard boy's fare—adventure stories and so forth—and that she used to enjoy reading her children the classics. "But, you know," she concluded, "I read for pleasure, and nowadays Bob reads hard. He reads all that philosophy and science and stuff. That's relatively new; he didn't used to do that." And then, as an afterthought, she added, "I mean, I read hard, too, I suppose, but then it's the Scriptures."

Walking back toward my car, I found myself pondering environment and heredity, just how much childhood grounds adult character and in what ways. As for Bob, it seems clear, his mother provided him with a solid ethical foundation—he would balk at the word *morality*—and the strong imperative to make something of his life. From his father he derived an easygoing insouciance. And yes, it makes for an unusual mixture. But there is something more. I just leave off wondering what was making little Bob so fiercely independent so early on. When Bob speaks of the "charmed" nature of his early life, is this because he actually did experience a happy youth, or because he really was able to disregard whatever pain there was as it was happening, or because he's been able to disregard it since? One wonders, especially because of the starkness of the solitude this youth subsequently engendered. There is an irreducible mystery in all of this.

CHAPTER 3

Army, Schooling, Europe, and Early Work (1946 – 57)

One afternoon in June 1946, immediately following his gradua-
tion from Dorsey High, a group of Bob Irwin's buddies piled him
into a van and dragged him over to the Inglewood army recruit-
ing office. The GI Bill's handsome benefits were about to lapse,
and these kids stood a good chance of being drafted anyway later
on, so the whole gang of them had recently decided to enlist en
masse. "Naturally I hadn't even thought about it," Bob recalls
today. "As usual I was just floating along. But they carried me
down there, filled out all the papers, huddled around, egging me
on. All I had to do was sign, and they were saying, 'Come on, sign,
sign. . . .' So, like an idiot, I signed. That's how I joined the fucking
paratroopers."

After a few weeks, Irwin was transferred out of the para-
troopers (owing to a football back injury) and into the regular
infantry. Within a few months he'd been shuttled over to Europe.

"I was stationed in a town called Kassel, right in the middle of
Germany, up against the East German border. It had been 98
percent destroyed during the war—really incredible. It had been
a secondary target: apparently whenever they hadn't had any
place else to bomb, they'd bomb Kassel. So the town was com-
pletely flattened. Literally. People would appear on Sunday;
they'd just rise out of the ground, out of the cellars they were
living in. It was the dead of winter, very cold, very depressing."

To escape that desolation, Irwin managed to hitch onto one of
the army's touring baseball teams, and from that he moved to
competitive swimming. Within a few months he was running the
officers' swimming pool in Heidelberg, which is where he sweated
out the rest of his tour of duty. Late in 1947, facing the prospect of
another German winter, Irwin lopped six months off his tour in
exchange for three years in the civilian army reserve. By early
1948, at age nineteen, he was back in Los Angeles.

During his stint in Europe, Irwin had neither visited mu-
seums nor practiced art, but returning to Los Angeles he enrolled
at the Otis Art Institute without a moment's hesitation. Today he
can offer no explanation for the choice. "It was preordained, I
guess." He had always figured he was going to be an artist.

He was blessed—or, as he says, "cursed"—with a natural facil-
ity for drawing. "In my years since then as a teacher, I've seen it
over and over again. It's the kids with the greatest facility who can
run up against the biggest problems. You are the best in your class
without even trying, which is the best way to learn nothing. There
are no questions, nothing's pressing you, you're just operating off
the top of your facility. The not-so-facile kid just plugs along,
every step is a working step, and he comes to the twentieth step
and it's just another step. But facility is a funny thing: it takes you
way up—you soar, and you look like you're really doing
something—but at a certain point you go as far as you can with
facility, and then you hit the big questions. And for you, who've
never been pressed, that can present a huge roadblock. I've seen a
lot of kids get completely waylaid at that point, totally confused,
sometimes permanently."

In Irwin's case, facility was to carry him effortlessly through

stints at three art schools and numerous tours of Europe. At least in terms of his artistic vocation, he would face no fundamental challenges. "I had excellent eye-hand coordination," he recalls. "The idea of perspective was never very difficult: I've been able to do it from the very first time I ever picked up a pencil and without, as I say, there really being any reason why that should be so. They had a design class at Otis, and I aced it. Drawing and painting were a breeze." The very first time Irwin applied oil paint to canvas in art school, for example, the resultant work, a dockyard pastoral entitled *The Boat Shop*, was juried into the Los Angeles County Museum's prestigious 1950 Annual. ("That painting was really more drawing than painting," Irwin recalls. "Boats in a repair yard, done in very somber colors. The whole canvas was stained in deep, rich browns and greens and all of that.") A few years later, Irwin's first watercolor was similarly successful.

Otis, as Bob remembers it, was very traditional and very provincial. There was not the slightest hint of the exciting upsurge of abstract expressionism which was at that very moment transpiring on the other side of the continent. It was all still lifes and models, landscapes, and cones. "There was a guy teaching an anatomy course there," Bob reminisces, "where everybody was given a corpse to carve up during the semester. Well, I didn't think that was such a good idea. I attended one day, and when he said that that's what we were going to do, I just said, 'Pasadena,' because I wasn't interested in doing it. That guy's still there. He'll probably keep teaching that course till the day he dies, and then they'll just slap him on the table and carve him up."

During the Otis years, Bob specialized in portraits of old men and derelicts, the sad denizens of the park that fronted the institute. Mrs. Irwin, when I spoke with her, recalled one particular image Bob captured of an old black man. "It was the most beautiful drawing you ever saw," she insisted (she's never quite gotten over Bob's decision to move on from this early style). "Here was this old man, his sad chin resting on his hand, with an expression like he was expressing the sorrow of the whole Negro race." According to her, Bob much preferred these subjects to the young models he was being offered at the institute. "'It's no challenge to draw someone who's young and beautiful, where everything is perfect,'" she recalls his telling her. "'You need the lines, the character. . . .'" He sold the portrait of the old black man for $75.00.

His subjects may have been sad, but his life was breezy. For three years he extended the winsome camaraderie of his high school years: he danced contests, built cars, chased girls, bet horses. On the side he worked a succession of odd jobs. During the summers he was a lifeguard or bouncer up at Lake Arrowhead or out on Santa Catalina Island. He took it easy. One balmy afternoon at Arrowhead, he received word that he was being recalled into the army. It was July 1950; the Korean War had begun.

Irwin narrowly averted being shipped over to Asia by securing assignment to Camp Roberts in California's central valley. He hated it. He hated it so much he has simply blocked most of the next year and a half out of his memory. His mother recalls that when she reached him with the news in Arrowhead, "He couldn't believe it. He hated the military life, especially the regimentation, the way the enlisted men were treated, although he had no desire to be an officer. That's why he'd managed to get out six months early in the first place, which is in turn why he was even eligible to be called up that second time."

Irwin bridled at this sudden, completely unexpected truncation of his freedom and of the education upon which he had embarked. And yet, his tour of duty was relatively undemanding.

"The main thing was to be as anonymous as possible, to just disappear," he told me one afternoon, summoning as many memories on the subject as I was ever to get from him. "I got so good at it that as they were marching us off in the morning to some dumb thing or other, I would simply step out of line and veer off, shoot pool all day, and step back into line as they marched the platoon back to barracks in the late afternoon, without ever being missed."

He was assigned to special services and asked to organize the sports program. He'd spend mind-deadening hours spooling and unspooling movie reels. Time passed. Whenever possible he dashed down to Los Angeles for a few days. A charcoal drawing he made, the portrait of an exhausted soldier's sunken face, was sent to Washington, D.C., and won first prize in a military competition. (Mrs. Irwin still owns the piece, although she has to keep it hidden in the closet, out of the way of her son's violent retrospective judgment.) Time crawled. Finally it was over.

Upon returning to Los Angeles, Bob enrolled in the Jepson Art Institute, an independent school that had been founded re-

cently by Herbert Jepson. It was staffed by Rico Lebrun, Howard Warshaw, and William Brice, which is to say by the reigning figures on the Los Angeles art scene at that time. The surreal figurative distortions of Lebrun and Warshaw were taking top prizes every year at the County Annuals throughout the early fifties. Lebrun, a charismatic Italian émigré, thrilled his lecture classes with his comprehensive surveys of the great themes in the High Tradition. Bob was singularly unimpressed.

"Everybody at Jepson's was into talking these really weighty games," Bob recalls, "very ponderous, socialist in temperament, in some cases even Marxist. That wasn't anything I particularly paid attention to, but there was this sort of 'gang's all here' attitude permeating the place." (In this context it is interesting to note that the McCarthyite hysteria—the trial of the Hollywood Ten and the Los Angeles city council's inquiry into communist influence on the visual arts—which no doubt formed the urgent backdrop to these intense discussions, was just passing Irwin right by.) "The thing that amazed me is that they had these drawing classes, and I'd be in there drawing like a son of a bitch, and then I'd go around and look at everybody else's drawing boards to see what was going on, and there wouldn't be anything on them! They were all talking and going through these weighty things, and nobody was *doing* anything. Or if they did anything, they all looked alike, a bunch of miniature Lebruns. It was real confusing, like, 'What the hell's going on here?' So I decided I was in the wrong place, and after three months I just checked out."

Irwin thereupon checked into the Chouinard Art Institute, the other principal art school in Los Angeles, and continued to do, in his words, "all the ordinary things." Around this time he dabbled in "California School watercolors," dreamy landscapes in watery tones. "God, those things were dumb," recalls Irwin, "kids and merry-go-rounds and balloons, I was *so* naive." His mother hoarded these pieces, doled them out selectively to particularly deserving relatives, whose mantelpieces they adorn to this day, to Irwin's painfully recurrent dismay.

"I don't think the teachers who were teaching me through those years were particularly smart," Irwin judges in retrospect. "They didn't ask me one really hard question. If they did, I didn't hear it. Or I didn't understand them. I'd have to say that my art education wasn't much. By the time I got out of art school, having

gone to two or three places, I was still very naive. Nothing of any significance had taken place. I hadn't gained any sophistication in terms of my awareness of what was going on in art at that time. I was not even aware of who the most interesting artists were. It was almost less of an education than it was like preparing to be a plumber or something: I was learning techniques."

If nothing much was happening to Bob at art school, these years during the midfifties were rich with the experiences he was garnering on his frequent trips to Europe. All through this period he'd work on the side and save up just enough to return to the Continent. Once there, like many young Americans, he'd play the currencies. "Europe was extremely inexpensive in those days; you could go over by boat, and then, depending on where you changed your money—Tangiers, Paris, Amsterdam, Zurich—you could sometimes double or even triple it. All the countries tried to maintain these ludicrous official rates, but there was always a thriving black market on the side. The only country in Europe in those days where you could get the black market rate legally was the Vatican—they exchanged money at its real value—so I visited there several times and got some exposure to Michelangelo in the process."

Though Irwin now began visiting the museums, for a long while his curiosity remained at best perfunctory. Mainly he walked around the cities aimlessly. "I walked in the daytime for a long, long time, but then I got into the habit in the evening of buying myself a couple bottles of beer, sticking them in my pocket, and then just walking, for example, in Paris, all night long in Paris until it became dawn, and then returning to my hotel room, sleeping till evening, having dinner, and starting out again. Just walking by myself. At certain times of night I'd be the only one out in the whole city. I mean, whole areas were just dead silent. And it was an incredibly romantic, very beautiful city, especially late at night like that."

It was a strange way to see Europe. "After I'd been over about six or eight times during that decade," Bob recalls, "having spent maybe two or more years there altogether, I remember once having a conversation with some people who'd just come back from a two-week tour and being unable to convince them that I'd been there at all. They'd talk Étoile and Elysées and Opéra and all those names, and I couldn't remember any of that stuff. I'd probably seen more of Paris than all of those people combined, but I

couldn't tell them anywhere I'd been in terms of the name of the street or the cafe or whatever. I just wasn't interested in that. In fact, I maybe saw all the churches in Paris, but I never *went to see* any of the churches in Paris. In my wanderings there would be this building and I'd walk into it just like I walked into every building, but I didn't care whether it was built in the Whatever or who did it. I mean, even to this day, I couldn't care less. On the other hand, I retained a very real sense of the differing textures of each of those places. . . ."

With each new trip Irwin began spending more and more time in the museums. As his own involvement in art grew, his interest in the masters expanded—but only to a point. "After going through the Louvre twenty times and the National Museum and the Prado and whatever—I can't remember the names of the ones in Amsterdam and Florence—well, after a while it got to the point where I'd enter a room and just twirl around and go to the next one and twirl and then the next one. . . . I mean, it got to the point where if I ever saw another fucking brown painting . . . I was so fucking tired of brown paintings. I mean, they all looked exactly the same! After a while my whole relationship to the history of art got cleared out to a matter of trusting my own eye. I mean, I could enter a room and go like that, zap, and pick out the one or two paintings that were at all interesting in terms of technique, like some Davids that were technically really incredible; and there were some that really just jumped out at you, like some Vermeers which were just spectacular. Now and then a piece of Egyptian art or something would really bang you. And if you ever saw an impressionist painting in that atmosphere—which I did once, saw a Gauguin through a haze of brown—it just summoned you back to your senses. But as for the Renaissance and the high tradition, I just came to see that—man, are you kidding?—I wasn't interested in any of that stuff. And I'm still not. I look at Da Vincis and Piero della Francescas, and I'm not interested at all. I look at them with the same kind of interest I'd have turning the pages of a magazine.

"And for somebody who's just growing up as an artist, that sorts the world out pretty good. Suddenly there's a huge chunk of stuff you don't have to deal with anymore. And from that point on, I realized I was in the twentieth century, and I wasn't at all interested in historical forms."

During these trips to Europe, Irwin was thus getting his bear-

ings in relationship to the historical tradition, but even more fundamentally he was taking his own measure. Speaking no foreign language, he found himself as isolated and solitary in Europe as he was social and gregarious in California. Sometimes that isolation became extreme. On one trip—probably in 1954, after he'd left Chouinard—it became transcendental.

Bob had been headed south from Paris toward Morocco, when, passing through Barcelona, he first heard about Ibiza, a small island off the Spanish Mediterranean coast. He continued to North Africa, but several weeks later, for no particular reason—it was cheap, it was warm, it was said to be peaceful—he ventured out to the dry, barren island. In subsequent years Ibiza (pronounced "E-bē-tha" by native Castilians) became known as something of an artist's colony, a winter resort, but during the season Irwin spent there, it was still utterly remote. On the edge of a barren peninsula, Irwin installed himself one day in a small rented cabin and then did not converse with a soul for the next eight months.

Today, when he talks about it, he can't explain why it happened. It just did, gradually, this distancing of himself from the world: the night walks in Paris, the North African desert, and then, by an ineluctable process, this season on Ibiza.

He does recall how it felt. "It was a tremendously painful thing to do, especially in the beginning. It's like in the everyday world, you're just plugged into all the possibilities. Every time you get bored, you plug yourself in somewhere: you call somebody up, you pick up a magazine, a book, you go to a movie, anything. And all of that becomes your identity, the way in which you're alive. You identify yourself in terms of all that. Well, what was happening to me as I was on my way to Ibiza was that I was pulling all those plugs out, one at a time: books, language, social contacts. And what happens at a certain point as you get down to the last plugs, it's like the Zen thing of having no ego: it becomes scary, it's like maybe you're going to lose yourself. And boredom then becomes extremely painful. You really are bored and alone and vulnerable in the sense of having no outside supports in terms of your own being. But when you get them all pulled out, a little period goes by, and then it's absolutely serene, it's terrific. It just becomes really pleasant, because you're out, you're all the way out."

He had brought along a pad and some drawing supplies, but he did not use them. Instead he just sat on a rock, isolated. "I mean, there were people," he clarifies, "but they were simply not people. They were just part of the landscape. Those people were from another world, another time, fishermen in broken-down barks, farmers scraping the scrabbly ground. We had nothing in common, certainly not language—there was no contact. There was this outcropping, and then the Mediterranean carving up the pumice below, and inland some forests, fir trees. You ate whatever the fishermen took in that day. Time became kind of unreal."

He thought about less and less. Finally he just thought about thinking. No longer calibrating his thoughts in terms of a social reality, in terms of how he would have to square them to the requirements of the world, he almost stopped thinking in terms of language. There was a slow purification of thinking; he speaks of arriving at pure ideas, stripped of any worldly ambitions or motives.

"Ideas, when they get like that," Irwin explains, "then you can really get into the game of reason. You can really sit down and reason the nature of what you are thinking. When you peel all those layers away and you arrive at just the qualities of the ideas themselves, it becomes very clear and very simple as to why they are what they are and do what they do. Then, later, when you bring back in the motives and the aspirations and the rationales, you can begin to see how they in turn alter the ideas."

He stayed through the winter, an unseasonably cold winter endured without hot water or heating. The months passed. Spring arrived. One evening, walking into the nearby village, he saw a poster for *Singin' in the Rain*—in Technicolor with Gene Kelly. The screening was due to begin in just a few minutes in the town's tiny, creaky, old theater. He walked in, was suffused for an hour and a half with the sound sets and palm trees of southern California. "That broke the spell!" He left, walked back to his stucco cabin, packed his gear, and was gone the next morning. A week later he was back in Los Angeles.

Curiously, Irwin's Ibizan solitaire had little immediate effect on the course of his life: its lessons would lie dormant for ten years; he would not even begin really to consider them for another twenty. Instead, he resumed his California existence. These were the years when he consolidated his half-baked interest in

horse racing into a professional vocation. Meanwhile, he also consolidated his social life, in 1956 marrying Nancy Oburg, a lovely Swedish-American woman seven years his junior, the sister of one of his sister's friends.

His art resumed its conventional course—nothing spectacular, the standard progression of a talented young artist fresh out of art school. He began attracting the attention of decorators and art dealers, sold a few works, continued to apply himself. The paintings tended to grow a bit more daring, a bit more abstract. A typical work of this period, which Irwin sold to screenwriter Stirling Siliphant, celebrated a cockfight through a vertiginous swirl of colors that just barely retained their figurative form. In evaluating this phase of his career, Irwin feels that "maybe the only drive that I had during that period was that each time I could do something and do it very easily, I would not be interested in doing it again. Nothing more than simple boredom, in the beginning, I think, forced me to be a little more adventuresome about the kind of things I tried to do."

He plodded along. He built up a certain reputation.

THE
NARROWS
(Part One)

The question is asked in ignorance,
by one who does not even know what
can have led him to ask it.

—Søren Kierkegaard in his guise as
Johannes Climacus,
Philosophical Fragments

CHAPTER 4

Ferus
(Los Angeles/
New York)

By 1957, the precocious twenty-nine-year-old artist was mounting a one-man show at the Felix Landau Gallery, perhaps the most prestigious showcase in Los Angeles at the time. It is difficult today to discover exactly what was included in that show. One contemporary witness recalls the canvases as "abstract landscapes." Virtually no newspapers or magazines documented the proceedings. Irwin himself has completely lost track of the paintings in the meantime, and he shows no interest whatsoever in trying to retrieve them. "Let's just say they were 'controlled abstractions,'" he offers impatiently, "'controlled' meaning they were essentially mannered. There was a lot of drawing in them.

They were not gestural; they were very designy drawings with a lot of rich colors and so on and so forth. All of which was not very interesting.

"But for the first time . . ." he continues, pausing. "I think that may have been the initial breakthrough. I had broken my leg skiing, and I was there putting up this exhibition that I was getting ready to have. Landau was a very respectable gallery; it was a big exhibition for me. So there I was, hobbling around on these crutches, helping to finish hanging the show. And for the first time, I think, I really got a good hard look at what I was doing. Now, obviously, they were fairly acceptable, or I wouldn't have been having a show at that gallery. But for me, at that moment, a half an hour before the exhibition, I got that first really clear look at what I was doing, and it was terrible. I mean, it was really bad. A very frightening kind of experience.

"You can romanticize yourself, and you can have all these aspirations and ideas and illusions about what it is you're doing, but then every once in a while you might get lucky enough to get a real look at what you're doing, I mean, just that kind of straight focus which happened at that critical point. And I knew that everything I'd been doing wasn't worth shit. I spent that evening—it was really a very painful evening—with people telling me how terrific the things were, you know, my friends. But at that moment I just stopped being involved with Felix Landau, and I stopped being involved with the things I had been doing.

"My education, I think, started then."

If this was the beginning of Irwin's education, Ferus was the name of his school, for just down the street from Landau's gallery, a motley batch of beatniks, eccentrics, and "art types" had recently convened to form a gallery by that name. Indeed, the Ferus Gallery, which thrived between 1957 and 1966, and which Irwin would presently join, gradually becoming a central figure, proved the seminal source for the blossoming of modernist art in Los Angeles during the sixties.

The Ferus Gallery was initially the contrivance of two extraordinary young men from very different backgrounds, Walter Hopps and Edward Kienholz. Hopps, a brilliant, young art enthusiast with a penchant for the surreal, was a local boy out of Eagle Rock High School and UCLA. While still in high school he

had wheedled his way into the Hollywood home of Walter Arens-
berg. (Actually, he was one of the appallingly few Angelenos who
ever tried.) Arensberg had gathered perhaps the world's fore-
most collection of the work of Marcel Duchamp and his surrealist
colleagues. (It is one of the quirky charms of L.A. art history that
during the late fifties Arensberg was unable to persuade any local
institution to accept the bequest of his remarkable collection; it
finally had to find a permanent home in the Philadelphia Mu-
seum of Art.) In later years, Hopps would move on from Ferus to
important curatorial positions at some of the top contemporary
art museums in the country (he is currently with the National
Collection of Fine Arts in Washington, D.C.). If Hopps was a bit
scattered, given to flights of inspiration but impatient with the
requirements for landing, Ed Kienholz was utterly down to earth.
He came out of rural, eastern Washington state, richly endowed
with a farmboy's practical expertise and a horsetrader's uncom-
mon sense. He had arrived in Los Angeles a few years earlier and
was already honing the rugged visual vocabulary that would cul-
minate, a few years later, in the haunting assemblages—*Roxy's,
The Beanery, The State Hospital, The Illegal Operation,* and others—
which would establish his international reputation. Between 1955
and 1957, each man had attempted his own ramshackle gallery
situation on the fringe, beyond the fringe of the otherwise staid
L.A. art scene; but in 1957 they decided to pool their resources
and establish a space in the heart of La Cienega Boulevard's Gal-
lery Row. Hopps hustled the financing and set a theoretical tone
for the proceedings; Kienholz supervised construction and then
manned the gallery from the tiny studio shed he reserved for
himself in the back.

On March 15, 1957, the Ferus Gallery opened with a group
show entitled, "Objects on the New Landscape Demanding of the
Eye." It featured works by many of the pair's friends as well as a
rich sampling of important contemporary work from San Fran-
cisco, including canvases by Richard Diebenkorn, Frank Lobdell,
and Clyfford Still. (This, for example, may have been the first
occasion at which a Still was shown in Los Angeles.) The coming
year and a half would feature shows for a wide variety of artists,
united more than anything else by their common incompatibility
with any of the otherwise extant structures for art support in Los
Angeles. The gallery would develop a certain notoriety (its fourth

show, for example, an exhibition of mysterious, cabalistic collages by Wallace Berman, was closed down by police on grounds that it was pornographic), but pathetically little patronage.

"The old Ferus Gallery," Irwin recently recalled, "was sort of Baggy Pants and Blackface doing a whole number in the backyard, dancing for nickels and dimes—which was fine. It was a good growing-up stage, it was very loose and wide open. There were about twenty-five people grouped around the gallery, and they all formed a sort of informal coop. They all thought they were into something real interesting. It was a very strong attitude; people were very positive there. I sensed almost immediately that that was where the energy was in town, and that I had a lot to learn from those people."

Irwin may first have been drawn to Ferus through his old high school connection with John Altoon, who was one of the fledgling gallery's premier artists. But early on he sensed an even greater affinity with three of the gallery's other principal painters: Ed Moses, Craig Kauffman, and, most important for him, Billy Al Bengston. Moses and Kauffman had both studied at UCLA (Kauffman had been a high school friend of Hopps's and had joined him on his visits to the Arensberg home). Bengston had studied for a period in San Francisco with Diebenkorn. They all had a sense, if only through magazine articles, of the abstract expressionist revolution that was taking place in New York, and they were addressing its challenge in their work. In that posture, they were virtually unique in southern California at the time.

"As I say," Irwin continues, "my education began with my exposure to those people. I started spending all of my time down at Ferus, even though I was showing up the street at Landau's. They kind of treated me like a minor league partner. I suppose they viewed me as being precocious and not very smart and very naive. I suppose I had a certain drive and intensity which compensated for some of that. But Kauffman was far and away the best artist at that time. And I think that Bengston was far and away the one with the most potential. Bengston had a terrific amount of effect on me at one point. He was very caustic and very opinionated, the king of the one-liners, always zapping you at your most vulnerable point. Craig Kauffman was one of the most sarcastic people I've ever known. They continually pointed out to me the errors of my ways, how dumb the things I was doing were."

Bob paused for a moment, as if to reflect on the vagaries of the passage of time. "Bengston was a major influence on me, that's really true. I can say now that I absolutely dislike Bengston intensely—he's one of the few people in the world whom I do have a real distaste for—so when I talk about his influence, it must be so. He was just painting much better paintings than I was, much stronger, doing big abstract expressionist things, and I was learning a lot from watching him. We were also sharing a social life. Actually, as I look back on it, I was probably sharing *his* social life."

During the autumn of 1958, the old Ferus Gallery reached a crisis point. Twenty shows had come and gone, with virtually no sales. Enthusiasm was high, but the focus was diffuse, and the economics were dire. At this time, Irving Blum strode onto the scene. He was, as Irwin subsequently characterized him, "something altogether different."

Blum was a young man from Phoenix by way of New York City, where he had first gone with the intention of becoming an actor. He carried himself in a smooth, dapper manner, which some have likened to that of Cary Grant. In New York he gradually shed his thespian ambitions as he became increasingly absorbed with art. He hung out in lofts with struggling young artists like Jasper Johns, Andy Warhol, Ellsworth Kelly, Frank Stella, and Robert Rauschenberg. He got a job working for Hans Knoll, the renowned dealer in contemporary furniture, helping to supervise the art purchases that Knoll made in connection with his design commissions for such places as the Seagram's Building. In 1958, after Knoll died in an automobile accident, Blum decided he wanted to found a gallery of his own. He simultaneously realized that another gallery was just what New York did not need. He headed out west to survey the situation: it didn't take long for him to figure out where the action was.

It is unclear whether Ferus could have long survived without the entrepreneurial savvy that Blum was about to inject into it. It is clear, however, that it changed markedly with his arrival. Blum and Hopps negotiated a transition, bought out Kienholz (for a reputed $100 and a legacy of bad feelings), brought on a silent third partner (Sadie Moss, a wealthy widow with an adventuresome taste in the arts), and then completely revamped the gallery. They started by moving it out of its funky quarters behind

Streeter Blair's antique shop, across the street to a clean, white-walled space that looked for all the world as if it had fallen out of a skyscraper on Fifty-seventh Street.

Then they began paring the stable. Blum felt, and he was able to convince Hopps, that trying to service twenty-five artists at once was getting none of them anywhere, that the two of them needed to select a more manageable number and then redouble their efforts on their behalf. They finally settled on having seven artists from San Francisco and seven from Los Angeles as the initial core of the new Ferus. Assessing the relative merits of the artists in Los Angeles, they decided at that point to include one young man who had not even had a slot in the old Ferus. That young man was Robert Irwin.

"As Walter and I looked around the community," Irving Blum recalled for me a few months ago, "one of the artists who really caught our eye was Bob Irwin, who was showing at that time at the Felix Landau Gallery."

We were sitting in the back office of the prestigious gallery he shares today with Joseph Helman, on Seventy-fifth Street in New York, less than a block from the Whitney Museum of American Art.* After years of trying to nurture a support system for art in Los Angeles—first at the Ferus and then with his own gallery—Blum gave up in angry frustration in 1973. His recollections of his years at the Ferus are imbued with a sense of the vigor of the time but are tinged also by a cynical disappointment at the failure of an important collecting scene to emerge there. He is today a great proponent of the absolute centrality of New York in American art, and he belittles Los Angeles as much as he once championed it. Still, his recollections of those years at Ferus swell with retrospective enthusiasm.

"Irwin was painting beach scenes and landscapes that somehow had a very curious organization and seemed to both Walter and me very interesting. But what impressed us even more were the conversations we had with him. He was extremely naive, but he was extraordinarily ambitious, and as committed as anyone I had ever encountered. He was fiercely curious and tremendously disciplined. So we invited him to join our group, and he accepted; and during the next few years we watched his transition from a

*The Blum-Helman Gallery has moved in the meantime to expanded quarters on Fifty-seventh Street.

figurative painter into an abstract expressionist. He was to paint some absolutely extraordinary abstract expressionist canvases, many of which, by the way, he destroyed. Still, some of them have survived in private collections, and I confront them now and then when I visit L.A. They're really technically marvelous."

The new Ferus core in Los Angeles included Altoon, Bengston, Kauffman, Moses, Kienholz, Ken Price, and John Mason, and during the next several years Irwin shared studios with many of them. (Interestingly, very few of those who were cut from the Ferus roster in 1958 persisted into important careers; whether this is an indication of the self-evidence of the choice at the time or the self-fulfillment of its impact later on is unclear.) "The gallery never did anything that all the artists didn't basically agree on," Irwin recalls. "We were essentially all hitting on the same issues. Everybody used to drop by the gallery or down the street at Barney's Beanery. The gallery was like the focal point. It was really very supportive in that sense. It wasn't exactly a club, but we all hung together.

"Ferus was like a magnet. It was an energy level, a level of conviction, an attitude about art, a general attitude about the significance of the work, a sense that we were all at the right place at just the right time."

And yet, for all the intense absorption in working and looking at each other's works, the Ferus people spent little time theorizing about their work. "I think the artists in L.A., especially at Ferus, were not very verbal," Irwin maintains. "There was no such thing as an artist's meeting or a Ferus manifesto. There was very little dialogue. Certain of the artists refused to do it at all; they found it distasteful. Bengston, for instance, simply forebade such discussion, no doubt because he was incapable of it. Art was something you did individually, a personal thing, and there was little attempt to try to convert it into a kind of group activity or a group affirmation."

Rather than supporting each other in any particular aesthetic positions, the Ferus artists supported each other in their living; their own sense of community sheltered them from the relative indifference with which the community at large greeted their efforts.

Irwin often speculates about the effect of the Ferus community's relative lack of sophistication, especially compared with that

of its New York counterparts. Irwin may have been utterly under-educated, but his colleagues were at best only a few steps ahead of him. "I think it's both a gain and a loss—and maybe I typify it to some degree—that a generation of artists in L.A. had to grow up without a very strong literate or historical background, that in this community, in terms of writers, especially at that time, the amount of dialogue we had with anyone outside ourselves was really minimal, as opposed to, say, a group of artists living in New York. They had a much richer tradition of dialogue, among themselves, and between themselves and good critics and historians—people with real ability. So I think they were more conscious of their historical parameters than were the people I was involved with. And that, as I say, for both win and lose: on the loss side, the lack of sophistication that one derives from that; but on the plus side, the degree to which the things that you work out finally begin to emphasize those things that you've really become involved in and are thus more, in a sense, your own resolutions."

Nevertheless, the Ferus artists became mildly obsessed with New York. One of the group, usually Blum, would go east for a visit, and upon his return he'd be pumped for his impressions of the state of the galleries, the new trends, the fading ideologies; but what was really being asked was, "How do we measure up here in L.A.?"

"They were always debating that measuring-up issue," Blum recalls, "and it seems to me that at that particular time—we're talking about 1958, '59, '60—they were measuring up quite well. Remember, at that time, the best New York could produce in a really visible way was second generation abstract expressionism. So we're talking about people like Grace Hartigan, Mike Goldberg, Al Leslie, Paul Jenkins: these were the people who were in the art magazines in a regular way. These were the people that they looked at and indeed did supersede, I feel. I feel that Irwin at his peak, certainly Kauffman, Bengston, Altoon, and Moses at theirs, were abstract expressionist painters of real quality and at least as good as the best that was being produced in New York during that comparable moment, but with much less focus because they were out there."

Irwin himself phrases the issue even more emphatically. It is his conviction that the insularity and naiveté of their West Coast situation allowed a few West Coast artists to see the New York

abstract expressionist achievement freshly. Just as the original abstract expressionist flowering in the late forties had been possible in New York because of the fresh manner in which a group of "rustic" Americans—Jackson Pollock, Mark Rothko, Barnett Newman, Franz Kline, Robert Motherwell—were able to confront and transcend the by-then stylized aesthetics of the European surrealists and cubists of the previous generation, so ten years later a group of even more rustic Californians were better able to appreciate the true significance of *their* achievement than were the second generation artists who were living right there in New York, where abstract expressionism had begun in the meantime to ossify into a stylized code. By the late fifties in New York, the abstract expressionist achievement had already been digested into conventional categories and gestures. The sophisticated critics with their literate biases may have snapped themselves out of "reading" the canvas for subject matter, but they were still "reading" the artist himself: the drama of his action in the world, the canvas as a trace of the artist's existential confrontation with his own reality. The artist's activity in creating the work had become the work's compelling subject, and the whole superstructure of nineteenth- and twentieth-century (European) literature and philosophy was being brought to bear in its interpretation. Irwin feels that the second generation New Yorkers became mired in this self-reflective critical morass, indeed began posing as "abstract expressionists," whereas some of the naifs working in California were gradually able to transcend these postures and to see that the true abstract expressionist achievement consisted not so much in shifting the locus of reading but rather in bringing the literate bias itself into question. One of the first shows held at the new Ferus, in January 1960, was a "Fourteen New York Artists" exhibition (James Brooks, Willem de Kooning, Arshile Gorky, Philip Guston, Hans Hofmann, Franz Kline, Joan Mitchell, Robert Motherwell, Louise Nevelson, Barnett Newman, Jackson Pollock, Milton Resnick, Mark Rothko, and Jack Tworkov), and Irwin feels that in many ways Los Angeles in 1960 offered a vacuum into which these stray crystals were able to fall and then form in unique ways.

Whereas Blum might concur in principle with some of Irwin's observations about the situation of Los Angeles artists in the late fifties, he nevertheless in retrospect bemoans the failure of many

of these artists to move to New York, where he feels they would have made a truly substantial impact. Staying in Los Angeles, he feels, they not only failed to garner the attention New York lavishes on its artists but also to profit from the intensity it requires. "I mean," he insists, "New York is the center. When you talk about galleries that sell paintings, there are two thousand in New York, as opposed to ten in L.A. When you talk about periodicals, every single art periodical of any note or quality is based in New York. (Even *Artforum,* which started out in Los Angeles, finally moved to New York.) When you talk about the art establishment, it exists in New York and nowhere else. Now, if you're going to ignore all that, you certainly can, but you do so at your own peril."

I started to point out to him the incongruity of hearing such a passionate defense of New York from someone who had once championed Los Angeles equally passionately. "Well," he interrupted, "fifteen years ago I had maybe an idyllic vision of the possibilities of Los Angeles, but I've since come around in my thinking. I think that what you see in Los Angeles is very much what you have, that everything else is speculation, everything that's likely to happen is just that, it hasn't happened. Los Angeles is simply the palest version of what goes on here. As a dealer in L.A., for example, I remember how people would come in and look at a painting and say, 'Well, Irving, let me think about it for a few months,' knowing full well that in two months' time that work was likely to still be there, that there was no urgency. Urgency was the thing that drove me out of California finally, the lack of urgency as far as selling material was concerned. People would wait and deliberate and finally the interest would be deflected. In New York they have one hour or less, and if they can't conclude the sale in that time, then there's somebody standing just behind them who's likely to. And that lack of urgency filters down to the art making as well. You can do it two months from now just as easily as today, with the same result, and in the meantime, the beach is beckoning."

A few weeks earlier I'd been talking in Los Angeles with Irwin about the same Los Angeles-New York issue. "See, what I've always liked about this town," Irwin said, "still do, is that it's one of the least restrictive towns in the world. You can pretty much live any way you want to here. And part of that is because the place has no tradition and no history in that sense. It doesn't have any

image of itself, which is exactly its loss and its gain. Like when New Yorkers tell me what's wrong with L.A., everything they say is wrong — no tradition, no history, no sense of a city, no system of support, no core, no sense of urgency—they're absolutely right, and that's why I like it. That's why it's such a great place to do art and to build your ideas about culture. In New York, it's like an echo chamber: its overwhelming sense of itself, of its past and its present and its mission becomes utterly restricting."

When I mentioned these comments to Blum, pointing out that Irwin felt it was precisely the lack of urgency in Los Angeles that allowed him a certain kind of focus, Blum quickly countered, "I think he's absolutely right, it does allow that kind of focus — *if you're Robert Irwin*. I don't think it allows that kind of focus if you're anyone else. By that I mean it allows that kind of focus if you're extraordinarily committed and focused in a way that Robert Irwin really is. He's able to withdraw from those temptations. But I think if you're anyone less than Robert Irwin, you can't withdraw and you are indeed distracted. Irwin speaks from his own vantage point, and it's a highly developed and committed vantage point, and I think there aren't many artists like Robert Irwin. I mean, we're talking about someone who was extraordinarily driven and fiercely competitive."

I commented that it was hard to square the "fierce competitiveness" of the Irwin he was describing with the apparent serenity Irwin projects today. "Well, I don't understand that serenity," Blum confessed. "I don't understand what's beneath it. I just can't believe there isn't still the same kind of endless, agonizing churning that there's always been. I'm suspicious of that serenity, although I've confronted it. It's absolutely different from the way he used to be. I mean, he was a tough competitor—he made no bones about it. And his ambition was, as I say, limitless, which was all very clear upon first meeting him. He believed violently in what he was doing, and it was not that unusual for him to get into physical fights about things he believed in. Now he seems almost tranquil, utterly content . . . and I mistrust that tranquility. I don't know how to deal with it. I just know Irwin as the eye of the hurricane, and I don't understand this new Zen quality."

I pointed out that from his earliest days at Ferus, Irwin had been dealing in Zen themes. "Oh, yes," Blum replied, "always, but he was dealing with Zen in the most aggressive way Zen has ever been dealt with."

CHAPTER 5

The Early
Ferus Years:
From Abstract
Expressionism
through
the Early Lines
(1957–62)

"There was a certain point," Irwin was explaining to me one afternoon, "when I realized that if I was going to play, I was going to have to make the commitment necessary to do it. There was no simple shortcut. It was a question of, 'Do you want to do it, or don't you?' And I don't remember what it was that instigated it, but at one point I decided I really wanted to do it."

We were sitting in his living room talking about the period during the late fifties and early sixties when his work underwent the remarkable transformation from his early, evocative land-scapes, through an abstract expressionist phase, and on to the threshold of the minimalist passion that has dominated his labors

ever since. He was trying to be as concrete as possible in account-
ing for the sequence of steps in his aesthetic development. His
assimilation of the principles of abstract expressionism, he was
explaining, had itself been doggedly concrete.

"Now, that point came a bit later. At first it was just a question
of aping the moves of people like Bengston. At first, I suppose, it
was mainly just the competitive goad: for the first time in my life I
was confronting contemporaries whose work was manifestly su-
perior to my own, and I just wanted to catch up."

Very much under the influence of Bengston, Irwin launched
into his first abstract expressionist efforts on a vast scale. "I was
painting large, very large canvases at that time," he recalls. "They
were ten feet by twelve feet, eight feet by ten feet, that kind of
scale. I was using a kind of paint a lot of people used at that time
(we'd inherited it from Lobdell in San Francisco), a very cheap oil
paint that came in cans that you bought at a regular paint store
and then maybe mixed with corn starch to give it body. Those
paintings were very rich, very gestural, very runny, that paint
running in black and rich colors. They were very expressionistic,
emotive kinds of things. They were about as rich as you could get
them in that way, or at least as I could get them."

Jules Langsner, the premier art critic in Los Angeles at the
time, described the works in Irwin's initial Ferus show in his re-
view in *Art News* (June 1959):

> Irwin paints with a sense of exhilaration in the way color and
> texture can be sprung into an independent mode of existence.
> He favors a flamelike turbulence which may erupt in isolated
> swirls or burst in sheets of color over the surface of the canvas.
> These flamelike shapes are usually slashed in ridges and rib-
> bons of pigment varying from high-keyed oranges and reds in
> one work to reserved and cool tones in another.*

At this stage, to the extent that Irwin was thinking about his
paintings, he was concerned with the authenticity of the gesture;
he was continually trying to make it more straightforward. The
gesture, or the concatenation of gestures, became the painting's
subject. Gestural integrity and emotional power were somehow
tied together in his thinking. This is not to say that the canvases
were just dashed off. "The process in creating that kind of canvas
was like—what?—10 percent action and 90 percent ass scratch-

Art News 58 (Summer 1959): 60.

ing. First you prepared yourself, cleaning up and arranging your palette and tools, sweeping the floors, and then finally, when you were ready, you faced the empty expanse of white canvas and made your first stroke. You were looking for what was interesting ' and what could be. You went through all the possibilities in your head, edited them down, distilled them, and then you made your next gesture. You'd make a stroke—in there, say—you did something. Then there was a flurry of activity in which you dealt with that. You then lapsed into a period in which you tried to decide about what you'd just done. Was it interesting? Did it work? What demands did it make? So there were periods where the thing moved along like a dialogue, where you'd push and look, push and look, back and forth. Flurry and lapse. And this continued till the painting seemed resolved, whereupon you collapsed in spent satisfaction. (It was a very pleasurable way to work.) A couple of weeks was about the extent of it though, because after a couple of weeks the painting started stiffening up, the paint itself lost its plasticity."

All that effort notwithstanding, it was important that the canvas itself not look overworked. That elusive quality of spontaneity was one of the first that Irwin set out to master. "I was finding it very difficult to control that much space," he recalled. "It takes a lot of control to push that much paint around and for it to look as if it was not struggled with, as if it was spontaneous. There would be parts of the canvas which would start to work, but by the time I'd get another part to work, the whole would begin to look labored."

In this context, Irwin sometimes singles out a particular achievement of Willem de Kooning's. "Really the best abstract expressionist paintings ever—in my opinion the best single ones—were an at-that-time recent series of large paintings by de Kooning. And one of the things about them is that they have this quality: it's as if they were done in ten minutes. They look utterly spontaneous. A few simple gestures just explode on the canvas. But the control is amazing! The stroke stops and the paint splashes, but with the precision of the lace on a Vermeer collar. I mean, having done those kinds of paintings and tried to get that kind of freshness, I know the guy was really a master. He really knew what he was doing. Because, believe me, it's not easy!"

During these early stages of his abstract expressionist paint-

ing, as we have seen, Irwin saw the gesture as the canvas's subject, its figure, and he evaluated his success partly in terms of the gesture's seeming authenticity. But as he proceeded, he came to feel that the whole context of figure and ground was coming into question, that it was indeed precisely the abstract expressionist project to fulfill cubism's initial ambition of collapsing the artificial distinctions between figure and ground. Irwin's aspiration, at first vaguely phrased even to himself, was to create a canvas that would read as one field; this ambition would animate all his activities over the next five years.

One of the ways in which Irwin first began to grapple with these issues was through his gradual discernment of a series of laws of spatial composition as binding within the world of painting as the laws of physics are for the larger universe.

"That's one of the facts in abstract expressionism that a lot of its imitators could never really understand. They understood the gesture; they knew how to make all the marks, the right moves, as it were. But they would make, say, a big black slash across the canvas and then counter with a red one in front of it, not really realizing that when you looked at the painting, the red one would occupy a nonexistent space—we'll just play a game—would occupy a space, say, a foot deep. And that in terms of how you looked at this canvas, there wasn't a foot left in the space to occupy, to live in. That the black slash, let's say, filled the space right up to the front and there was no more space! So there was this physical contradiction. They never really understood how to put the painting together in any physical terms, how each color or element in the painting has weight and field density, and that they all must be consistent. They were putting it together in intellectual or gestural or pictorial terms, but they didn't understand the actual physicality of a post-cubist painting, how it exists in the world.

"Look," he continued. "I can't sit in that chair because you're already in it. In other words, you're displacing a certain amount of physical space and you're doing it in a particular way (if you were wearing a cape, you'd be displacing still more and in a completely different way). Well, it's the same with the canvas. And there are a set of physical rules which apply. When I say my paintings at the Landau show were terrible, when I say my early abstract expressionist efforts were complete failures, that's not

false modesty. They were. They were riddled with physical con-
tradictions, gestures overlapping that simply couldn't be doing
what they were doing in terms of how they were physically read. It
wasn't just a question of strong, spontaneous gestures, but of how
they related, one to another, how they led one to another, not just
in terms of a two-dimensional read but in terms of a three-
dimensional read. They all had to wrap into the same volume of
space in the same time frame, and they had to do it according to
certain kinds of visual laws about what made sense with what, laws
which were not that far removed from the laws of physics."

Artists who came to abstract expressionism with a literate
pictorial bias, Irwin feels, were especially unprepared to confront
these physical issues. This was particularly the case with the Euro-
pean abstract expressionists, he argues, steeped as they were in
the tradition of post-Renaissance pictorial expression. Paradoxi-
cally, one artist who exercised a pivotal fascination for the young
Californian, particularly in terms of his mastery of those physical
laws, was a contemporary European, but not one of those who is
usually considered an abstract expressionist. "The Italian painter
Giorgio Morandi captivated a lot of us," Irwin recalls, "and we
eventually even staged a small show of his paintings at Ferus" (in
1961). "Now, here was a painter who'd been repeating the same
subject, the same theme, over and over again, for years. In his
studio, he had a collection of bottles and jars, and he painted them
continuously: small paintings of groups of these bottles on his
table, a kind of still life. So in one sense they seemed extremely
traditional, extremely formal. They still had a subject matter in
the most classical sense, the simplest, most direct kind of subject
matter, unloaded in any way. This especially seemed the case
when you compared Morandi with some of his bold, gestural
contemporaries, say, someone like Pierre Soulages, with his mod-
ernist imagery, the strokes and slashes and all that. I mean, some-
one with a conceptual, literate eye, oriented toward looking at the
imagery, would certainly think of the Soulages as the modern
painting and the Morandi as the old-fashioned one. But if you
looked at them on the physical level, in terms of how they actually
dealt with the time and space relationships within the painting
per se, the Soulages was pre-cubist, almost floating in like a
seventeenth-century space, with its sense of distinct figure and
ground; whereas the Morandi was essentially the same as a de

Kooning or a Kline, with its intimate interpenetration between figure and ground. In Morandi they were never really separate. In fact, even with the figurative elements, there were cases where his ground actually got in front of the figures or in many cases couched them so intimately that there was no separating the two. Physically he carved a space for each one of these elements, where the amount of space left by the so-called ground was exactly that which the object occupied, so that it was as if the air had taken on substance. They were really good paintings."

In an attempt to exercise greater control over his own paintings, to master the laws of their physical composition, Irwin now radically contracted the perimeter of his canvas. "A lot of what I had been doing in those large gestural paintings," Irwin recalls, "seemed to me afterwards as being not very controlled, in the sense that a lot of the stuff that was going on in them had no reason for being there. There were just too many things that were accidental, too much incidental, too many contradictions. I decided that one of the problems was that I just couldn't handle the thing on that scale. So I started out painting the same paintings on a very small scale, where I could really control every gesture, so that each one was very much an intended thing." The result was a series of small, square canvases, twelve inches by twelve inches, or eight by eight, which finally had almost no imagery at all because of the intimacy of how you looked at them. The gestural concern at this scale began to be replaced by a textural one. The paintings were tightly woven, their surfaces utterly opaque. There was no sense in which they were "open windows" (the standard post-Renaissance characterization for the fictional reality of the painting). Indeed, these canvases weren't even intended to be hung on a wall. They were embedded in thick wood frames that couched the flat painting surface not only at the sides but all the way around; the frame constituted a rich, smooth box for the image. The paintings could be laid on their backs on a table, and they were intended to be picked up and held. The viewer subliminally became involved with the intimate tactile element, the smooth, warm softness of the wood he was feeling contrasted with the thick swirls of paint he was seeing, but seeing feelingly. The effect was one of calm, of intimacy, of meditation.

Throughout these years, Irwin and his friends at Ferus dabbled in Zen and other oriental philosophies. Some of Irwin's col-

leagues, notably Kauffman and Allen Lynch, pursued these studies with considerable intensity. Lynch, for example, had a marvelous collection of pottery, including a number of raku tea bowls (seemingly casual, irregular cups impressed with the simplest of gestures, say, a thumb mark). And indeed, such rakuware serve as a better analogue for these small hand-held pieces than would an open window. "Those hand-held paintings got very quote-unquote 'Zen-like' in a meditative sense, as opposed to an open gestural sense," Irwin recalls. "While the gestures were there, they were very subtle, almost like Zen calligraphy, terse gestures where the emphasis was on the control of nuance. And the fact that you were meant to hold them meant that they could only be experienced privately, intimately." Nevertheless, Irwin, who had even given most of his earlier abstract paintings Zen titles (such as *The Black Raku* and *The Ten Bulls*) still insists that his actual knowledge of Zen was minimal. "None of the people I knew really read," he recalls, "and I didn't either. That doesn't mean I didn't skim. For example, I remember a book of haiku making the rounds, and I may have read two or three of them without really focusing." It was rather that certain Zen themes were in the air.

Fifteen years later Robert Pirsig wrote the novel *Zen and the Art of Motorcycle Maintenance,* and its blending of oriental spirituality with western technology seemed an abrupt revelation. But Irwin's predisposition to Zen attitudes came precisely out of his earlier fascination with cars. His work throughout this period, indeed throughout his life, was imbued with what might be termed "a hot rod aesthetic": precision, attention to minute detail, and passionate concern for the consistency of the whole. The intensity with which Irwin as a teenager had nurtured his cars was now echoed in the thoroughness with which he fashioned his small boxes. Just as he had spent hours polishing surfaces on his cars in places where no one would ever see them (the insides of the doors, the undergirdings of the dashboard, the fitting of the carburetor linkage), so now he devoted hours to perfecting his wooden boxes, to the extent of even rubbing their interiors. He even disdained artificial products when polishing the wood frame, confining himself solely to the natural oils of his hands, his forehead, the sides of his nose and so forth.

"The Zen stuff was just reinforcing something I'd learned long

before while working on my cars," explained Irwin. "There's a consistency to physical objects that somehow reads all the way through, so that when you make a physical object, if it lacks the proper amount of weight or if it lacks a certain density I mean, if its outside says, 'I weigh so much and I have such-and-such a density,' and when you pick it up, you discover an inconsistency there, then you can sense that, you can *see* it, even without picking it up. It's absolutely essential that everything be done all the way through." These small paintings were not the last occasion this theme would be heard.

Throughout the late fifties, Irwin continued to survey the progress of other artists, groping for a way of seeing his own work more clearly. Slowly his emphasis shifted; whereas previously he had phrased the challenge in terms of the gesture's seeming authenticity or the painting's compositional consistency, now he began to think more in terms of the canvas's physical presence.

"I'd visit galleries, look at shows, such as they were out here at that time," he recalls, "you know, very informal, in something of a daze, but every once in a while something would cut through the fog. I remember one time, for instance, seeing this small Philip Guston hanging next to a large James Brooks. Now, the Brooks was a big painting on every scale: it had five major shapes in it—a black shape, a red, a green—big areas, big shapes, with strong, major value changes, hue changes. Next to it was this small painting, with mute pinks and greys and greens, *very* subtle. It was one of those funny little Guston kind of scrumbly paintings, a very French kind of painting. That's probably the reason he never made it that big: they were maybe too French for the way history was being made in the macho fifties. But the guy really knew how to paint those paintings. They were *really* smart paintings.

"But anyway, my discovery was that from one hundred yards away—this was just one of those little breakthroughs—that from this distance of one hundred yards, I looked over, and that goddamn Guston. . . . Now, I'm talking not on quality, and not on any assumption of what you like or don't like, but on just pure strength, which was one of the things we were into. *Strength* was a big word in abstract expressionism; you were trying to get power into the painting, so that the painting really vibrated, had life to it. It wasn't just colored shapes sitting flat. It had to do with getting a

real tension going in the thing, something that made the thing really stand up and hum. . . . Well, that goddamn Guston just blew the Brooks right off the wall.

"Now, by all overt measures — size, contrast, color intensity — that shouldn't have happened. Everything was in favor of the Brooks. But the Guston blew it right off the wall. Just wiped it out. Not on quality, just on power. The Brooks fell into the background, and the Guston just took over. And I learned something about . . . some people call it 'the inner life of the painting,' all that romantic stuff, and I guess that's a way of talking about it. But shapes on a painting are just shapes on a canvas unless they start acting on each other and really, in a sense, multiplying. A good painting has a gathering, interactive build-up in it. It's a psychic build-up, but it's also a pure energy build-up. And the good artists all knew it, too. That's what a good Vermeer has, or a raku cup, or a Stonehenge. And when they've got it, they just jump off the goddamn wall at you. They just, *bam!*"

As Irwin began to look at more and more paintings in this light, his thinking became increasingly specific. He weighed each gesture in his own paintings, trying to determine whether it contributed or detracted from the overall energy field. Without articulating it in so many words — although today, in talking about the process, he can be disarmingly graphic — he evolved what amounts to a calculus of presence. "There's no such thing as a neutral gesture," he insists, for example, "because by the very fact of its being there, it draws a certain amount of perceptual attention. Let's say it drags a weight of .06 in the overall thing; well, then it's got to give back — I don't know how much — and some elements contribute more than others. If it's drawing .06 in attention, let's say it's got to give back .12 in energy. Otherwise there's no reason for its being there. Now, some areas are staging areas. But there can also be a critical gesture, where like .06 can translate to .20 or .25, a major move, a major gesture. I mean, certain things are just support. Everything doesn't maximize all the time. There's a kind of working trade-off. But there's no such thing as a neutral. If your .06 is just giving back .06, then you're losing ground. In those days I didn't think in those terms exactly — that's just a way of explaining it — but I did quickly come to see this thing about there being no such thing as neutrals."

Along with his growing conviction concerning the impossibil-

ity of a neutral gesture, Irwin began to think of his paintings as having a double nature. "At this point," he continues, "I began to recognize the difference between imagery and physicality, that everything had both an imagery and a physicality, and furthermore that for me, the moment a painting took on any kind of image, the minute I could recognize it as having any relationship to nature, of any kind, to me the painting went flat. Now, I don't know where I got that idea, but there it was. Imagery for me constituted representation, "re-presentation," a second order of reality, whereas I was after a first order of presence."

Phrased simply, the moment a painting read as an image *of something* (a swan, say, or a cloud or a cow jumping over the moon), it no longer presented itself purely as an energy field in its own right. It behaved like a psychologist's ink blot in a Rorschach test, summoning all manner of projected associations, and this Rorschach effect knocked down the physicality of its presence. Nor was this Rorschach effect confined to Irwin's audience; he himself suffered from a residual tendency to read images into swirls of paint. His own awareness of the physical presence before him was continually dribbling away in imagist associations.

"The big challenge for me," he recalls, "starting around then, the 'less is more' challenge, was simply always to try to maximize the energy, the physicality of the painting, and to minimize the imagery. It could all be looked at essentially as turning the entire question upside down: moving away from the literate, conceptual rationale and really reestablishing the inquiry on the perceptual, tactile level. Nobody quite understood that at the time, because they were still thinking in image terms and in terms of literate connotations. When they talked about a painting, they translated it into subject matter, in a way, but it's not only about that. It's about presence, phenomenal presence. And it's hard: if you don't see it, you just don't see it; it just ain't there. You can talk yourself blue in the face to somebody, and if they don't see it, they just don't see it. But once you start seeing it, it has a level of reality exactly the same as the imagery—no more, but no less. And basically, that's what I'm still after today. All my work since then has been an exploration of phenomenal presence."

As Irwin began to expand the perimeters of his canvases once again, following the series of small, hand-held boxes (which, incidentally, he never displayed; they were solely developed for his

own research), he was therefore already posing some fairly sophisticated questions to himself. "I think these were my first fairly serious questions," Irwin ventures. "They were not very deep, not very complex, but they were fairly good in terms of my problems at the time."

The questions at first were two-pronged: First, from the point of view of the calculus of presence, he began trying to strip his canvases of any gestures that were arbitrary or superfluous; only the necessary gesture could command an immediate presence. Second, with a view toward the Rorschachability of the image, he worked to develop a visual vocabulary with the least possible literate connotations. Having thrown out everything else that wasn't working, Irwin presently arrived at "one of those 'Aha!' moments." He realized that the straight line itself was the most energy-efficient, the least Rorschachable gesture.

"The simple straight line seemed to me to be my best possible tool, the cleanest element I could find, with the least amount of literate associations to it, and the greatest amount of power on the other side."

Irwin's earliest line paintings were very much betwixt and between, the lines still very painterly, richly impastoed, heavily gestural. "I did a series of several paintings where a lot of lines overlapped one another—maybe thirty, forty variants, still very rich, but now with the tactile thing running out to the edge, and the lines somewhat overlapping in the center of the canvas, making a kind of briar patch, almost, like a web of lines. They were still very emotive."

Although this "painterly game of pick-up sticks" still harkened back to the abstract expressionist tradition, these canvases were beginning to take on some concerns of their own: they were exploring the status of figure and ground once literate and psychological connotations had begun to be bled from the figure — and Irwin was increasingly seeing that relationship (between figure and ground) as a continuum. "I was no longer just looking at objects or gestures occupying space but rather, in a sense, at matter and energy having varying degrees of density—varying degrees of actual substance occupying space which has varying degrees of energy. We're talking about running all the way from totally empty to totally occupied, like from air to lead, with all the things in between. The interaction between so-called figure and

ground, between so-called object and space, revealed itself as being simply a scale of different degrees of corporeality such that they slide right past each other, so that the object maybe starts out being totally corporeal, totally dense, and by degrees becomes more and more energy, from solid object to just vaporous air, with space meanwhile going all the way from being so-called emptiness to having actual physical properties to the point of having actual density. So there was a nice slide there, and the whole issue of figure and ground took an interesting step further in my mind; where the main issue became this continuum, having nothing to do with content but rather purely with its own physicalness and how that physicalness was experienced perceptually."

As Irwin's perceptions sharpened, he continued filtering out everything that didn't contribute. His briar patch thinned, and within a year he was left with a series of paintings displaying seven or eight lines. "The lines were still rough, and although they had spaced out a bit, they were still angular, sometimes touching slightly, sometimes not." For several months, Irwin seemed to backslide, concerning himself mainly with the status of the lines, their interrelationships, the way energy passed among them. Their interpenetration with the ground seemed to drop out of his focus for a moment. Furthermore, if these canvases still represented a decided advance (because he was, after all, finding a way to explore a figure without its having literate connotations), they nevertheless continued to be haunted by the possibility of a pictorial, as opposed to a perceptual, reading. They had come a long way, but they still could be subsumed to a Renaissance-style viewing.

"When people talk about how to read a Renaissance painting," Irwin explains, "they talk about how you should go from the point of most focus, which is the key figure, and then run down the arm and pick up the drape of the gown down to the floor and up the pillar; you should actually move through the painting, from the most important to the least and then right back to the most. Through the painter's sophisticated compositional technique, you are brought around by way of the flow of the lines, the dapple of the colors, the hierarchy of the subject ideas—all of these things working in tandem and sometimes even in counterpoint."

In Renaissance and most post-Renaissance painting, the

viewer's gaze thus flows from one part of the canvas to another across a field, almost a map, of articulation. And although Irwin had already broken down most of the pictorial elements in his painting—the figurative subject, the Rorschachable image—he was still left with a painting that was articulable. The eye followed the lines, from one energy nexus to another, from intersection to separation, and so forth. These relationships seemed to be what the painting was about.

Furthermore, Irwin came to feel that his approach was still somewhat heavy-handed. "Those push-pull intersections, for example, were dramatic, but they weren't really necessary. The action I was interested in took place without your having to be conscious of why it took place. So it was during this dialogue that the rough lines straightened, becoming simply horizontal, their presentation thinning to a spare ribbon. Because what took place between the lines happened just as much with them straight as it did with them at an angle, and now they no longer lent themselves to a literate or even an articulate read but rather maintained themselves at a more purely perceptual level. This adjustment in turn allowed me to move beyond the more overt issues into the hidden questions, which were the real issues for those paintings in the first place."

So it was that by mid-1961 Irwin arrived at his next phase, the paintings he refers to as "the early line paintings" (the previous canvases, for purposes of distinction, may be dubbed "the abstract expressionist line paintings"). "I thereupon came to a painting which had essentially a solid color ground—say, an umber ground—atop which were four straight horizontal lines, say, two dark umber as opposed to the light umber ground, and then maybe say, two blue lines." Irwin had taken the means of traditional painting right to the edge, but he was still balancing on this side of the edge. Although the possibilities for an articulate reading had been pared to a minimum, these canvases still trafficked in such pictorial concerns as spatial composition and color illusion. The blue lines seemed to hover forward, the umber lines to lay flat. The placement of the lines accentuated or minimized this phenomenon. The lines still read as figure to the field's ground. They seemed to be what the painting was "about" ("Oh, that's a painting of four lines and how their colors create an optical illusion"), when the whole point was to create a painting that

wouldn't be "about" anything. As Irwin insists, "The early lines were still paintings in a traditional sense. They had all the accouterments, all the aspirations of a painting. The late line paintings, which by the way used essentially the same means — straight lines on a single colored ground—were to be my first successful attempt *not* to paint a painting. In 1961, I still didn't know how to do that. I'm not even sure that's what I was setting out to do. I was just following a line of inquiry, and at that point, I had to jump."

CHAPTER 6

The Later Ferus Years: The Late Lines (1962–64)

There are many ways to characterize the leap that Irwin made in his vocation between 1962 and 1964, the period when he produced his ten late line paintings. One way is to say that, whereas before he had been interested in creating a painting that evinced certain characteristics (a certain level of spontaneity or consistency or presence), now he was much more concerned with how he himself, as an artist, perceived those gradations of quality. A whole range of ideas that had been floating at the periphery of Irwin's activity was now being introjected into the very center of his painting world.

"The thing that I now realize was happening during those

years was a sort of taking assessment of my own sensibilities. I was for the first time really sitting down and asking myself some hard questions about why I liked something one way and not another. That very simple question that I asked myself, about why there were so many arbitrary things in my paintings ... it was just simply paying attention to my own sensibility and taking stock of it and deciding that too many things in there simply didn't make sense. Make sense on what basis? What did I mean by 'making sense'? I really didn't have a clear idea at that time. But I had developed this notion that if I spent long enough and allowed myself to think about a particular idea hard enough, that I would begin to gain some awareness or some knowledge about it."

This trust in the value of his own persistence was one of the lessons Irwin had garnered from his months of self-imposed isolation on the remote Spanish island of Ibiza during the midfifties. "I found out during that period when I was alone for eight months that my head, on a day-to-day basis, is really very superficial. I mean, it responds and bounces around like a rubber ball in a way. But if I gave it no other purposes or activities in the world except simply to sit there and weigh my own feelings, my own attitudes, my own thoughts about things, well, then I began to know something about those things.

"So I really applied that during those two years, which is not to deny that I had other influences. But I really think that the art act for me has always been much more that than it has been formal. It's been less formal and more of this kind of singular, disciplined taking assessment of my own sensibilities, asking myself how I possibly can do such-and-such, or why I can't.

"Now, of course, there was a certain amount of naiveté wrapped into it as well, in just simply being willing to trust myself. To say, 'Well, it doesn't make sense to me,' and to pursue that, to devote two years to just sorting out these things based on some feeling you have about what it is you're doing as a painter. I mean, really, if I'd been smarter, I might not have been able to do it, because I'd have recognized the naiveté in it. I might have recognized the loss, the lack of sophistication. You really run the risk of inventing the cotton gin all over again in the year 1960: while it's a terrifically creative act, at the same time it's totally meaningless, because it's ground that's already been gone over, its moment is gone. So there was a great risk in that, but even more, there was that great naiveté."

The trust in his own persistence, which was a consequence of his days on Ibiza, Irwin now coupled with an intuitive mandate as to where he should focus that persistence. "I found a certain strength in sustaining over a period of time my attention on a single point. After a while, it's like you peel back the layers of that issue and are able to get to a much deeper reasoning of how and in what way this thing makes sense, rather than each time taking on a whole new concept, a whole new aspiration, a whole new idea—all of which is very fine but which is what we sort of normally do. Like you paint a painting, and then you paint another painting, but each time you take on a whole other mouthful, and you're only able to chew each one just so finely. So, anyway, I did just the opposite." Which is to say, over the next two years Irwin did nothing but paint the same painting over and over again.

How Irwin arrived at this notion of continual repetition is not completely clear, although it is interesting that here again he mentions Morandi as an example. "One of the extraordinary things about Morandi's achievements," he asserts, "is precisely the spareness of his means. It's always those same bottles on that same table. On a conceptual level, the subject remains constant. One could, I suppose, insist upon interpreting the relationship between various sets of bottles. But what Morandi did there was to take the same subject to the point of total boredom, to the point where there was no way you could—or *he* could, anyway—seriously any longer be involved with them as ideas or topics. I mean, through sheer repetition he entirely drained them of that kind of meaning: they lost that kind of identification and became open elements within the painting dialogue he was having. And the remarkable thing was that although the content of those paintings, in the literate sense, stayed exactly the same, the paintings changed radically. I mean, each painting became a whole new delving into and development of the physical, perceptual relationships within the painting."

Although Irwin would have had no occasion to read Kierkegaard during this period, it is perhaps in this seminal existentialist's formulation of "intensive rotation" that we find the best characterization of what Irwin was up to with his late lines. In the first volume of *Either/Or*, Kierkegaard has his poet-protagonist write an essay on "The Rotation Method" in which he distinguishes

between two modes of experience. With the first, he draws an analogy to those farmers who conserve their land by rotating their crops from one field to another as the years go by. "Thus," he completes the analogy,

> one tires of living in the country, and moves to the city; one tires of one's native land, and travels abroad; one tires of Europe, and goes to America, and so on; finally one indulges in the sentimental hope of endless journeyings from star to star. Or the movement is different but still extensive. One tires of porcelain dishes and eats on silver; one tires of silver and turns to gold; one burns half of Rome to get an idea of the burning of Troy. But this method defeats itself: it is plain endlessness.

"My own method does not consist in such a change of field," Kierkegaard's young poet continues,

> but rather resembles the true rotation method in changing the crop and the mode of cultivation (rather than the field). Here we have the principle of limitation, the only saving principle in the world. The more you limit yourself, the more fertile you become in invention. A prisoner in solitary confinement for life becomes very inventive, and a simple spider may furnish him with much entertainment.*

This is not the only time that Irwin's untutored intuitions were to strike a surprisingly resonant chord with an important movement in European philosophy. Indeed, working on the nether coast of a distant continent (what, after all, could provide a greater contrast with the low, brooding skies of the Danish north than the balmy, palmy surf coast of southern California?), Irwin was something of a phenomenologist naïf, or, as he sometimes calls himself, "a rustic." Philosophy students sit in their cubicles trying terribly hard to concentrate on an abstract phenomenological reduction which, amazingly, in his stubborn, empirical fashion, Irwin has simply lived. (We shall have occasion to return to this theme.)

"A prisoner in solitary confinement": with this phrase, Kierkegaard in turn seems to anticipate the life-style Irwin was presently imposing on himself. What he was attempting to accomplish was nothing less than a complete suspension of the world's aesthetic values, a bracketing of the usual standards for the "aes-

*Either/Or, trans. David and Lillian Swanson (New York: Doubleday Anchor, 1959) 1:287–288.

thetically correct" in order better to gauge what he himself experienced. "But to withdraw from the concepts of the world involved in a parallel way my withdrawing myself from the world," Irwin explains. "They were the same thing.

"I embarked on two years of painting those paintings, two lines on each canvas, and at the end of two years there were ten of them. So I painted a total of twenty lines over a period of two years of very, very intense activity. I mean, I essentially spent twelve and fifteen hours a day in the studio, seven days a week. In fact I had no separation between my studio life and my outside life. There was no separation between me and those paintings. Everything else became subsumed to this; this became my whole life, and so the whole question as to whether I had a marriage or whether I had a social life just fell away."

At first he continued seeing his Ferus friends once in a while at the local bar, late, very late, for an hour or so of small talk. (Indeed, at one point early in this period, when Irwin's doctor bungled a minor surgical operation so badly that the ensuing infection "almost killed" and in any case incapacitated him for more than a month, his Ferus friends rallied to his aid, staging an auction to help defray some of the medical costs. It was, as one of them put it to him when he initially balked at accepting the proceeds, a "simple example of artists' insurance.") But presently even this spindly connection began to fray.

His marriage, meanwhile, which was on its second try (Bob and Nancy had divorced in 1959 but remarried in 1961), entered a period of widening suspension. One afternoon I asked Bob where his studio had been during those years, and he had no trouble describing it and its location in exacting detail, but when I asked him where he and Nancy were living during the period when he was painting the line paintings, he registered a blank; nor could he summon the memory at any time during the next several days.

The outside world progressively receded from his experience. As Irving Blum recalled for me, "Whenever I was sitting at the front desk at Ferus in those days and a collector would come in who wanted to visit one of the artists' studios, well, I always had to call Bengston to make sure he'd be there or call Moses to make sure he could be found, but Irwin was the one person I never had

to call: I always knew that he would be in his studio, and he always was. He was never anyplace else but that studio."

When you think about Irwin's activity during this period, you keep expecting Rod Serling's voice (that other epiphany of the early sixties) to intrude, amidst a falling spangle of percussion, confirming that, yes, this man has definitely strayed . . . "into the Twilight Zone." The entire enterprise basks in irreality.

"In the beginning, all this was not very considered," Irwin recalls. "It was done very intuitively. My concentration was not real good. It was mostly a question of just staying in the studio and simply not going out. Whether I did anything or didn't do anything, whether I was able to work or not, I simply would not let myself leave. But after a while, if you don't let yourself leave, then everything else begins to leave, that is, all your other reasons or ambitions in being there; and if you're very fortunate, you might then reach a point of being completely alone in an intimate dialogue with yourself as acted out in the realm of the painting."

Irwin would sit in his closed studio, staring at a monotone, textured canvas of fairly bright color, such as orange or yellow, with two thin lines in the same color spread horizontally across the field. "I would sit there and look at those two lines. Then I'd remove one of them and move it up an eighth of an inch — I had a way of doing that that I'd worked out. . . ." And to his astonishment, Irwin noticed one afternoon that just raising the line that one eighth of an inch *changed the entire perceptual field!*

The morning Bob recalled that afternoon for me, we were sitting in the living room of his Westwood home. A college football game was transpiring on the color TV set, and Bob was annoyed, not only because the game itself was unimportant but also because the broadcasters were being slow in relaying scores from the games that did matter, that is, the ones on which Bob had money riding. As he soared into his description of this discovery process, he seemed to leave the game entirely behind.

"Look," he said, pointing at the clean, white wall on the other side of the room. Dark bookshelves flanked the wall, and a black girder bisected it. "Look at that wall carefully and you'll of course see that its whiteness is not of just one tone. The light is streaming in from the window, so that it's a brighter white to that side, fading into grays over to this side. There are blues and greens and even

purples. It's a little bit more difficult to see the incidental transitions, the low-grade shadows caused by the varying textures, because of the starkness of the contrast between the white wall and the black plank. Still, if I were to daub a slash of red paint in that corner, it would change the whiteness of the entire field. Now, a slash of red paint is a major gesture, and you'd almost need something that extreme to see the contrast in this situation. Because of the extremity of the black-white contrast, for example, it's difficult for you to perceive how the whiteness of even a particular spot on the wall changes as you yourself move through the room, or as the sun moves through its day. But as you reduce the incidental contrast, it becomes easier to see such subtle discrepancies. If that plank, for example, were gray instead of black. . . .

"Now, what I was doing in those line experiments was to try as much as possible to clear away such incidental distractions. I used, for example, a bright orange paint straight out of the tube for my ground, applied it very evenly over the canvas, trying to avoid any discrepancies in the field while at the same time providing a definite texture. Then I applied the two lines out of the same tube. And it was soon thereafter, when I moved one of those lines that eighth of an inch, that I suddenly realized that that gesture changed everything in the field, not only the composition but even the color! I'd raise that line by the thickness of a sheet of paper, and from across the room this seven foot by seven foot field was no longer the same."

At first it was not a question of whether the change had been for better or worse: Irwin was simply amazed by the fact of it, or, more precisely, as he subsequently phrased it, "by the fact of how incredibly discerning the human eye can be." Simultaneously he became aware that a thin crack along the wall a few yards away from the canvas likewise exerted its presence; that when he plastered that crack over and repainted the wall, the canvas itself presented an entirely new aspect. He took to cleaning out his studio, smoothing out and repainting the walls all around, readjusting the lights. Every morning, before resuming with the canvas, he would attend to the smudges on the walls and the floor left over from the day before.

The question presently became where to place the lines for optimal effect. Why did one placement look better than another, and how pure was the perceptual judgment that ascertained this?

"At first I just placed the two lines intuitively. But then I said to myself, 'Who really put those two lines on like that?' Was it really spontaneous intuition or was it rather cultural indoctrination? I mean, when you think of the degree to which we are inculcated to the whole idea about order and pattern and relationship: the way the street out there is laid out, the way this room is laid out, the fact that I went to school and took a class in design or learned to read from left to right. We have all these incredibly complicated assumptions and ideas about order which are operating all around us. So when I go up and put two lines on the canvas, did I put them on? Or was I simply reflecting this whole baggage that I'm carrying around? That was not really a negative; I just came to doubt that I myself had done it."

The question then became, How else do you do it? Irwin's first gambit was to intellectualize the process, to look for more clever solutions, more interesting, more profound solutions: for example, to float one line right up near the upper border of the canvas. But that just reintroduced the literal subject once again, pointing, not to the presence of the canvas, but rather to the cleverness of its composition and, by inference, of its creator. The painting became a painting *about* how smart the painter was.

So once again Irwin was faced with the question of an alternative. The answer, he found, in time. He would sit and concentrate on the canvas for hours, for days, for weeks.

"I started spending the time just sitting there looking. I would look for about fifteen minutes and just nod off, go to sleep. I'd wake up after about five minutes, and I'd concentrate and look, just sort of mesmerize myself, and I'd conk off again. It was a strange period. I'd go through days on end during which I'd be taking these little half-hour, fifteen-, twenty-minute catnaps about every half hour—I mean, all day long. I'd look for half an hour, sleep for half an hour, look for half an hour. It was a pretty hilarious sort of activity."

Irwin's entire progression had been dictated by upsurges of boredom; bored with the figurative, he'd moved on to the abstract, and so forth. Now, he mobilized boredom itself as one of his means. "I put myself in that disciplined position, and one of the tools I used was boredom. Boredom is a very good tool. Because whenever you play creative games, what you normally do is you bring to the situation all your aspirations, all your assump-

tions, all your ambitions—all your stuff. And then you pile it up on your painting, reading into the painting all the things you want it to be. I'm sure it's the same with writing; you load it up with all your illusions about what it is. Boredom's a great way to break that. You do the same thing over and over and over again, until you're bored stiff with it. Then all your illusions, aspirations, everything just drains off. And now what you see is what you get. Nothing more. *A* is *A* and *B* is *B*. *A* is not plus plus plus all these other things. It's just *A*. And suddenly you've got something showing you all its threadbare reality, its lack of structure, its lack of meaning. And then you have a chance to Boredom's great. It's a silly tool, but finally it's a very good one. There are possibly more sophisticated ways to get at something like that, but when you come from where I came from, you take your tools where you can find them."

Little by little, Irwin honed his sensibility. He began to notice nuances he hadn't seen before; his focus extended, his concentration increased.

He became convinced that if he could give himself over to the canvas, if he devoted the time, that instead of his telling it what was correct, it would tell him. "Renaissance man tells the world what he finds interesting about it and then tries to control it. I took to waiting for the world to tell me so that I could respond. Intuition replaced logic. I just attended to the circumstances, and after weeks and weeks of observation, of hairline readjustments, the right solution would presently announce itself."

In terms of the actual process of applying paint to canvas, Irwin's procedure remained consistent throughout. "The ground was put on very carefully so that it had a tactile surface to it and yet at the same time betrayed a minimum of incident. It was very opaque; there were no blue skies or open, airy colors. For instance, I used orange, which is the *most* opaque color, and a very difficult color to handle in any sizeable amount in a pictorial painting. The surface was very, very dense, so it had a definite presence, a definite place, spatially, in the world. The lines, which were now almost always the same color as the ground, were always put on by hand, never mechanically—and that was important. The eye could tell. In other words, I applied those lines as straight as my hand could make them, preserving all the nuances of the hand-drawn line without, if possible, ever becoming overt about

it. I could have moved to a mechanical basis, which a lot of the people at that time were beginning to do, for example, in so-called hard-edge painting. But one of the things that really would have entered there was an implicit commitment to geometry, to the logic and techniques of geometry, which remove the individual and his hand from the action and instead impose that conceptual structure as the overlaying rationale. I began walking a funny line there, because someone could easily have started to think of these things as falling into that logic, but they weren't at all. I mean, the reductiveness is much more oriental or humanistic in the sense that the human presence is very much insisted upon. A geometrically programmed computer could neither generate nor validate these paintings."

From out of this curious two years' passion emerged the ten late line paintings. Everything in the painting—the size of the canvas, the choice of color, the texture of the field, the placement of the lines—combined to suspend any sense of incident, to project a tone of benign neutrality. "The lines were spaced such that your eye could not really ever read the two lines simultaneously, nor even get involved with the kind of compositional thing. The lines were intended not really to dominate the grounds as a figure-ground thing. In fact, your eye tends to become caught up in a sort of negative space—in other words, an area of ground—and not really look at the lines at all.

"Each time I painted those paintings, I thought about the idea of not putting the lines on at all. And in terms of where I seemed to be heading, it would have been—let's say on an intellectual level—it would have been closer to where things were going. But at the same time, I was not operating at an intellectual level, which is one of the peculiar things that is sometimes misunderstood in my work: that the thing has a kind of intellectual overtone to it, or that it's theoretical or conceptual. The reason I didn't go to not using lines is because on all the physical, tactile levels, the way the painting felt in terms of how I read it, it didn't work without the two lines: it simply needed them. Now, a little bit later on, I realized there was a guy who had already done that in a way; it was a guy who I was never involved with but who had made that gesture. Yves Klein in Paris had done some paintings called *International Blue*, and they were just all blue ground. So, on an intellectual level, he had made that gesture, saying simply that a paint-

ing could exist without anything on it, in terms of a mark or such. Ad Reinhardt's work was also similar. But in terms of what I wanted to do, I was not interested in it as an idea. I was interested in terms of how one could read this actuality, this physicality, without those kinds of what I had come to consider distractions."

During the two years of his work on the late line paintings, Irwin's vocation had undergone a complete transformation. This is at first difficult to see, because the canvases in one sense seem so similar to their predecessors. "On a certain level of reading," Irwin confirms, "the pictorial elements in the late line paintings are essentially the same as in the earlier works: straight lines on a monochrome ground. On a literate level, it's like a variation but within the same framework. But structurally speaking, on an experiential level, they are in an entirely different world. They are now addressing the root questions, which, as in philosophy and physics, are not about the play of superficial ideas or incidents at all. They're about the basic relationships of the three or four primary aspects of existence in the world: being-in-time, for example, space, presence. When you stop giving them a literate or articulate read (the kind of read you'd give a Renaissance painting) and instead look at them perceptually, you find that your eye ends up suspended in midair, midspace, or midstride: time and space seem to blend in the continuum of your presence. You lose your bearings for a moment. You finally end up in a totally meditative state. The thing is you cease reading and you cease articulating and you fall into a state where nothing else is going on but the tactile, experiential process.

"One of the things about looking at those paintings," he continues, "is that they have no existence beyond your participation. They are not abstractable in that sense." You can take, for example, an Ellsworth Kelly, and you can talk about it as a square space bisected by a flowing curved line of a particular type (a line describing the graph of a particular equation), painted green to one side and orange to the other; and although, of course, the experience of actually confronting the canvas in person is unexcelled, there's still a large part of the experience that is abstractable. Later that day, back at home, you can still summon that painting, the idea of it, to your mind's eye. This is impossible with one of Irwin's late line canvases. They only "work" immediately; they command an incredible presence—"a rich floating sense of en-

ergy," as Irwin describes it—but only to one who is in fact *present.* Back at home, you may remember what it felt like to stand before the painting, the texture of the meditative state it put you in, but the canvas itself, its image in your mind, will be evanescent. That is why for many years Irwin declined to allow his work to be photographed, because the image of the canvas was precisely what the painting was *not* about.

Indeed, the problem is even more complicated than that. For in a very real sense, the achievement of these paintings was in their making, and the finished canvas at one level is only an incidental relic, a fossil of that original process of discovery: not only do you have to be present before these paintings in order to experience them, it may be that you have to have made them as well. Irwin admitted as much one afternoon: "With those late line paintings, the process was intimate to the solution. I sometimes wonder whether anyone in the world has seen those paintings but me."

This dilemma became particularly acute as Irwin emerged from his studio after two years, eyes blinking at the daylight, and started trying to show these paintings in galleries, first at Ferus and then later, in New York, at the Sidney Janis Gallery (as part of a group show). He had spent months and months working out particular solutions within the context of the conditions in his studio—the light, the spatial proportions, the angles of the encompassing walls—one canvas against a bare plane receiving weeks and weeks of even attention. What sense did it make to have a show of four or five of them along one wall of a gallery or a museum, or even optimally, one on each wall, a space where, in all likelihood, the light and spatial relationships were entirely different from those in his studio, and the extent of the viewer's attention would likely be minutes at best? Even the ideal viewer would still have to go home when the gallery closed, and most viewers were far from ideal: they paced the gallery in much the same way they would have had it been stocked with Van Eycks or Cézannes.

This growing divergence of intention between the artist and his audience was to plague Irwin for some time to come. In subsequent shows—of the lines, and then of the dots and especially of the discs—he concentrated on trying to control every physical circumstance of the work's presentation. Thus he repainted the gallery walls and floors, smoothed over cracks, spent hours tun-

ing the lights, even tried to "paint out" the shadows cast by guard-rails, all in an attempt to replicate the situation in his studio and especially to minimize the kinds of distractions to which he had become hypersensitive.

Paradoxically, in New York, his efforts had the opposite effect. "Everything I did to cut down on distractions," Irwin recalls of a 1968 show at the Jewish Museum, "*they* saw as *distracting.*" Many New York critics tittered at "the fetish finish" of this bizarre California perfectionist, lampooning the hermetically sealed conditions at his exhibition. "And, of course, in that environment, my efforts *were* distracting," continues Irwin. "But this was because they interpreted all my activity in a *social* context ('Oh, he's such a freak, look how he behaves!') rather than a perceptual one.

"The fact is those New Yorkers couldn't see the difference. *They literally couldn't see it.* That reminds me of a conversation I had with Frank Stella a few years later when he was out here doing some work at the Gemini lithography workshop. We were having lunch one afternoon, and he said to me, 'Why do you go to so much trouble in finishing your paintings, for example, in making the edges on your frames so perfectly straight?' I asked him, 'Why *don't* you? How can you not?' At that time, Stella was making those hexagonal paintings with the hexagonal doughnut holes in the middle. In his sketches he would use a ruler for the edges, but the canvases themselves had edges which were often wobbly and uneven, completely unattended to. 'Why don't you make your paintings like your sketches?' I asked him. 'Or, if not, why don't you have wobbly edges in your sketches?' Well, his answer was simple: 'It's not important.' He simply didn't see the unevenness. His eye was like a razor, just cancelled out all that incidental effect. And indeed, my edge, which *was* straight, to him read as peculiar. The human eye is an incredible thing!"

Irwin goes on to generalize: "That was the difference between the artists on the East Coast and those on the West. We saw it and they didn't. They relied on *con*ception while we worked in the domain of *per*ception. Without any vast backdrop of history to support our investigations, we just had to rely on our eyes." (This is an especially ironic assertion, because the "sloppiness" of the East Coast abstract expressionists is often pointed to as a sign of their intuitive contact with the emotional, while the "Cool School"

look of many West Coast artists is usually seen as a hyperdevelop-
ment of the cerebral.)

Those New York critics who weren't lambasting Irwin's "fet-
ish finish" were busy trying to enlist him into their own cam-
paigns. "At one point Clement Greenberg asked me to be a spear-
carrier in his opera," Irwin recalls, referring to the *Post-Painterly
Abstraction* show Greenberg was at that time organizing for the
Los Angeles County Museum of Art (1964) in which he was to
make the definitive case for the hegemony of color-field painting.
"He asked me, and after reading his proposed catalogue essay, I
naively said no. I was correct in the sense that what he was trying
to do I had no sympathy for, it was not what I was doing, and it was
not my involvement. I was naive in the sense that I didn't know
who he was. I just wrote him a letter and told him how dumb I
thought his ideas were."

Apart from that particular case (Irwin becomes particularly
incensed by criticism that he feels first defines the issues and then
selects and crops the artists to fit the designated mold), Irwin
often has had problems in being typecast as an artist of a particu-
lar sort: an abstract expressionist, a color-field painter, an op
artist, a minimalist, a conceptualist, and so forth. While it is true
that his trajectory has often taken him through the domains of
these movements, usually he is just passing through, hot on the
trail of his own concerns. Critics who for a few years are celebrat-
ing the fact that he's come round to their view are often quickly
disappointed as he "reverts" to some other. In his own terms,
however, his trajectory has been arrow-straight.

With the late line paintings, Irwin began to fall into a pattern
that was to characterize his attitude toward public display of his
works throughout the next decade. During the first few exhibi-
tions of the work, as we have seen, he lavished maniacal attention
upon every detail of the show's circumstances, spending days and
sometimes weeks preparing the gallery space, and, when pieces
were sold, devoting similar attention to their installation. But at a
certain moment, after maybe the third or fourth show, the third
or fourth sale, he simply washed his hands of his involvement.
"After a while I just cut the umbilical cord," he comments. "I had
to. I mean, otherwise I'd still be employed full time going around
supervising the installation and lighting of my pieces around the
world. No, I'd cut the umbilical cord, and after that I'd totally lose

interest in them. They'd just fall away. I mean, for instance, I hear about how badly hung one of the lines is over at the L.A. County Museum, and maybe I wince for a moment, but I have no need to go over there and get it fixed. As far as I'm concerned, I've gotten everything I need out of them.

"I came to see that when I was preparing those public shows: the canvases were so highly realized that virtually nobody else was going to know the difference one way or another. I mean, why was I going to so much trouble? Obviously, as I came to realize, it was for myself. I was still learning, studying, considering the effect of the circumstances, and so forth. And as my research moved on, I no longer needed to attend to those particular examples."

Slowly Irwin returned to the world. During the next several years he continued to focus his attentions in the studio—first on the dot paintings, then on the discs, eventually on the scrim experiments—but gradually his reclusive self-exile dissolved. This was partly because he no longer needed the discipline; he had developed an ability to retain his focus while still interacting socially.

"You gradually make a kind of rough compromise with the world which allows you to float and flow. I mean, when I drive a car, I can attend to driving the car, and when I think about art, I can think about art in the sense that I've established it for myself, without letting art become a victim of the way I drive a car, or vice versa. For a while that was hard. But once you're able to make that distinction, and once you've done it long enough, you're able to move in the world once again."

Furthermore, the more Irwin worked, the more the world itself seeped into his focus. Already by 1964 Irwin was spending much of his time *outside* the canvas, attending to cracks and windows and floorboards, because all of these things were impinging on the reality of the canvas. But those incidental circumstances were becoming interesting to Irwin in their own right. And as he now admits, "Already then I was literally breaking out of the picture plane as the center of my concern. I was becoming more interested in the room." This interest would now expand over the next few years: by 1969 he would be making rooms without objects, and by 1970 he would abandon his studio altogether.

Finally, in terms of Irwin's return to the world, we must understand that he had never intended to leave it. It was never that

Irwin opposed the world's conventions per se. For example, he wasn't opposed to pictorial or articulate reading of images on any principled grounds. It was rather that he wanted to suspend such conventions as much as possible, to hold them in abeyance, to bracket them, as it were, in order to consider them and their implications more directly. His was a full-scale assault on the taken-for-granted. Just why should he take it for granted? Over the next several years, Irwin continued this "phenomenological reduction" (as his activity might have been called by more bookwise philosophers), successively bringing into question all the usual requirements for the art act—image, line, frame, focus, signature, permanence, eventually even objecthood—but in doing so, he was not rejecting them. He was precisely bringing them into question: he expected answers. At any point in the future, any or all of them could be brought back into his art activity—but brought back in a new way, as considered and evaluated components of that activity.

In this context we can look at the late line paintings in two ways. On the one hand, they constitute the beginning of a phenomenological investigation that was to take Irwin, over the next decade, through a succession of reductions—through the dots, discs, columns, rooms, desert experiments, and city projects that were to follow—all the way to a ground zero, achieved somewhere in the midseventies, when Irwin declared that nonobjective art now meant "nonobject," and that perception itself, independent of any object, was the true art act. But another way of seeing those late lines is to realize that they themselves were that ground zero, that in a period of two years Irwin had achieved a complete revolution in his thinking, and that everything that was to follow was merely an acting out, a fleshing out of the discoveries he had made with them, discoveries the implications of which it took him another decade to unfurl.

In any case, biographically, the late lines constitute the fulcrum of Irwin's artistic career. "All my activities after those line paintings," Irwin concedes, "are a result of how those paintings taught me to look at the world." This was true on the obvious level, that is, they taught him how to perceive the world in a new way. "When I look at the world now, my posture is not one of focus but rather of attention. There's a floating kind of feeling when I work in a situation now." But there was also a more subtle

(and pervasive) transformation, that of his driving motive. When Irwin initially joined Ferus —the reason he left Landau in the first place —he was animated principally by ambition. He was fiercely competitive: he wanted to be the best goddamn abstract expressionist on the block. Something happened, though, over the next several years. He got hooked on what he was doing: curiosity came to supersede ambition as his principal motivation. It has stayed that way ever since.

"Those lines," Irwin is likely to grin nowadays, "that was where, at age thirty-five, I finally grew up and became an artist."

THE NARROWS
(Part Two)

Philosophy unties knots in our thinking; hence its results must be simple; but philosophizing has to be as complicated as the knots it unties.

Ludwig Wittgenstein,
Zettel #452

"You know," Irwin advised me one morning as we began talking about his movement toward the dot paintings, the works that would command his attention between 1964 and 1966, "you have to be careful in taking these things I'm saying and working them into too clear an evolving narrative. There's a danger in spelling these recollections out so lucidly that your reader gains the impression that at the time I knew what I was doing and where all this was leading in some sort of intellectual way. You have to make it very clear to anyone who might read your essay, especially any young artist who might happen to pick it up, that my whole process was really an intuitive activity in which all of the time I was

only putting one foot in front of the other, and that each step was not that resolved. Most of the time I didn't have any idea where I was going; I had no real intellectual clarity as to what it was I thought I was doing. Usually it was just a straightforward commitment in terms of pursuing the particular problems or questions which had been raised in the doing of the work.

"Maybe I was just gradually developing a trust in the act itself, that somehow, if it were pursued legitimately, the questions it would raise would be legitimate and the answers would have to exist somewhere, would be worth pursuing, and would be of consequence.

"Actually, during those years in the midsixties," he doubled back on his formulation, "the answers seemed to matter less and less: I was becoming much more of a question person than an answer person."

There is a strain in the Jewish mystical tradition that asserts that there exist questions larger than the sum of their answers, questions all of whose possible answers would never exhaust them. Irwin's concern was drifting into questions of this sort, although he himself would bridle at any imputation of mysticism.

"The thing that really struck me the most as I got into developing my interest in the area of questions," Irwin continued, "is the degree to which as a culture we are geared for just the opposite. We are past-minded, in the sense that all of our systems of measure are developed and in a sense dependent upon a kind of physical resolution. We tag our renaissances at the highest level of performance, whereas it's really fairly clear to me that once the question is raised, the performance is somewhat inevitable, almost just a mopping-up operation, merely a matter of time. Now, I'm not antiperformance, but I find it very precarious for a culture only to be able to measure performance and never to be able to credit the questions themselves.

"In my own career, my growing commitment to the questions has in fact led to something of a dearth in the area of performance. I get to an idea, I perform on it for a certain period of time, and then I'm gone. During the question period, I don't perform that well, or my performances are awkward or stilted or not resolved or what have you. Just about the time I really start getting them together and they get resolved, I do a short spurt of performance, and then I'm off again. So on a performance level, it's true, I've left a slightly shaky record."

"Whenever Irwin did a series of works," his former dealer Irving Blum once complained, "he pretty much exorcised them in his own head and then set another standard very quickly and another set of ambitions and went on to pursue that phase of his evolution. Which was fine. Only, in the process, everyone who I had painfully developed in terms of a kind of sympathy to the earlier work couldn't make heads or tails of the new, so that the process of education had to start over as if from scratch. Being Irwin's dealer during that period presented some extraordinary challenges."

"Early on," Irwin continued, "around the time of the large abstract expressionist canvases, I wasn't even looking for a question. I was still very much involved with performance, still trying to make art in the best sense of the word. But subsequently, the early line paintings began raising questions which could not be resolved in terms of those paintings and which in turn pushed me toward the late line paintings, in the doing of which a new set of questions emerged, requiring new responses—and that's how I drifted into the dots."

The issue raised by the late line paintings, finally, was that of the lines themselves, for no matter how muted their imagistic connotations, no matter how flattened their status as figure to their backdrop's ground, they still read *as* lines, the paintings seemed to be paintings *of* two lines, and that prepositional tendency had the effect of dribbling away the viewer's presence before the canvas. The viewer had insuperable difficulties positioning himself before the canvas in such a way that the lines didn't preposition themselves before his gaze. Whereas unmediated presence was increasingly becoming Irwin's obsession.

So, in 1964, Irwin arrived at the question, "How does one paint a painting without a linear mark?" One possible solution — that of merely refraining from applying the lines to the contiguous color field of the ground—made sense intellectually but failed to work experientially. The resultant canvas tended to read as a spatial vacuum, a void, rather than a "positive assertion of space," a field of energy. As Walter Hopps described in his catalog essay for the 1965 São Paulo Bienal, what Irwin was after was not so much a color field as "a field of color energy."

Irwin's solution to the problem, arrived at during three years of work which were perhaps even more arduous and reclusive than those that had preceded them, was disarmingly simple, or at

least apparently so. "I'll explain it very quickly," Irwin offers. "In the dot paintings I took a large squarish canvas and painted it an even bright white. (Actually, I used a special kind of paint: I prepared the canvas with a series of thin coats of Lucien Lafitte Fournier silver-white, which was the best white lead paint I could find. The white lead was necessary, in that while it would of course yellow with age, as will all whites, if you expose white lead to ultraviolet light for a short period, it will very quickly return to pure white.) Then I put on the dots, starting with very strong red dots, as rich as possible but only about the size of map pins, put them on very carefully, about one every quarter inch or so, such that they seemed neither too mechanically nor too crudely applied — either way they would have thereby drawn attention to themselves as patterns — concentrating them toward the center and then dispersing them less and less densely, missing one or two here and there, as they moved out toward the edge. Then I took the exact opposite color and put a green dot between every single pair of red dots, doing the same thing out to the edge, stopping the green maybe just a little before the red so that there was a slight halation of the two colors on the edge. But in the center they essentially canceled each other out, so that you didn't see either green or red but rather the energy generated by the interaction between the two.

"Basically," he continued, "the paintings would vibrate. One of the things that painters all along have known is that you build energy by the interaction between things, that one and one don't make two, but maybe five or eight or ten, depending on the number of interactions you can get going in a situation."

In this observation, Irwin echoes, certainly without realizing it, the formulation of e. e. cummings, who in the foreword to his 1926 volume of poetry, *Is 5*, ventured:

> At least my theory of technique, if I have one, is very far from original; nor is it complicated. I can express it in fifteen words, by quoting The Eternal Question and Immortal Answer of burlesk, *viz.*, "Would you hit a woman with a child? — No, I'd hit her with a brick." Like the burlesk comedian, I am abnormally fond of that precision which creates movement. . . .
>
> Ineluctable preoccupation with The Verb gives a poet one priceless advantage: whereas nonmakers must content themselves with the merely undeniable fact that two times two is four,

he rejoices in the irresistible truth (to be found, in abbreviated costume, upon the title page of the present volume).*

That precision which creates movement: e.e. cummings in turn seems to have anticipated Irwin's passion of forty years later. For the rich, full sense of space energy Irwin achieved in the dot paintings was the result of an operation considerably more intricate than the simple application of dots across a white field. Indeed, the very canvas to which these dots were applied was the product of months and months of research.

Irwin had gradually become troubled by the status of the painting's edge within the experience of its viewing, and he developed two strategies in order to minimize the edge's intrusiveness, that is, to render the edge as mute as possible. First of all, he made each painting in the shape of a square of approximately seven feet, or more accurately phrased, an approximate square of seven feet, for, as Walter Hopps reported in his São Paulo essay, "Irwin decided to vary the dimensions from those of a true mathematical square to achieve the *appearance* of a perfect square." If a square would read more neutrally than a rectangle, an actual square still harbored a disturbing tendency not to read as one at all but rather as something vaguely rectangular, in either height or width, depending on how it was viewed. So Irwin spent months experimenting — indeed this phase of his research had already begun with the late lines — until he arrived at those precise dimensions (82½ × 84½″) which in fact read as square and hence inobtrusive. (The general scale of the canvas, the approximate seven-foot dimension, was itself the product of considerable research. Irwin came to feel that within the current practice of painting and coming out of the history of that practice, the seven-foot scale would read as neither large nor small, but rather, if anything, as nondescript.)

To further deemphasize the status of the painting's edge, Irwin ballooned the center of the canvas forward, only slightly (no more than two inches) in an even swell, not enough to be noticed as such but enough so that the painting's edge seemed to fall away and the sense of the central dot hive became further energized. "You take that curved surface," Irwin subsequently

Poems 1923–1954: The First Complete Edition (New York: Harcourt, Brace, & World, 1968), p. 164.

explained, "and anyone standing in front of it would not see the curve. But if you give yourself the simple comparison and put it next to a flat canvas of exactly the same size, you would very quickly see how much difference there was."

While in theory the curve seemed like a simple enough strategy, in practice it presented devilish technical difficulties. "The thing is," Irwin explains, "if you make a compound curve it's very easy to do, but to make a very slight one is very difficult because the swell has to be held at every point. A compound one begins to hold itself, but for the minimal effect I was seeking I had to build a very complicated shell, using much the same kind of strutting they once used in making airplane wings, and then cover those struts with a thin veneer of wood. The canvas was then stretched over that, around and behind, and then more wood was laid across the back of it.

"By the way, those paintings were finished both on the front and the back, which reads through from the small hand-held objects and maybe from my exposure to Zen potteryware—the basic idea being that any gesture or act that you're involved in, if you're involved in it as more than a gesture or idea, should read all the way through. Those stretcher bars were finished on the inside in ways no one will ever know; I spent days, weeks, months finishing things no one is ever going to see. But it had much more to do with the fact that I couldn't leave them unfinished. I just had this conviction that in the sense of tactile awareness, if all those things were consistent, that then the sum total would be greater, even though that might not be definable in any casual, connected way.

"The end result in terms of this curved canvas was that on the level of physicality, the curved read as more complex than the flat. But on the level of imagery — well, there was no imagery at all. In other words, there was no overt sense in which the thing was curved. You didn't say, 'Ah, a curved canvas,' and attach it to an idea. You only picked it up subliminally, this added energy. So in a way that's a perfect example of what I was talking about, in other words, that I could maximize the energy or the physicality of the situation and minimize the identity or idea or imagery of the situation. Which in turn allows me to reiterate that I was not pursuing an intellectual issue here but rather a perceptual one."

It is an extraordinary experience to come upon one of these

canvases in a museum. The distinguished art critic Philip Leider, in his catalog essay to Irwin's 1966 show at the Los Angeles County Museum of Art, suggested the complex succession of impressions that these paintings can evoke:

> One is confronted by what at first appears to be an immaculate white picture plane, about seven feet square, and nothing more. Some time must pass — a minute, or two, or three — before the viewer becomes fully aware of an indistinct, irregularly shaped mass which seems to have emerged out of the white plane (or is perceived within it, or behind it), roughly centered. The coloration is so subdued that there is no possibility of defining what one sees in terms of it, but rather in terms of what it suggests: a quality, an energy, one feels, which will tend, ultimately, to dissolve itself uniformly on the picture plane in a kind of entropic dissipation. The rest — after the elements of the painting have, so to speak, "emerged" — is a history of the hypnotic involvement between the viewer and the elements of color and whiteness before him.

Elsewhere in the essay, Leider emphasizes this uncanny temporal element in the dot paintings' self-divulgence:

> What Irwin manifestly wishes to do is *to slow the viewer down*, to prepare him, in effect, for an encounter. A certain measureable duration of time is necessary before one can even see what there is to be seen, so that the viewer will either see it the way Irwin wants him to see it or he will — quite literally — not see the painting at all.

The Philadelphia Museum of Art owns one of these paintings, and I was standing before it one afternoon when a couple walked into the room. The young woman, gesturing with a sweep of her arm, sighed in mock exasperation, "See, this is what I mean." Her friend smiled knowingly (although it was clear that her comment did not arise within the context of any particular conversation they were having but rather tapped an ongoing aesthetic frustration), and the two moved quickly on. They had literally not seen a thing — one does not, one cannot in that amount of time. She was just sick and tired of having museum walls cluttered with empty white canvases.

Had they stopped for a few moments and looked at the painting, however, they might have experienced an uncanny frisson. William Wilson, the *Los Angeles Times* art critic, on first encountering these canvases in 1966, reported that "the paintings blush,"

and that verb perfectly captures the experience in all its temporality. A mute white canvas suddenly changes its aspect — there is a moment of tart disclosure, almost like that in Rimbaud's poem "Knowing Girl"*— and we in turn blush back. There is a shudder of engagement. Walter Hopps points out, "The virtually indescribable effect seems to be of light itself. If there is any way to describe this effect, perhaps it is as if a golden white area of light pulses somewhere in the silver white of the canvas." Engaging the picture, we in turn engage the wonder of our own perceptual faculties. As in so much of Irwin's later work, for a few moments, we perceive ourselves perceiving.

Leider's 1966 catalogue essay is particularly noteworthy for its prescience, because in its final paragraph it sounds a theme that, while it was only beginning to be evinced in the dot paintings, would come to grow in importance with regard to Irwin's subsequent work and indeed today might be seen as the artist's central concern:

> What Robert Irwin is insisting upon, these paintings seem irresistibly to declare, is that the medium is not the message. They explore a division, as absolute as can possibly be demonstrated, between the art-object and the art, between painting and the experience of art. What stays in the museum is only the art-object, not valueless, but not the value of art. The art is what has happened to the viewer.

The extent of Irwin's commitment to the dot paintings as objects was to receive a traumatic test at a fairly early juncture. "When I first did those paintings," he recalled for me one afternoon, "I was outrageously precious about them, *outrageously;* you can't believe how precious I was about those paintings. They were so hard to do, took so much time, they were so tedious, I'd gotten so involved with them; I was just utterly precious about their installation, their lighting, everything. So people just naturally assumed that was my attitude about them. And I don't know that at the time I could have argued otherwise: I was acting the prima donna pretty well.

"Anyway, in late 1965 I was selected to be one of the artists representing America at the São Paulo Bienal. There were seven of us, one of whom was Barnett Newman. This show was de-

*Robert Lowell's translation of Rimbaud's "Knowing Girl" is in Lowell's *History* (Noonday, 1975), p. 91.

scribed as 'six tugs moving a large liner into port,' which is kind of how it was: Newman was nearing the end of a terrific career, and he was flanked by six young upstarts. So it was a nice show, and Newman went down to São Paulo six times to oversee the installation of the thing, and the six tugs stayed home.

"So I don't really know what took place (I have no idea how they looked), but I was told subsequently that both the dot paintings I had in the show were destroyed within the first day. They simply had to block off my area, close it off."

I asked him what he meant by "destroyed."

"Just that," he replied. "People attacked them, they cut them with knives, they threw things at them, they spit on them. I don't know what all was on them when they got back; it looked like Coca Cola. And they marked them all up, not just one person, apparently, but a number, because there were all these different gestures.

"Anyway, because of the tremendous preciousness I'd been exhibiting, everybody was afraid to tell me that these things had been destroyed. It was only a few months after I'd done them, so my connection was still fairly strong. Plus it had taken me almost three years to do just ten of them, so the loss of a couple was a major loss in terms of output.

"So anyway, I don't remember who it was, probably Blum, who finally got up the nerve to tell me. And I was really struck by the fact that I had absolutely no emotion about it at all. I mean, zero. Even I was amazed by that. That was an attitude I'd entertained intellectually for some time, maybe three years; but to have it actually happen and to have that attitude hold, that was a surprise. But a nice surprise in the sense that from that point on I knew I would no longer be operating or living in that kind of time frame."

I asked Irwin why he supposed the people in São Pualo had been so incensed by his dots.

"I really don't know, to be honest with you. I suppose the paintings were perceived as a very minimal kind of expression (I mean minimal on the level of content, imagery, what have you; they weren't at all minimal on all the levels we talked about); and for some reason during that period of time, that really angered people. I guess it was the loss of value. I guess they recognized a real attack.

"Which is interesting," Bob shifted tone, "because those paintings were simultaneously being accused of a number of other things. I mean, L.A. artists were continually being accused of a certain superficiality. At that time, the phrase they used, which was a very effective way of putting you into a lesser category, was 'the Cool School.' I mean, that's a real great phrase: they can deny they're saying anything, but you know damn well what they're saying.

"But I sort of thought that reaction in São Paulo was very interesting toward something that was thought of as cool. I mean, the fact is that it has no overt political, social gestures in it, and you'd tend to think that therefore it would read as neutral, I mean, *cool* and *neutral* being parallel. But, anyway, here was an audience that was probably not supersophisticated, and yet they somehow intuitively recognized an attack on a lot of the values they held. It threatened them."

(It did not occur to Bob, and I refrained from suggesting to him, that it might have been precisely the haughty neutrality of his paintings in the otherwise politically charged context of Brazil in 1965 that so infuriated the paintings' desecrators: a political challenge they might have welcomed!)

"Anyway, over the years I've seen that kind of reaction fairly frequently, not so frequently nowadays. But in the beginning I had people dragged out, literally dragged out, screaming that I couldn't do that, that I had to stop!"

In this context Irwin drifted into an anecdote about a confrontation that occurred the night the Museum of Modern Art's 1965 touring exhibition, "The Responsive Eye," opened at the Pasadena Art Museum. (His dots were included in an appendage to the show, flanking a group of Reinhardts.) "It was a big show, so before the opening there was a fancy dinner in celebration, and all the big patrons were there, and they invited some of the artists. People were just put at tables—you know how they do it: mix groups—and I was at a table with several Pasadena types, including this lady who had just given the museum a million dollars. The dinner was very, you know . . . you get six strangers sitting at a table, so it's one of those stilted situations. Plus there's a terrific imbalance in terms of what people are doing there.

"But anyway, at the museum, later that evening, this lady all of a sudden just came up to me and told me, literally told me that I

was not to do this kind of art anymore, that I was no longer to perform in this way. I mean, for some reason she got the idea that she could tell me that: she just insisted that the whole thing was absolutely un-Christian, anti-American, whatever. And what struck me the funniest was how she told me that I was not to do this any longer. I was to cease and desist: that was it.

"Well, in the direct confrontation, I didn't react at first. I just sort of listened to her and thought, 'How weird.' Eventually I turned around and started to walk away. When I got halfway across the room, this big crowded room, she started shouting, 'Don't you dare walk away from me like that!' So I spun around and yelled, 'Fuck you, lady!'"

Bob was now laughing heartily, savoring the memory, the middle finger on his extended left hand upthrust in sweet recapitulation.

"And then I got really mad, and I shouted, 'Fuck you, you dumb son of a bitch!'"

More laughter, the middle fingers on both hands proffered defiantly.

"And she just fainted."

Calming down. "They literally had to carry her out of the place."

Irwin paused and once again changed tone. "So, I suppose if I'd been in São Paulo while they were attacking the things, if I'd been right there, chances are I might have reacted strongly. But it had no reality for me. I mean, I'm told that some work I did a few years back is destroyed. Okay, conceptually I can say, 'Oh, God, there goes so many months' work, and there's my economics for the next year, and there goes my place in the world historically.' You can run those through your head and respond to them if you want. But they have no actual reality, or didn't for me.

"I suppose I'm a terrible stepfather to the things I've done, but as far as I'm concerned, I have no children in the world. I can intellectualize that maybe they should be preserved. But I have a hard time assuming the importance of the thing.

"That's a big difference between a West Coast artist and a European. A European artist really believes in himself as part of that historical tradition, that archive. They see themselves as part of the stream of history, and they conduct themselves in that way, with a certain amount of importance and self-esteem and so

forth. I guess people out here have gained that more now, but when I was growing up as an artist there simply wasn't any stream for you to orient yourself toward. Obviously you think what you do is important, or you wouldn't be pursuing it with the kind of intensity you do. But the minute I start thinking about making gestures about my historical role, I mean, I can't do it, I have to start laughing, because there's a certain humor in that."

In their execution, the dot paintings had been raising all kinds of questions, which, given Irwin's history, was not surprising. Some of them, however, were not purely related to the ongoing trajectory of his aesthetic inquiry.

"Yeah," Irwin recalls, "those paintings raised a lot of questions for me. Questions like, Wasn't this thing of being an artist supposed to be interesting or entertaining, or at least fun or at least fulfilling? I mean, the thing about being an abstract expressionist is that it was a very playful, joyful kind of work, in a way. But those dots paintings were just the opposite. They were the hardest thing I ever had to do—physically. Unbelievable. I mean it was actually painful work to do. In addition, here I was, this grown man, slaving away putting dots on a canvas, as my whole social reality slipped away. Toward the end of it I had just about lost touch with everyone!"

During the dots, Irwin's marriage itself became increasingly spotty. There was little acrimony, but little of anything else either, just a growing sense of distance, culminating in a second and final separation. In order to divvy up their material possessions, Bob and Nancy spent their last evening in an all-night game of gin ("This round's for the toaster ... this round's for the car ... this round's for the table ... this round's for the deck of cards ...") which apparently ended up pretty even. After that Irwin poured himself into the work with even more focused concentration.

"I ran into a girl the other day," he said to me one morning, "a real nice friend of mine from during that period. She used to come by the studio once in a while. And she remarked on how I dealt with her in those days, which was almost—I mean, no gestures. In other words, she'd come over and we'd make out and she'd leave, and it was like she hadn't even been there, like she'd had no consequence. She commented on that, that that's how she felt. And it was true: she had had none. It embarrasses me in retrospect to think about it, but there really was no room for anyone else in my life during that time."

Meanwhile, Bob was also withdrawing from his Ferus associations. In this case, actually, it was Ferus itself that seemed to be fading away, the victim, perhaps, of its own extraordinary success. For Ferus had, almost singlehandedly, spawned a contemporary art collecting scene in Los Angeles — one that peaked during the mid- and late sixties and then, unaccountably, seemed to subside. Although the money involved was still pathetically meager, it was nevertheless enough to threaten a camaraderie born of shared poverty and neglect. Petty jealousies emerged, grudges about how money and attention were being dispersed within the cooperative. When Blum advanced relative newcomer Larry Bell $10,000 to help equip his studio with the sophisticated glass-glazing machinery he had come to require for his pioneering explorations, veteran Bengston rebelled, demanding double the sum, and some of the other artists followed suit. In the resultant turmoil, Bengston barged in on Irwin in his studio one afternoon, demanding his support but instead raising his ire (Irwin felt Blum was being unfairly and hypocritically maligned), and the two fell into a violent brawl. It was the collapse of their friendship — they have not spoken to each other since — and it was, in fact, an early intimation of the gallery's coming dissolution. By the winter of 1966, Ferus had folded; and by 1968, it was already being canonized, the subject of a haunting retrospective at the Los Angeles County Museum of Art.

CHAPTER 8

The Discs
(1967 – 69)

As was becoming usual, the successful resolution of the questions Irwin had posed for himself in the dot paintings left him with . . . more questions, harder questions, a more supple perplex. Just as Irwin's abstract expressionist achievement had prompted him to question the previously assumed artistic requirement of image and his lines had then led him to question the requirement of line, so now the dots were bringing yet another orthodoxy into question.

"My questions as I finished the dots," Irwin explained to me one afternoon, "were still fairly simple — I mean, very direct. When I finished the dot paintings, they worked very well in creat-

ing this physical space which was occupied by a perceptual kind of energy. But you were immediately aware of the confine, because everything that was beginning to happen in those paintings seemed incongruous, being held as it was firmly within that rectangle. And I had never examined the assumption as to why a painting exists within a frame."

Irwin's movement from dots to discs provides yet another example of the way in which his aesthetic progression was animated by experiential rather than intellectual concerns. Something about the dots *felt* wrong; their energy seemed arbitrarily confined; Irwin began to work on that feeling, to play with it, and in the process stumbled onto the *idea* of the arbitrariness of that confine. Only much later did he actually begin to play with that idea.

"The question for the discs was very simple," Bob continued. "How do I paint a painting that doesn't begin and end at the edge? In other words, I no longer felt comfortable with that sense of confinement. It no longer made sense to me. Now, I had not worked that out philosophically, I had not even begun to dig into the root question of how an orthodoxy like that becomes so deeply rooted that it becomes hidden. I mean, we ordinarily start with the canvas as a fact, as more than a fact. We start with it as a truth so deeply hidden that we don't even question it. It's simply there. Obviously there's a good reason for that, or it wouldn't have lasted as long as it has. But for some reason my activities brought me up to question on what basis we assume that. Still, in the beginning it was a simple artistic challenge: How do I paint a painting that does not begin and end at an edge but rather starts to take in and become involved with the space or environment around it?"

In effect, Irwin was on the verge of activating, in a positive sense, two elements within the art gesture whose influence, as potential distractions, had already been confounding him for some time—the lighting and the wall. As far back as the early lines, he had noticed the way in which incidental distractions within the room—an errant crack here, a stray shaft of light there—directly affected the physicality of his paintings, and he had therefore gone to extraordinary lengths to neutralize the environments in which he showed his works. Now, however, light and backdrop themselves were about to become active, positive

elements in the game of presence. The edge was about to be transcended both laterally (there would no longer be a boundary between the painting and the wall flanking it) and frontally (nor would there be a boundary between the art object and the light illuminating it).

Other artists, most notably Frank Stella, were also beginning to experiment with variations of the rectangle during this period, creating paintings whose perimeters bit into the walls around them. But Irwin was trying to create a painting that would simply *dissolve* into its environment. And whereas some artists (including Irwin himself at an earlier period) had long been concerned with lighting—eager that it not distract from, indeed that it enhance the presence of the painted image—Irwin was now concerned with light itself as an integral part of the aesthetic moment. There is thus no sense in which the discs that Irwin was presently paint-ing could be considered the art objects by themselves, even to the extent of requiring a highly specialized kind of lighting in order to enhance their effect. No, rather it was almost as if the paint on the discs was applied so as to enhance the lighting. At any rate, light and paint had now become equal elements in Irwin's new palette.

The discs, which Irwin created between 1966 and 1969, went through a succession of phases, but they retained a structural consistency. John Coplans compiled the statistical particulars in his catalogue essay for their 1968 showing at the Pasadena Art Museum:

> In the first place, each of Irwin's new paintings is dependent on the use of its ground, that is, a flat, gray-tinged wall approxi-mately 12 feet high in a suitably sized room or gallery. The wall needs to be at least 12 feet wide, but if possible, should be wider, and there must be sufficient depth for the viewer to stand be-tween 12 and 15 feet back. The ceiling immediately above the wall and the floor immediately in front of the wall are neutral-ized with paint the same ground color as the wall. All daylight is excluded from the room, and the wall is evenly lighted from top to bottom and side to side by a soft ambient whitish light of low intensity. Onto the center of the wall, and approximately 72 inches above the ground line, a circular, convex disc is mounted onto a concealed male-female tubular arm 20 inches forward and parallel to the wall. The convex shape is 60 inches in diame-ter [note: some discs were slightly smaller], the convexity is 2½ inches deep, and the thickness at the edge is 1/16 inch. . . . The

disc is cross-lit from four corners by incandescent lamps (two in the ceiling and two on the floor, placed equidistant from each other and approximately 6 feet back from the wall). All four lamps are of equal intensity . . . and the effect of the cross-light beamed onto the disc and the wall is to cast a clearly discernible, symmetrical, but elaborate shadow pattern of segments of a circle. Where the shadows overlap at the cardinal points, they are darker than elsewhere. The total shadow pattern is approximately 10 feet high and wide. The ambient light (mentioned earlier) has the effect of softening both the edges and the interiors of the shadows. The result of the cross illumination combined with the ambient light is that the shadow, the disc, and the outer area of the illumined wall are seen as an entity. Thus the three elements—wall, shadow, and painted disc—are equally positive; the shadow, in fact, sometimes becomes almost more positive than the disc.

The final integration of these three elements was the product of months of research, every single variable calibrated and corrected. To begin with, Irwin had to determine the most effective shape for the projecting component. "The reason for the circular disc," he recalls, "as opposed to making them square, was that that eliminated the four corners, corners being really powerful focal points, whereas what I was after was an evenness of presence." If the edge had bothered him in general with the dots, it bothered him most at the corners, which had seemed particularly incompatible with the effect he was aiming for. "The circle was simply the most neutral shape I could find." The convexity likewise derived from his work on the dots: in those paintings he had thrust the center forward slightly so as to deemphasize the edge, which thereupon seemed to fall away. In the discs he complicated this illusion by painting the center of the disc, the part closest to the viewer, roughly the same color as the wall, the element farthest from the viewer, thereby fostering an uncanny sense of indeterminate floating. Indeed, it was impossible to tell whether the disc was convex, concave, or flat. Somehow it seemed all of these at once.

To determine the correct shape—a convex disc—was one thing, to manufacture it quite another, and Irwin spent months caroming from one shop to another trying to wrest the form from a variety of materials. His initial attempts with his preferred medium—a translucent plastic that would have heightened the ambiguity between edge and shadow—were complete failures.

"They kept on turning out all floppy." He couldn't get the subtlety of curve to hold its form. He began looking at other possibilities.

"The thing about California," he observes, "is that there are hundreds of people out here into really eccentric specialties. There are all kinds of small job situations, people experimenting with very interesting materials that nobody else has even heard of, with applications ranging everywhere from aircraft and automobiles to signboards. It's just a matter of finding them. You start out asking questions and following leads, and it gets to be like being a private detective. I'd already had a bit of experience with that working on the frames for the dots. With the discs I don't know how long it took. There were times I'd set out in the morning and spend two or three weeks driving all day long, tracing a lead down, trying to find someone willing to undertake a particular kind of work."

I asked Irwin how these craftsmen regarded him and his project.

"I have no idea how they saw me. Actually, they were mostly guys at sign companies, and most of the time I approached them as a store-window decorator. I never approached them as an artist, because that wasn't something they were going to understand—hell, even I didn't understand it—and it only confused matters. It was much better to keep it on a practical level, as if you were going to do a hundred signs in this format."

After weeks of traveling from back alleys in Saugus to industrial parks in Orange County, Irwin eventually discovered an old metal shop in downtown L.A. "There were two or three of these guys working in this metal-shaping place. At one time, you know, that's how shapes were made, fenders and so forth. They weren't stamped out by big machines, they were shaped by hand. And these guys still did custom shaping, using aluminum, titanium, and all kinds of exotic metals. They molded a lot of the race cars for Indianapolis, for instance. They're really a dying breed. They used a machine that consisted of just a soft-shaped steel plate and a drop hammer, which also had a soft form to it. It was a pounder, and they varied its speed with a pedal at their feet. The particular guy I dealt with would take a piece of metal—by trial and error we ended up using a lightweight aluminum—put it in there, and he'd be amazing. He'd shape those discs such that when he was finished they were absolutely uniform and without a poundmark.

All the while he was doing it, he was having to relieve the stresses, otherwise the whole thing would warp. He had great skill, and yet he was very low-key about it; he was a beautiful guy. And he was very critical to me at that point. The whole sense of craft, which was very important to me at that time, was enhanced by finding somebody who really had that level of skill."

The old man ended up manufacturing about a dozen disc and arm assemblages, which Irwin took back to his studio, where he set about trying to figure out what to do with them. There was, first of all, the question of how they should be painted.

He began, perhaps not surprisingly, by spangling them with dots. When that proved unsatisfactory, he tried a smooth film of spray paint, reminiscent of the meticulous automotive applications of his youth. But that did not work either. "The earliest discs were smooth and shiny," Irwin recalls, "the space in the center seeming open and airlike, almost empty. But I was after something else. It took about eight months before I developed the technique that worked. I discovered that if you spray at just the right distance, lacquer dries on hitting the surface, and you start getting a fine grainy build-up, very texturey, so that the center of the disc becomes very strong in a tactile sense, no longer empty. Those discs began to have a visual resonance, a real field density. So when I got to that, I threw the earlier ones out and now began concentrating on the color gradations toward the edge."

If the center was white, the contours weren't quite. But what were they? The shadings moved through an extraordinary spectrum of diffuse colors—warm green, yellow, pink blue, brown violet—soft, foggy tones, "like sunset seen through layers of frosted glass," as one writer phrased it—from white ... to the color of shadow. Indeed, at the edge, there wasn't an edge. When the discs were lit correctly, they seemed to phase into their own shadows.

"Actually, it was best to exhibit those pieces in even, ambient, natural daylight, without any artifical supplementation, and there are a few places where they continue to receive that kind of display to this day. But most of the time, that kind of site is unavailable, and these are pieces which can be destroyed by the wrong kind of lighting. So I had to wrestle with the problem of an optimum artificial lighting configuration for all conditions." Irwin spent months tinkering with the problem before he finally

settled on his two-floor/two-ceiling approach, one of the simplest options, with its resulting rosette of shadow. Even then he spent weeks fine-tuning the lighting. "I was using standard incandescent bulbs, but the trouble with them is that they tended to be too yellow, and we're talking about color on a level where the warmness of the light had a tendency to cancel the coolness of the paint tones. I made a big distinction between Westinghouse, which was the worst, with the most aberrations and the highest yellow, and Sylvania, which was the best and the coolest. So I always specified Sylvania floods and even then had to contrive a pale blue transparent filter to correct for the remaining lean toward yellow, so that the bluish tones in the painting would be able to activate. Without that, they would have gotten so muted that the entire disc would have lost its presence. It was the kind of thing I paid a great deal of attention to in the early years when showing the discs; but more recently I've lapsed in my vigilance on such things, with the result that today there are probably very few places where the discs are being shown correctly."

Shown correctly, Irwin's discs are otherworldly. They seem to float ambiguously. Is it the disc seeming to dematerialize or the shadows taking on volume? There is an eerie, fluid sense of density, object and shadow playing in and out of copresence. White becoming color becoming shadow of white. Self-possession divulging itself.

"Visually it was very ambiguous which was more real, the object or its shadow. They were basically equal. I mean, they occupied space very differently, but there was no separation in terms of your visual acuity in determining that one was more real than the other. And that was the real beauty of those things, that they achieved a balance between space occupied and unoccupied in which both became intensely occupied at the level of perceptual energy."

During the latter half of his disc period, Irwin finally invented a way of successfully crafting the discs in plastic after all. He was able to circumvent their tendency to flop and waffle by compounding the subtle curve of the disc into an ever-so-slight double crown, a bulge within the bulge that served to stiffen the form. He thereupon revived his initial intention of playing with the translucence afforded by plastic.

In the decade-long, step-by-step progression that saw Irwin moving reductively from the abstract expressionist canvases right

out of his studio, the plastic discs constitute something of a brief hiatus, a digression, for nothing new was being subtracted in these late discs—almost the contrary. "One reason I stayed around to do those late discs is because I'd initially intended to do them in plastic, and now that I could I wanted to see how they'd look. Beyond that, though, they really were the one time when I hung around for the sake of performance. As I've said before, if there's one main area where I've been remiss, it's been perform-ance—I always move onto the next question almost as soon as I've worked out the answer to the current one. Well, the late discs were—and most people know me by those discs—the one period where I stuck around long enough and repeated something with no new principle involved. They dwelt more on the answer side."

Indeed, the plastic discs in one sense seemed to backtrack. For translucent though they were, Irwin had reintroduced an element he had seemed to have dispensed with a few steps back: the line. Slicing through the middle of the disc was a thin (approx-imately three-inch wide), exquisitely modulated bar of color. "It was like taking a mathematical proof and going backwards with it and finding the proof in reverse," Irwin explains. "In other words, I'd gone down this path in which I'd eliminated all the imagery and maximized the physicality, but when I got to the transparent plastic discs, they reversed, in that the physicality had become so great that to leave the center minimal didn't work. So I finally had to introduce back into the painting an element which had the potential to be imagery, that is, the bar through the cen-ter. Now, when I first tried to paint that bar through the center, it *was* imagery; it was 'a line through the middle.' For a time I figured I wasn't going to be able to do it. And it took me a while before I developed the skill or the ability to paint that disc such that the bar read as a space cut through the disc and not a bar lying on its surface. When I finally got to the point where I could do that, then it became acceptable. Furthermore, it was exciting, because it meant I had come to a point where, taking something with a lot of image properties to it, I was now familiar and articu-late enough that I could bring it into a painting and still have it be the physicality you dealt with and not the imagery."

That kind of command was going to be important in years ahead as Irwin moved from the hybrid situations in his studio out into the flux of the real world.

Grace: you work and you work and you work at something

that then happens of its own accord. It would not have happened without all that work, but the result cannot be accounted for as the product of the work in the sense that an effect is said to be the product of its causes. There is all that preparation—preparation for receptivity—and then there is something else beyond that, which is gratis, for free.

Robert Irwin's discs were some of the most grace-filled achievements in recent American art history—and that was only one of their problems.

Jane Livingston, in her catalogue essay for a 1969 traveling exhibit of the discs (Ft. Worth; Washington, D.C.; and Amsterdam) captured the dilemma succinctly. After recording that "Irwin emphasizes verbally that what he requires of the spectator is for him literally to 'enact the process of the work's conception,'" she went on to note: "There were of course serious problems arising out of the inevitable discrepancy between the artist's stated demands and actual uninformed confrontation with the works, which were, for one thing, exceedingly elegant and often ravishingly beautiful; one was not necessarily inclined, at least consciously, to respond as searchingly as hoped."

Ravishingly beautiful. Irwin once confided to me, "I know the world isn't breathlessly following my every move, saying after each new step, 'Ah ha, now he's made that move, it must mean this. . . .'" Nevertheless, he was at that time deeply involved in a progression of inquiry, and it must have surprised him a little, when he began showing his discs, that most viewers couldn't care less about the course of his research, so transfixed were they by the beauty of the wondrous apparitions it was engendering. The discs seemed to cast a spell. Otherwise pedestrian critics were driven to flights of poetry. Words like "pearlescent," "crepuscular," "mandarin," "lunar," and "Venusian" wafted from their pens, phrases like "etherealness and interior equivocation." It was as if the beauty of the discs was rendering their achievement invisible.

And there was a further problem, because the main way people tried to master the initial seductive lull of the discs was by imposing a symbolic interpretation upon them. The most consistent and widespread of these translations was a Jungian conceit that the discs were in fact mandalas, and Irwin had a hard time dissuading such translators. "The naiveté of my solution to the disc problem was that from the start I was completely oblivious to its symbolic possibilities. I mean, when I eventually showed them

and these people started coming back to me with the statement that they represented mandalas, I was really surprised. I mean, how could I have missed it? How could I tell them that during all the years I'd been working on them I hadn't once thought about that? Which is what I had to tell them, but which, of course, nobody believed, because how could anybody miss something as obvious as that? I mean, a circle sitting off from the wall just had to be a mandala—right?—even though I hadn't thought in those terms at all."

Nor had he thought of his discs as an eye, a moth, a four-leaf clover, a sun, a butterfly, or any of the other tags by which viewers attempted to tame the challenge of their presence. In a way, the discs betrayed a distressing capacity for being Rorschached, one which, had Irwin been invested in the reactions of his spectators, might have bothered him greatly. As it was, he had spent so much time alone that, for all intents and purposes, he was working exclusively for himself. They could have their symbols, he would focus on the implications of the disc answer for his ongoing inquiry into presence.

And those implications, Irwin was only now coming to realize, were vast indeed.

Ordinarily you raise a question, but once in a while a question will raise you, and Irwin's purely aesthetic question was about to raise him into a different realm of activity. For one thing, it was raising him right out of his vocation as a painter.

"What happened," Irwin summarizes, "is that the discs resolved that one simple question—how to paint a painting that doesn't begin or end at the edge—by more or less transcending painting." The discs were still paintings, in the sense that they consisted, among other things, of paint applied to surface. But they resided right on the border, and Irwin was already moving beyond them. "After the discs," he explains, "there was no reason for me to go on being a painter."

Furthermore, around this time Irwin came to see the inquiry he was pursuing in terms of the larger sweep of post-Renaissance art and thought. In dissolving the frontier between art object and environment, far from breaking with that tradition, he saw himself moving it forward. He elaborated on that contention one afternoon in a conversation that began with Barnett Newman and drifted far afield.

"Take a painting by Barnett Newman on display at a mu-

seum," he offered playfully, "one of those where he's made a line down the center, hard on one edge and soft on the other, across a large field of, say, red. If as a young artist you were to take that seriously as a purely aesthetic experience — how that line coursed through that space, what its relationship to that physical world was — then, given what I'm adding to it, it would be very difficult to understand how they could hang that painting on those two rods coming down from the ceiling: How were you supposed to separate the line in the painting from the rods on the wall?

"Well, of course, you do it on a scale of values. And what we're really talking about in pictorial art is a scale of values. In other words, the line in the center has some kind of compounded meaning which gives it the emphasis to be focused on. Whereas the rod on the wall, of course, is very meaningless. So therefore you can, in a sense, just not see it; in other words, you can just dilate it right out of your visual range. So what we're really talking about in this whole process is not anything to do with the painting itself, but rather something to do with this thing of value, that which makes an object exist in the world with the ability to isolate itself.

"And figure and ground is a whole system of that kind of focus. You've got a way of looking at the world, and given that system — no fault taken now — what it does is allow a certain kind of view of the world. In this case, you simply eliminate those rods by a deductive process of meaning. They're meaningless, so therefore they simply fall out of view.

"But now, when you have a construct like that, that's how you go through the world. In other words, you don't just do it when you're looking at painting. We're talking about a mental construct to which the whole civilization has deeply committed itself. And what it says, simply, is that as I walk through the world, I bring into focus certain things which are meaningful, and others are by degrees less in focus, dependent upon their meaningfulness in terms of what I'm doing, to the point where there are certain things that are totally out of focus and invisible. We organize our minds in terms of this hierarchical value structure, based on certain ideas about meaning and purpose and function.

"And perhaps more than anything else, modernist art as a movement has arisen as a critique of that hierarchical structure. When art begins the process of taking all the pictorial out of the pictorial, taking all the symbolic meaning out of the mark and the

line, what it's really doing, essentially, is flattening that value structure. That process of flattening has been under way for about five hundred years now, although it's really only become critical in the last one hundred, when the figure-ground dichotomy itself came into question. At first the flattening took place at the level of subject matter, that is, what was allowed to be portrayed as the figure in 'high' works. At first there were only religious subjects, Christ, the King; and then it became acceptable to portray this particular king; and then, this wealthy merchant; and then, this handmaiden; and then, her red shawl; and, eventually, just the color red. But with the cubists the flattening of the value structure moved beyond mere subject matter into the question of how that subject was itself presented. For really, in a sense, if you go from a classical painting, in which you have a strong figure-ground distinction, all the way to cubism, what you've really done is to flatten this value structure. What you're saying in cubism is that the figure, this thing of value, is no longer isolated or dissociated from ground by meaning, but that it's interlocked and interwrapped with this ground, that they're interdependent.

"If you take the cubist idea and really press it, though, what you have is what I was now being forced to deal with, at least in my reading of it. In other words, the marriage of figure and ground—which is how they always term the cubist achievement—of necessity leads to the marriage between painting and environment; essentially they are the same thing, just taking it one step further. When I married the painting to the environment, suddenly it had to deal with the environment around it as being equal to the figure and having as much meaning."

CHAPTER 9

Post-disc
Experiments
and Columns
(1968–70)

Thus, through the late sixties, Irwin continued to distill the fundamental essence of the art-making activity: having already suspended the usual requirements of image and line, he'd now dispensed with edge. But if the discs had effectively eliminated the frame from the art object, they still required an attitude of focus; they still demanded a heightened level of attention aimed at one area of the room. Irwin, meanwhile, had become fascinated by everything else that was already going on in the room anyway, and he was coming to see that the very attitude of focus needed to be brought into question.

"I could have manipulated the discs some more," Irwin began

one afternoon as we set out to chronicle this period of his life, roughly between 1968 and 1970. "In fact, I even did try a few things that were fairly interesting. One of them, in terms of the progression, would have probably been a nice addition. But time was moving a bit fast; the question was moving on, and there was no reason to spend the time necessary to perfect such elaborations.

"See, what I did was put a light in the arm of the disc with a focusing lens around it, and that just threw a thin line of light about the ceiling, the exterior walls, and along the floor. So that would have taken things further into the room, but it wasn't necessary to do. In other words, the point is, there was no reason to do any more of something within that confine. The confine had been broken. The question now was how to deal with a context in which the whole act is no longer confined to a pictorial situation. How do you get out and deal with the space itself?"

It was the very bias of "the pictorial situation" that Irwin was now confronting, a bias which required that the viewer "look *at*" something. The discs were still ensnared within that context, even if they were not pictures per se, even if much of the thing looked at was insubstantial shadow. One walked into a gallery and aligned oneself in perpendicular relation to a pictorial event, roughly ten feet in diameter, a sleight of substance and shadow. For the piece to work, Irwin found it necessary to clear the room of all incidental and peripheral distractions, but during the hours he spent doing that, he became even more interested in *their* presence than in that of his pristine shadow object. He began to wonder how it might be possible to make an art of the incidental, the peripheral, the transitory—an art of things not looked at (indeed, invisible when looked at directly) yet still somehow perceived.

If Irwin was moving on, it was not in the mode of rejecting his earlier work. "I think it's important to emphasize here," Irwin admonished, "that when I left something it wasn't really a negative thing. I have no negative feelings about those pieces: the lines, the dots, the discs. I didn't kill painting. It's just that it was no longer a useful thought form for what I was trying to deal with. Each time I had to find something materially, physically, that had the same scale as the questions I was asking."

Across the late stages of the discs, during a period when his

activity in terms of them was becoming increasingly perform-
ance-oriented, Irwin was simultaneously pursuing a program of
pure research in another studio nearby. "I set up this new studio,"
he explained, "in which I continued to experiment with light, but
now in a much more complex way. I was trying to deal with the
whole room situation. I set up one version where the walls were
entirely white and all the corners rounded off. I was trying just
about everything I could think of, using material, draping it;
using projected light; lighting one wall and not the rest of the
room; playing one wall off against the others by painting it a
slightly different color; putting all the room in cool except for one
aspect which I made warm; changing the temperature and play-
ing with wind currents — all kinds of things.

"But I was not able to resolve any of those possibilities, at least
to my satisfaction. And especially at that time, nothing ever left
my studio that wasn't highly edited or worked on. I never just sort
of did gestures. Or rather, all my gestures I did privately. I did all
kinds of different possibilities privately, and it turned out to be a
good education for me.

"Some of those things were fairly elaborate, and one group in
particular was fairly successful. I manufactured pieces of glass
that were eight feet tall and ten feet wide and so shaped that they
could stand on their own (they were curved at the bottom, like the
segment of a cone). So these were just great sheets of glass stand-
ing off by themselves in a peripheral area of the room. It took a lot
of technology to get them shaped like that. You couldn't do it with
safety glass; it had to be regular plate glass. And once they were
bent, even though they were drape-molded over a big form, there
were still a lot of tensions in them. To move them you had to grab
them by the edge and lift; it was real scary. Somebody could easily
have lost an arm on one of those, had it broke. So I finally never
put them in the world. I mean, I did a couple, and they made a
better transition, actually, than the columns which I did eventu-
ally show. But they were just too precarious. Instead I ended up
throwing a hammer at them from across the room and shattering
them to smithereens. Then I just picked up the pieces and threw
them away. No one ever saw them, and in fact there aren't even
any photographs, because I still wasn't allowing photos in those
days. But I kind of liked those."

The media that Irwin was deploying in these various experi-

ments were often transparent—glass or acrylic plastic—a carry-over from the translucency of the late discs but also an innovation in their own right. For what Bob was trying to capture in these efforts was the incidental, the transitory, the peripheral—that aspect of our experience that is both there and not there, the object and not the object of our sensations, perceived but seldom attended to. These transparent phantoms disappeared into their environments, and yet, upon occasion, almost at the corner of our eye, there they seemed to shiver—a gleam.

The only type of these various experiments Irwin ever did display before the public was a tall prismatic column (he installed one in his Venice studio, opening the doors to the public for three weeks in October 1970, with another version ventured in Don Judd's New York studio in spring 1971). "I made a few of those out of acrylic, which I was using because it had even greater clarity than glass. They were perfectly machined: they were really optical instruments, for all intents and purposes. So I showed one of them for the first time at my Venice studio. I had painted the walls perfectly white; just had one of them in the midst of that space with two shafted skylights overhead. And the column essentially disappeared into the space. It was there but it wasn't. As you walked around the room, suddenly it might flash. Or, because I'd notched a little facet along one side, there might appear, for just an instant, a single white line, or a thin black glint."

As beautiful as they were, however, these columns were only marginally successful. To begin with, their import was consistently misread. Most people who went to see them, if they saw them at all, came away with the impression that Irwin had indeed made a leap . . . from painting to sculpture. Once people noticed them, they simply went over and looked *at* them, in much the way they might have surveyed *Winged Victory*. After all, that was how one was supposed to look at sculpture, wasn't it? Unfortunately it was the columns themselves, with their internal contradiction of being objects about nonobjecthood, which provoked such mis-readings.

And if this was a problem when Irwin himself supervised every particular of their installation, things became utterly insuperable the minute the columns left his hands and entered private or museum collections. "First of all," Bob explained, "it's very important that those columns never be mounted. It's very impor-

tant that they never be focused upon as the center of a situation or a room. They should always be off-center, peripheral. For that reason, they became doubly unsuccessful, because . . . well, they were only marginally successful to start with because of their inherent contradictions, but they've now become physically unsuccessful as well because no one who owns one is willing to risk putting it in a situation where it might get bumped into. The edges are knife thin. People always end up erecting barricades or sashes around them, or putting them on pedestals, which in turn throws them right back into being objects." (Indeed, the column at the Northridge Shopping Center, outside Los Angeles, the biggest one Irwin ever made, is surrounded by an elaborate circular metal railing, as if it were some incredibly valuable jewel.)

"In one sense, they've never really been successfully acted out. They did what they did fine: they got me from here to there. And as things they're really quite elegant—very pretty. But in addition to everything else, they took so long to make that by the time I got around to showing them, I was already well beyond them. I never really put my heart into showing them. Every time a chance arose to exhibit them, I would convince the people to let me pursue some newer interest. So, as a result, I've still got several of those columns drawing rent at the warehouse."

Bob paused, tapped his fingers on the table, and took a swig of Coke. "Those columns were a little bit like the early line paintings. In other words, with the lines I'd been trying to paint a painting without the means of painting, but I didn't know how to do that, so I ended up using the means of painting. They made a gesture toward where I was going, but still, finally, they were very much tied to where I was. And it was the same with the columns. The column was an indication of my wanting to get out and treat the environment itself, I don't mean in the sense of building buildings or being an architect, but rather of dealing with the quality of a particular space in terms of its weight, its temperature, its tactileness, its density, its feel—all those semi-intangible things that we don't normally deal with. But I still didn't know quite how to go about doing that."

Robert Irwin, friend and car, circa 1944

Private Robert Irwin, displaying award-winning drawing, circa 1951

Members of the Ferus Gallery (early sixties): Standing: (left to right) Ed Kienholz, John Altoon, Billy Al Bengston, Robert Irwin, Allen Lynch; Diagonal: Craig Kauffman; Lying: Ed Moses.

PHOTO: PAT FAURE

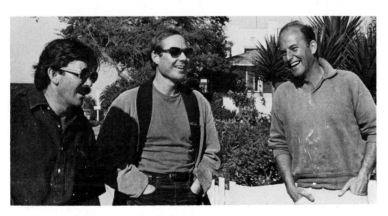

Billy Al Bengston, Craig Kauffman, and Robert Irwin, Venice, California, early sixties.

Irwin experimenting with
scrim in his Venice
studio, 1969

Irwin's face reflected in
experimental curved
glass, 1969

"Skylights — Column" in Irwin's studio, Venice, 1970

"Slant light volume," Walker Art Center, Minneapolis, 1971
PHOTO: WALKER ART CENTER

Dr. Ed Wortz of the Garrett
Aerospace Corporation
preparing for a ride in an early
model of a lunar gravity
simulator, mid-sixties
PHOTO: GARRETT AEROSPACE
CORPORATION

"Column," Northridge
Shopping Center, Northridge,
California, 1970

"Fractured light—Partial scrim ceiling—Eye level wire," The Museum of Modern Art, New York, 1970

Robert Irwin, "available in response," with students at the San Francisco Art Institute, mid-seventies
PHOTO: JAN BUTTERFIELD

"Black line volume," Museum of Contemporary Art, Chicago, 1975

Two views of "Untitled" (Filigreed Steel Line) Wellesley College campus, Massachusetts, 1979–80.

"Untitled" (Irwin's contribution to "Space as Support" series at the University Art Museum, Berkeley, California) 1979.

PHOTO: COLIN McRAE

A

C

D

B

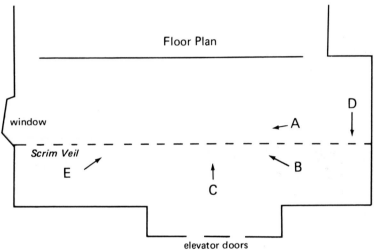

Floor Plan

window

Scrim Veil

E

←A

D

↑
C

→B

elevator doors

Five views of "Scrim veil—Black Rectangle—Natural light" at the Whitney Museum of American Art, New York City

PHOTOS: RICHARD MARSHALL

E

Irwin's proposal for the Embarcadero, San Francisco, circa 1977

Irwin's proposal for the civic center square in New Orleans, Louisiana, 1980

Irwin's proposal for the central oval at Ohio State University, Columbus, Ohio, 1977 PHOTOS: SUSAN EINSTEIN

DELTA

Aesthetics, ethics, metaphysics —
these matters of value, Wittgenstein
agreed, lay in the realm of the
unutterable. But it was natural and
inevitable that men should speak of
them, and much could be learned
from the way in which people went
about their foredoomed task of
trying to say the unsayable.
Moreover, it would not be clear
where the boundary of sanctioned
speech lay until an attempt had been
made to cross it and that attempt had
failed. Such efforts Wittgenstein
regarded with benevolence. He
treated them as reconnaissance
expeditions, perilous to be sure, but
well worth the effort expended
on them.

— H. Stuart Hughes, *The Sea Change*

PRELUDE

One way to think about Bob Irwin's life is to envision everything before that grueling night of self-doubt on the eve of his first show at the Landau Gallery—all the cars and the girls and the trips to Europe, the army and the art schools, the summers at Arrowhead and Catalina—as a vast, undifferentiated pool, a lifesource. Suddenly, starting out from that moment of revelation, his life narrowed into a rapids—a thin, focused, driving surge of activity. Beginning in the late fifties and continuing through most of the sixties, everything else seemed to fall away before the relentless flow of his aesthetic project: the abstract canvases, the early lines, the late lines, the dots, the discs, the columns. But in the later stages of that passion, a curious thing began to happen. In a way it was like a delta.

To a certain extent with the discs and even more so with the columns, what Irwin was doing in his studio was no longer the exclusive focus of his concern. He was increasingly absorbed in outside pursuits, activities whose imperatives in turn filtered back into his studio activity. It will be important to understand his involvement in some of these other pursuits if we are to comprehend the decisive move he was about to make as he entered the seventies, when, continuing our metaphor, the delta opened out onto a more oceanic ambition.

CHAPTER 10

Teaching

By 1968, the *Los Angeles Times* was describing Irwin as "a leader and a loner in California art."* Around the same time, Jane Livingston noted that "Robert Irwin's impact on his peers and many younger L.A. artists, as a theorist and an ideological mentor, has been immeasurable." Statements such as these are especially striking in the light of Irwin's own characterization of himself, as late as 1960, as an utterly naive and fumbling beginner, and his further characterization of his life-style, during the sixties, as that of a recluse. To be sure, it was precisely the intensity of

*William Wilson, "Robert Irwin's Works at the Pasadena Museum," *Los Angeles Times*, 19 January 1968.

his vocation and the extraordinary expanse it had had to traverse which lent to Irwin his sometimes mythic stature. His example loomed on the horizon. But Irwin's impact also had somewhat more pedestrian origins in that, with many of the younger artists, Irwin had in fact been their teacher. On three separate occasions — during the late fifties at Chouinard, the midsixties at UCLA, and perhaps most important the late sixties at UC Irvine — Irwin spent time as an art instructor.

One morning our conversation drifted into the area of teaching. "To me teaching is a really interesting activity," Irwin ventured, "and it's also one of the most precarious activities in the world, because it's such a huge responsibility." Perhaps one of the reasons Irwin has been such a successful teacher is because he invests his teaching with the same blend of responsive openness and earnest seriousness with which he animates his art. "One of the first things I learned about teaching is that you have to respond to each student individually," he continued. "You don't start with any idea of what they should be doing, who they're supposed to be, or what their performance level is, and you don't compare them to one another. You simply start with each one of them wherever they are and develop the process from there." Irwin's teaching method consists of blending the hard question and the light touch.

That method has been remarkably consistent through the years. The process he describes involves three stages. "The first thing you have to do is establish a performance level. You have to begin with the students' expectations. You have to develop their confidence and prove to them in their own performance that there isn't anything they won't be able to accomplish technically, eventually, given a lot of application, before you can begin to convince them that that kind of technical virtuosity doesn't deserve the kind of focus they have been led to believe it does by a performance-oriented culture.

"Simultaneously," he continues, "you want to be engendering a historical awareness, to help them to see that they begin in a specific time and place, in a historical context. You want them to understand that 90 percent of the things they take for granted are cultural solutions embedded in a history of such solutions: facts, but not necessarily truths. You want to give them a real historical awareness, not in terms of names and dates but rather in terms of

a progression of ideas, leading to an understanding of why certain questions are now being asked by their contemporaries."

In order to foster this awareness, Irwin would attempt to recapitulate in his students the process through which he himself had progressed. He would begin by challenging them to render an exact realistic depiction of a still life subject and then press them, through continual questioning, to find some way of including all the things that were being left out, thereby forcing them to invent cubism, expressionism, minimalism, and so forth for themselves. Once they had achieved that organic comprehension of the succession of approaches, they were free to locate themselves anywhere within its sweep or at its frontiers; but Irwin was insistent that they first experience the historical roots of their activities.

Finally, however, the real questions Irwin was trying to engender in his students were located less in the past than in themselves. "All the time my ideal of teaching has been to argue with people on behalf of the idea that they are responsible for their own activities, that they are really, in a sense, the question, that ultimately they *are* what it is they have to contribute. The most critical part of that is for them to begin developing the ability to assign their own tasks and make their own criticism in direct relation to their own needs and not in light of some abstract criteria. Because once you learn how to make your own assignments instead of relying on someone else, then you have learned the only thing you really need to get out of school, that is, you've learned how to learn. You've become your own teacher. After that you can stay on — for the facilities, the context, the dialogue, the colleagueship, the structure, and so forth — but you'll already be on your own."

Once he had brought his students to that threshold, Irwin goes on to explain, he was faced with another challenge, "which was that I might not like what it was they were doing. But my own feelings at that point were beside the point; or rather, since my relationship to those students had shifted from that of leader to coparticipant, my personal likes, dislikes, and biases were no longer critical to their development except as just one more issue up for discussion."

That was how the process was supposed to work, but there were many pitfalls, the most treacherous of which was perhaps

that of imitation. "It's very difficult to avoid, the student being lost in the beginning and the school set up to emphasize short-term performance. So they tend to imitate what you do as a way of associating with what you say. But what you're trying to do is develop their sensitivities and not your own. I have strong philosophic reservations about what it is we are actually talking about when we use the word *morality*, but as that word is most commonly used, I would think that the most immoral thing one can do is have ambitions for someone else's mind. That's the crux of the challenge and the responsibility of having the opportunity to deal with young people at such a crucial time in their formation. One of the hardest things to do is not to give them clues—'Here, do it this way, it's a lot easier'—and instead to keep them on the edge of the question."

The alternative is the kind of school where everyone is aping the style of the reigning doyen, the kind of situation Irwin says he encountered at UCLA in the midsixties. "I remember how badly it affected the faculty there. You can look at it two ways: you can assume Rico Lebrun was right and that he somehow put all these people on the right track. On the other hand, it looks to me like he took away their license to do something really on their own. Or they let him do it. I mean, he didn't do it, he was just a strong personality. But watching those people, it's like they were cutting their own throats."

Irwin's, too, is a strong personality, and he has been immensely sensitive to the problem of staying too long, of making too much of an impact, of having his presence harden into example. "The problem with teaching full time," he related to me, "and it's for that matter a problem I'm having with these conversations of ours in terms of my anxieties about the book you're writing here, is that there comes a moment when there occurs a shift from why to how. I mean, people want you to be their guru, and that's the last thing you can do for them, that's the worst thing. And wherever I've been, once it begins to shift from why to how, I simply leave: I'm gone."

For that reason, Irwin has never stayed longer than two years at any one place, and, for that matter, he's taught full time a total of only five years. Still, his contribution has been extraordinary, judged on no other basis than the sheer number of his students who have gone on to top-rank artistic careers. In his own terms,

however, his greatest success can be gauged in terms of the diversity of the approaches that those students have pursued. His first class at Chouinard, for example, included freshmen Larry Bell, Joe Goode, Ed Ruscha, and Ronnie Miyashuro. At UCLA he worked with Vija Celmins, Tony Berlant, and Maria Nordman. At Irvine he taught Chris Burden and Alexis Smith. A show of their cumulative work would virtually span the spectrum of directions pursued by midcentury American artists.

Although by the late sixties Irwin was widely heralded as a teacher and a leader in the southern California art community, he continued to regard himself as a plodding beginner, a novice at the elucidation of presence and perception. And indeed, he had yet to undertake one of the most rigorous phases of his research.

CHAPTER 11

Art and Science
(1968– 70)

Maurice Tuchman, the enterprising young curator for modern art at the Los Angeles County Museum of Art, had only been with the museum a few years when he conceived the somewhat dubious notion of placing artists with corporate sponsors in a vast Art and Technology program. He was curious about what established, practicing artists might produce were they lulled out of their studios and given access to the technologically sophisticated facilities of some of America's leading corporations. Initially he was one of the very few people thus curious, but after a great deal of prodding, he was finally able to enlist the wary cooperation of about twenty corporate institutions (another two hundred de-

clined), and he set about contacting artists and effecting the various matches. Andy Warhol, for example, was paired with Cowles Communications, Tony Smith with the Container Corporation of America, and Claes Oldenburg with Walt Disney Enterprises; Robert Rauschenberg began exploring the acoustical physics of mudbaths with engineers at Teledyne, and Jean Dubuffet tackled the problems involved in monumental scale with the research division of the American Cement Corporation.

Most of the artists, in one way or another, took the opportunity afforded them by the program to enhance the kind of work they were already doing through the application of technologically advanced methodologies. They ended up producing bigger, more elaborate, more sophisticated objects, objects which, in turn, comprised the content of Tuchman's *Art and Technology* exhibition at the Los Angeles County Museum in 1971. Oldenburg's huge, lascivious *Icebag* throbbed and undulated at the entrance; inside, Rauschenberg's *Mud-Muse* belched, and Warhol's three-dimensional, flowered shower-curtain streamed.

One of the first artists Tuchman contacted, early in 1968, was Robert Irwin, who was at that time in the process of moving from his discs to his columns. Tuchman suggested that the proposed exhibition might give him the opportunity of working with scientists at transcending some of the technical difficulties involved. But to his surprise, he found Irwin not the least bit responsive to such an approach. "I told him," Irwin recalled years later, "that I had no interest in producing a short-term object, a large, winking, blinking version of what I was then doing." Irwin was, however, thoroughly intrigued by the kind of cross-disciplinary interaction that the Art and Technology project might afford. "At that time, as you know, I was beginning to think about using energy in my work, as opposed to matter, and that meant dealing with light and sound and other kinds of energy forms. So the idea that I might be able to talk to some physicists, not about hardware or things of that sort, but rather about how they actually thought about those ideas of space and energy and matter, what their approach was to the whole question, their mental picture: that seemed to me to be something really worth doing.

"So what I told Maurice was that I wanted the opportunity to find someone who would be interested in exploring that kind of exchange rather than someone or some industry intent on making something. I felt that what you could make in six weeks or in

two months for an exhibition would really be essentially what you already knew. I mean, you would simply act out or develop something which was already essentially resolved, except maybe technically. This was too rich an opportunity and too interesting a situation to put that kind of deadline on it. And to his credit, Maurice went along with me."

Irwin paused for a few moments, and then added: "That show was a very difficult situation for Tuchman. They gave him a very difficult time at the museum, and then later a lot of the artists complained as well. But frankly, I found it real interesting, and as far as I'm concerned, they had nobody to complain about but themselves: they were the ones who squandered the opportunity."

In August of 1968, Tuchman began the process of finding a match for Irwin. The artist toured Lockheed's Rye Canyon research center as well as its Burbank production complex (it was at Rye Canyon that Irwin first encountered the kind of anechoic chamber that would come to consume his interests). Then, accompanied by Cal Tech's famous Nobel Prize-winning physicist, Dr. Richard Feynman, Irwin visited IBM's enormous San Jose facilities, after which the pair returned to southern California and spent several days at Pasadena's Jet Propulsion Laboratory, where scientists were busily tracking the *Mariner* and preparing for the *Voyager* spacecrafts. Although nothing came of these various tours, Irwin found his conversations with Feynman especially rewarding.

During that summer Irwin had also entered into an intense dialogue with James Turrell, a young artist who had recently completed studies in experimental psychology at Pomona College. Turrell was already providing Irwin with a great deal of intellectual background for his investigations, and Irwin now invited him to collaborate on his Art and Technology efforts.

So far there had been a good deal of excitement, but nothing had taken root. In November 1968, Tuchman contacted Garrett Aerospace Corporation and arranged for Irwin and Turrell to tour its life sciences department, where much of the work on the environmental control systems for NASA's manned space flights was being pursued (the moon landing was less than a year off). It was in this context that Irwin came to meet Dr. Ed Wortz, the head of that laboratory.

There exists a photograph of that first meeting. Irwin is

sporting a neat Edwardian beard, his hair moderately long at the sides; he looks very hip. Wortz, by contrast, with his short-sleeved white shirt, striped tie, four pens in his pocket, and short-cropped hair, looks very square. In fact, he looks exactly like all those flight operations engineers who used to scurry about in the background during Walter Cronkite's live telecasts from Houston Mission Control. I mention this because nowadays the clean-shaven Irwin seems utterly staid (he might have just walked off the neighborhood golf course); whereas Wortz, who in the meantime has dropped out of the space program to become a gestalt psychotherapist at L.A.'s Buddhist Meditation Center, in turn looks utterly that part, right down to the curls in his gray-flecked beard. It is as if the two have traded existences.

"So I was in my lab at El Segundo one day," Wortz recalled for me the day I visited him at his Pasadena home, "when I got a call from my corporate office, and they said they were sending over one of the corporation PR guys with two artists. I said, 'Gee, guys, thanks a lot, that's just what I need.'" Up to that point, Wortz, who had received his doctorate in aerospace medicine from the University of Texas and had gone on to research such issues as "The Effects of Centrifugation on Lung Volume as a Function of Differing Gas Compositions and Pressures," had had virtually no exposure to and even less interest in art. He was not looking forward to his afternoon.

"So an hour later," he continues, "in walked Bob Irwin and Jim Turrell . . . and it was love at first sight. I don't think any of us could believe how well we got on. From there, one thing just led to another."

"The thing that fascinated me about Wortz," Irwin told me subsequently, "was that he could handle more information with less difficulty and less prejudice than anyone I'd ever met. I mean, I would be sitting in his office—which I started doing with increasing regularity—having this conversation about philosophic or aesthetic attitudes, and someone would come in. . . . (They did much of the physiological work for the lunar explorations: how much energy it took to walk up a 20-degree grade wearing a spacesuit with a 20-pound pack on your back in that gravitational situation, that kind of thing.) Anyway, people would walk in and ask him about some very complicated mathematical formula or some other technical problem; he'd discuss it with them, make a

decision on it, state it back to them in alarmingly simple terms, and then come right back to talking with me, without skipping a beat! And his attitude with the most technical or the most sophisticated kinds of information, or with the kinds of things I was dealing with, or with the possibility of monsters in Loch Ness: he would handle them all with no variance, no prejudice; he seemed to deal with each one equally. And I really found that fascinating."

As it turned out, the three men, each in his own way, were interested in essentially the same thing: man's sense of his environment, and particularly his perceptual sense of that environment. Apart from that, they had no special irons in the fire, no particular ambitions. As Irwin put it, "We decided that all we wanted to find out was how two radically separate disciplines could interact, what could be the grounds. There was no way that I was going to find out everything Wortz knew the way he had, in other words, bit by bit, going to school, learning all the technical data. And there was really no need. The question was, is it possible for me to understand how and in what way he sets his questions and structures his information?"

At first they just met for discussions; they toyed with the question of how they might eventually "make art" out of their deliberations, not so much with the intention of producing anything as with the aim of focusing their considerations. Turrell compiled thorough notes and the museum subsequently published excerpts from these notes as part of their exhaustively detailed *Report on the Art and Technology Program 1967 – 1971*. (The section on the Irwin-Turrell-Wortz collaboration runs almost twenty pages.) Those notes, in some places, suggest many of the positions Irwin was to consolidate during the seventies. For example:

> Allowing people to perceive their perceptions — making them aware of their perceptions. We've decided to investigate this and to make people conscious of their consciousness. . . .
>
> If we define art as part of the realm of experience, we can assume that after a viewer looks at a piece, he "leaves" with the art, because the "art" has been experienced. We are dealing with the limits of an experience — not, for instance, with the limits of painting. We have chosen that experience out of the realm of experience to be defined as "art" because having this label it is given special attention. Perhaps this is all "Art" means — this Frame of Mind.

The object of art may be to seek the elimination of the necessity of it.

The works of previous artists have come from their own experiences or insights but haven't given the experience itself. They set themselves up as a sort of interpreter for the layman. . . . Our interest is in a form where you realize that the media are just perception.

The experience is the "thing," experiencing is the "object."

All art is experience, yet all experience is not art. The artist chooses from experience that which he defines out as art, possibly because it has not yet been experienced enough, or because it needs to be experienced more.

All art-world distinctions are meaningless.

From out of these hours of conversations they drifted into experimental projects. Irwin was eager to resume playing with the kind of anechoic chamber he had seen at Rye Canyon. "An anechoic chamber is a totally sound-dampened, light-blackened room," Irwin explains. "The one we ended up using, at UCLA, was a particularly fine one; it was suspended so that even the rotation of the earth was not reflected in it, or any sounds being bounced through the earth—a jackhammer five miles away or something. Nothing went into that space. And no light at all. We would go in there, one at a time, and sit in a chair in the middle. Then they'd shut out the lights and close the door, and you'd just be there. You had no visual or audio input at all, other than what you might do yourself. You might begin to have some retinal replay or hear your own body, hear the electrical energy of your brain, the beat of your heart, all that sort of thing. We got so that we could spend maybe six or eight hours in there at a time, each of us, testing the acuity of our powers of perception.

"There were all kinds of interesting things about being in there which we observed, but the most dramatic had to do with how the world appeared once you stepped out. After I'd sat in there for six hours, for instance, and then got up and walked back home down the same street I'd come in on, the trees were still trees, and the street was still a street, and the houses were still houses, but the world did not look the same; it was very, very noticeably altered."

All three of them experienced the same world shift, a phenomenon whose intensity so amazed them that they subsequently designed a battery of experimental tests that they then adminis-

tered on twenty-five volunteer subjects, almost all of whom testified to the same perceptions.

"We speculated that the difference came from one's having been isolated in total deprivation of audio or visual input. For one thing, what happened is that those two senses changed their thresholds. In other words, there is a certain way you look and see and listen every day, but when you're suddenly cut off from the world of sight and sound for six or eight hours and then return to it, there occurs a change in the acuity of the mechanism. In addition, there may be a shift in sense dependence. That is, when you're in a space having no visual or audio input, which are the two primary senses, you tend to begin taking in more information through the other senses. You start spending more time making a tactile read, building your world in that black, soundless space with information from those other senses, so that when you come out, that shift simply persists for a while, it continues to be honored, and you take in different degrees of information. And we all know that the complexity out there is ... we might as well say infinite. ..."

Among Turrell's notes in the LACMA documentation of the Irwin collaboration can be found a "Quote from Blake: 'If the doors of perception were cleansed, everything would appear to man as it is, infinite.'"

"For a few hours after you came out," Irwin continues, "you really did become more energy conscious, not just that leaves move, but that everything has a kind of aura, that nothing is wholly static, that color itself emanates a kind of energy. You noted each individual leaf, each individual tree. You picked up things which you normally blocked out. I think what happens is that in our ordinary lives we move through the world with a strong expectation-fit ratio which we use as much to block out information as to gather it in—and for good reason, most of the time; we block out information which is not critical to our activity. Otherwise we might well become immobilized. But after a while, you know, you do that repeatedly, day after day after day, and the world begins to take on a fairly uniform look. So that what the anechoic chamber was helping us to see was the extreme complexity and richness of our sense mechanism and how little of it we use most of the time. We edit from it severely, in time to see only what we expect to see."

The anechoic experience in turn provoked other explora-

tions. The trio concocted Ganz fields ("visual fields in which there are no objects you can take hold of with your eye," 360 degrees of homogenious color—white, in their case—which afford the sensation one might experience sticking one's head inside a giant, evenly lit Ping-Pong ball); they monitored alpha waves, interrupted each other's sleep, practiced meditation. They reproduced a peculiar experiment they'd come upon in the literature in which they were able to confirm that Carlsberg Elephant Beer tastes best when drunk within the aural context of a particular tone (650 Hz.) and that varying that pitch only slightly renders the brew almost undrinkable. Irwin, who was fascinated by the ability of the two eyes to integrate their separate perceptions, mastered a technique for separating their focus: "Both Wortz and I learned how to do this," he claims. "We taught ourselves by placing a dot on a window and gazing both at and beyond it, thus allowing two planes of focus, one for each eye. Or else, by staring at a single pencil long enough to become conscious of the separate images we were receiving from each of our eyes. I can still do it any time I want. It takes a few minutes concentration, but I can just separate them, for example, having one eye register foreground and the other background."

"We could have spent the rest of our lives pursuing any one of these lines of development," Irwin summed up years later, "because they were all really worthwhile and their potential was thrilling. But we were using them simply as ways to find out how we each thought about things, what each of us saw that the others didn't, how we organized things differently."

"Bob approached information differently than Jim or myself," Wortz told the LACMA chroniclers. "Jim and I are primarily information sops; we sop it all up. Bob withholds information. He keeps the information at a distance . . . and yet arrives at the same observations and conclusions."

With me, years later, Wortz speculated on Irwin's special interest in the sensory deprivation experiments. "As I gradually learned about his artistic history, I came to understand that Bob had been working with sensory deprivation long before he entered that anechoic space. Really that's what he must have been doing during those months when he spent hours on end holed up in his studio staring at two lines on a canvas. And that discipline brought him a very special kind of knowledge. I mean, Bob really

understands a line. I don't understand a line, but I am firmly convinced that he does. He understands it deep in his nervous system. He understands it from his cortex right down his spinal column."

The three men had been working together for nine months and were beginning to actually consider plans for translating their experiences into a participatory installation at the LACMA show when suddenly, in August 1969, Turrell dropped out of the collaboration altogether. Irwin to this day is baffled by the occurrence, and somewhat hurt. It is not that dissimilar to other cases where younger artists have blown abruptly and furiously free of his powerful gravitational field. Perhaps there is something to the Anxiety of Influence. At any rate, Turrell subsequently denigrated the significance of the interaction. "I don't know that anything really startling came out of the whole thing," he told the LACMA chroniclers. "I sometimes feel I've found some things out, but they don't apply to anyone else unless they come to them in the same way." Free of the project, Turrell went on to a highly original career of his own.

Irwin, by contrast, is considerably less circumspect in his evaluation of the collaboration. "The biggest product of Art and Technology thing," he feels, "is the effect we had on each other. I radically changed Ed's life, and he radically changed mine."

There was no clear moment when the Art and Technology collaboration between Irwin and Wortz came to a conclusion; rather the two men simply proceeded to other cooperative ventures. In the fall of 1969 Wortz was asked by the National Aeronautics and Space Administration to begin researching the concept of habitability as an adjunct to the planning of long-term manned space projects. He invited Irwin to participate, and the two men decided to start out by convening a "National Symposium on Habitability," a gathering of all the psychologists, doctors, planners, architects, engineers, academics, and humanists who they felt could help reconnoiter this virgin territory. The symposium took place in May 1970.

Volume four of NASA's publication of the collected papers of the symposium includes a sequence of photographs showing a grungy, dilapidated alley (the scene is beachfront Venice, California) and a bus pulling to a stop. A group of well-dressed professional men disembark, wander down the alley, and then file

through a hole that has been knocked into one of the walls (bricks and debris spill back into the alley). . . . The professionals look incredulous.

"What happened was this," Wortz recalls. "First, we housed all the participants at the International Hotel right by the airport. Then we bused everybody the first morning to this alley behind Market Street, off-loaded them, and they all had to wander down this alley, through a hole in the wall and into this really pristine environment. That was Bob's studio at the time, and as is typical with him, he had spent weeks preparing it (without either financial remuneration or art-world recognition), simply because he'd gotten turned on by the idea.

"Anyway, that first day, as they entered, there were these big two-foot-diameter white tubes along the entire length of the other end of the room, standing vertically, floor to ceiling. It was very elegant, very pristine. Larry Bell had created two wonderful plated-glass skylights, and Frank Gehry had helped Bob design the interior, which consisted of various raised acoustic platforms and islands but no chairs. The fact that everyone had to sit on the floor immediately moved the situation into a considerably more informal mode. Some of the participants read papers they had prepared, and that afternoon everybody broke into smaller groups. In the evening we bused them back to the hotel.

"The next day, when they returned, all the tubes had been removed, one end of the structure was gone, and in its place, across the entire length of the room, hung a thin translucent film, which allowed outside light and shadows to flow into the space. The third day that translucent wall was gone, and the room now simply opened right into the street. So the people on the street— drunks and beach bums and young kids—just drifted right into the symposium.

"The afternoon sessions," continues Wortz, "were held in about five different environments designed for smaller groups. Bob designed one that was completely white and had no edges at all. It was brilliantly lit, and it was very interesting, because when you were in there you *had* to pay attention to the other people. If you didn't, if you looked away from someone's face, you soon began to get nauseous. Larry Bell designed a space that was so oppressive that it was never used. People would just go in, turn around, and leave. It was basically a black room with one bare

light bulb hanging in the middle. Larry made another room whose walls were angled in such a way as to render the space extremely reverberant so that people kept having to scoot their chairs closer and closer in order to hear one another.

"So all these different rooms had very interesting effects on people's behavior, and the upshot of it all was that at the end of the conference we asked them what effect the environments had had on their behavior, and they all said they hadn't noticed any. Which told us something about the 'experts' we were dealing with."

Had one asked Irwin in 1965 how he viewed the relationship between his activity and that of a scientist, he might well have replied that he saw none whatsoever, or that he saw the two enterprises as diametrical opposites. By 1970, however, after spending several years working with scientific researchers, he had developed a rich sense of the interpenetration of the two endeavors.

"Take a chemist, for example," he elaborated one afternoon. "He starts out with a hypothesis about what might be created if he combined a few chemicals, and he begins by simply doing trial and error. He tries two-thirds of this and one-third of that, and marks down the result: that doesn't work. He tries one-third of this plus one-third of that plus one-third of something else; and then he tries one-quarter and three-quarters; and he proceeds on that basis, a sort of yes-no trial and error.

"What the artist does is essentially the same. In other words, what you do when you start to do a painting is that you begin with a basic idea, a hypothesis of what you're setting out to do (a figurative painting or nonfigurative or whatever). Say you're going to paint a figurative painting that's going to be about that model over there and the trees outside behind her and the oranges on the table. It's just a million yes-no decisions. You try something in the painting, you look at it, and you say, 'N-n-no.' You sort of erase it out, and you move it around a little bit, put in a new line; you go through a million weighings. It's the same thing, the only difference is the character of the product.

"Let's say at a particular point the scientist gets what he set out to get, he arrives at what he projected might happen if he mixed the particular right combination of chemicals in the right way. But the same thing is true of the artist: when he finally gets the right combination, he stops, he knows he's finished."

Bob wasn't the only one struck by the analogy. Wortz for his part during our conversations also had frequent recourse to the artist-scientist comparison, one which we might likewise not have expected from him before 1967. One afternoon Wortz described Irwin himself as "not unlike those scientists who work in their little cubbyholes for years and years on experiments, and sometimes the experiments work, and sometimes they don't.

"I remember one time," Wortz went on, "when Bob had a piece of work that he was ready for me to see and I went over. He had rented this funny kind of garage with a little slit door; you crawled through this door into this really ancient garage, and in the middle of it was this ultra-pristine wall. It was about four feet tall and two feet thick and went all the way across the space. He was talking to me about the size of the wall, the thickness, what worked with it, what didn't. There it was, months of work, and maybe three people saw it. A few days later he demolished it, built another one, and later demolished that. I don't think he ever made one of those for display anywhere, and they were *so* beautiful. It took me a while to understand—I mean, here he was, an artist, and how could he *not* show his work?—to understand that what he was doing was pure research."

For Irwin, however, if art is in many ways like science, it is at the same time not science, and the ways in which the two differ are as revealing as their similarities. "Once the scientist is finished, you can look back over his notes to consider the precise sequence of yes-no weighings which brought him to his solution. It's all quite logical and structured," explains Irwin. "The artist, on the other hand, keeps no such record (although historians would love it if he did). Rather, he literally paints over his errors. Six months later, when you ask him, 'Why did you stop there?' and he replies, 'Well, because it felt right,' his answer may not seem acceptable from a logical point of view—I mean it seems as if he just chanced on the final version—but in fact it's quite reasonable. Given the basic fundamentals, he's tried just about every damn combination possible, every way possible, until he's finally arrived at what makes sense to him. The critical difference is that the artist measures from his intuition, his feeling. In other words, he uses himself as the measure. Whereas the scientist measures out of an external logic process and makes his decision finally on whether it fits that process in terms of various external abstract measures."

Elsewhere Irwin has characterized the distinction he is speaking of here as that between logic and reason, and the articulation of that dichotomy has been one of the most important themes in his developing thought during the seventies. Indeed, nowadays when he writes or speaks, he usually takes the opposition for granted, as if everyone in their everyday parlance conceived of reason and logic as virtual opposites, with the result that members of his audiences are sometimes baffled by what they perceive to be sudden turns in his argumentation. He addressed this dichotomy directly in the essay he composed for the catalogue of his 1977 retrospective at the Whitney. "I can reason," he wrote, "but I cannot logic. ... I *use* logic." He then amplified the polarities involved:

> Reason/individual/intuition/feeling: Reason is the processing of our interface with our own subjective being.
> Logic/community/intellect/mental: Logic is the processing of our interface with our objective constructs, our social being.

One afternoon Irwin phrased it this way: "Scientists tend to operate through a logical process in the material world. In science it seems necessary that your facts be concrete, repeatable, and predictable, which means there has to be an existing reliable form of measure. And the only reliable forms of measure, as far as science is concerned, are pure abstractions, that is, abstract systems which can be overlaid onto the world of experience. Euclidean geometry or a clock or a scale are pure abstractions. You can count on them to be the same every time. And, as long as you have that kind of measure, then what you're getting can be held to be factual, as it were, in line with the original hypotheses and proved in performance."

Continuing this line of thinking, Irwin argues that the artist's enterprise is different both in terms of its way of measuring and what it sets out to measure. "Reasoning appears to be more confused, more haphazard, partly because of the scale of what it tries to deal with. The logical, in a sense, seems more successful because it cuts the scale down. In fact, that's what makes it logical: it takes a very concise cut in the world and simply defines or refines by deduction the properties of that cut, but it never deals with the overall complexities of the situation. It only applies within the confines within which it operates, so it seems much clearer. The

artist, however, as a reasoning being, deals with the overall com-
plexity of which all the logical subsystems are merely segments,
and he deals with them through the intuitive side of his human
potential—and here inconsistencies are as meaningful as consist-
encies." Things that would fall outside the scientist's purview are
precisely the kinds of things that activate the artist's curiosity.

Actually, Irwin will quickly reverse field, this was not always
the case with art. Art and science for centuries coexisted as ad-
juncts to one another: the Greek sculptors, for example, were
anatomists of the highest order; Leonardo da Vinci subsequently
set the highest standard for both art and science and no doubt saw
the two pursuits as inseparable; and post-Renaissance art, in
terms of figuration, composition, and perspective, set ever higher
technical, which is to say logical, standards.

But as the civilization as a whole began to rely more and more
on logic as opposed to reason, a process Irwin today traces to
developments in the seventeenth and eighteenth centuries, art
began to veer away. "The civilization that you and I live in makes
most of its critical decisions based on logic," Irwin contends. "I
feel that maybe a hundred and fifty years ago, which is now a
legacy which we are having to deal with, art began to drop out of
that; it began to become less logical. Even though it proceeded
logically, it found questions that could not be answered logically.
The reason it moved away from figuration was not that it was
antifiguration, but because figurative thinking and the processes
of logical thought are really parallel. That is not a negative state-
ment; it simply states that they do essentially the same thing: they
are mates in a way. Now, at some point, if we should look at the
world and feel that all things are not subsumable to or resolvable
by logical thinking, then we have to begin to develop an antithesis,
and that really is what contemporary art is in our culture, an
antithesis. The degree of its cultural estrangement testifies to that
idea."

Of course, Irwin concedes that not all art currently being
done operates out of this antithetical posture, and in so saying he
comes nearly full circle. Indeed, the great majority of art being
done consists in a consolidation of the advances already made at
the cutting edge of avant-garde development. Thus, to do a
neocubist painting today is a very different kind of activity from
having done a cubist painting in 1910; there is now almost a

technique, a logic to such an activity. That kind of art making, according to Irwin, is not all that dissimilar from the work of the journeyman chemist who applies the techniques of a well-established system to each new set of particulars. Nevertheless, at what Irwin calls "the periphery of the body of knowledge," whether we are speaking of chemistry, physics, mathematics, psychology, or art, there are laborers who are working beyond the sovereignty of the techniques of their disciplines. They are all guided principally by reason, quite simply because, past a certain point, the tether of their logic no longer extends. (Or more accurately phrased, perhaps, it is they who are extending it.) These researchers, in Irwin's view, have more in common with each other than they do with the technicians in their respective disciplines. He has dubbed their colleagueship "the dialogue of immanence."

"I really feel that there is a kind of dialogue of immanence," he explains, "that certain questions become demanding and potentially answerable at a certain point in time, and that everyone involved on a particular level of asking questions, whether he's a physicist or a philosopher or an artist, is essentially involved in the same questions. They are universal in that sense. And although we may use different methods to come at them, even different thought forms in terms of how we deal with them—and we will eventually use a different methodology in terms of how we innovate them—still, really those questions are happening at the same moment in time. So that when we find these so-called accidental interrelationships between art and science, I don't think they're accidental at all."

Another word Irwin uses in this context is *inquiry*. All these researchers in their own ways are engaged in the process of inquiry, and the most salient feature of inquiry is its open-endedness. It is pursued for no reason whatsoever; it is the project of the passionately curious. The wilderness is stalked by explorers without maps and without any particular goals: their principal compass is their reason.

CHAPTER 12

Playing the Horses

One thing about inquiry: you don't make much money doing it. Nor, for that matter, was Irwin making much money on his art (this despite the fact that since 1966 and the collapse of Ferus, Irwin had forged a highly supportive relationship with Arnold Glimcher's prestigious Pace Gallery in New York, where he mounted four one-man shows between 1966 and 1971). He simply was not producing much by way of salable items. There had only been ten late line paintings, ten dots (two of them destroyed at São Paulo), and about fifteen of each of the two styles of disc. The discs, for example, sold for $5,000 each, when they sold, but they appealed to a highly specialized sensibility, and not all of

them sold immediately. Irwin was not being paid for his Art and Technology efforts. He was paying for the discs' storage.

Not that Irwin was complaining. He is quite adamant on the question of whether society owes the artist a living; he feels it does not. He urges young artists to structure their finances in such a way that they do not have to rely on the sale of their art: he urges them to reduce their material requirements and to cultivate alternate sources of income. The important thing, whenever possible, is to safeguard the art from impinging financial pressures. Irwin does not subscribe to the sackcloth-and-ashes school of artistic romanticism; he sees no special virtue in starving in garrets.

"Look," he said to me one day, "it's really quite simple. Pursuing the questions which art provokes is a long-term activity that necessarily needs to be free of short-term measures and rewards. In order to maintain a natural balance and continuously develop the ability to make reasoned observations and decisions, it is necessary that you take very good care of yourself, since *you* are the crux of it all. I'm always very kind to myself. I indulge myself in lots of ways. I give myself lots of free time. I allow myself lots of room for mistakes and contradictions. And I spend a lot of time entertaining my personal fantasies and playing the games I enjoy. I don't let money questions get to me. It's just a matter of good health."

His motto could be, modest needs lavishly met. (Ed Kienholz, his friend from the earliest Ferus days, once recalled for me that back in those days, "Bob always maintained a thousand-dollar balance in the bank. If he had $1,001 in his account, that meant he had one dollar for dinner.")

During the mid- and late sixties Irwin was supplementing his meager art income in part through his teaching, but that only for a few years at a time. His principal source of income was playing the horses.

Irwin had been frequenting the race track since high school (his parents' home was only a few miles away from Hollywood Park). Over the years he had improved from a "two-dollar stab-and-grabber" to the point, during the sixties, where for several years running he was deriving a sizable portion of his livelihood from his betting; not once has he registered a losing season. There were times when he even owned shares in some up-and-coming thoroughbreds. (He bet mainly horses, but during the fall he was also regularly placing wagers on college football games.)

This would all be tangentially interesting, if merely to help account for Irwin's financial survival, but it has more substantial significance as well. Indeed, it might be said that, alongside his early experiences with cars and his subsequent education at Ferus, horse racing constituted the third most important element in the honing of Irwin's aesthetic sensibility. It was at the race track, more than anywhere else, that Irwin learned the distinction between logic and reason and trained himself in the proper deployment of each.

We were talking about it one day. "I think the race track was probably, in terms of discipline and learning, one of the most important activities I ever had," he explained. "It didn't start out that way, it wasn't intended that way, but through my general competitiveness maybe it really turned out to be an interesting exercise. You know, the way some people went to school and really exercised their minds, really got interested in learning and pursuing things—which I did not. That aspect of my interest came in through horse racing, because the race track may just be a game, but it's incredibly complex and intricate. In fact, I can't think of a game that's more complicated.

"The thing about the race track is the incredibly wide range of information that has a bearing. If you're going to have a chance there, you have to achieve the discipline necessary for keeping track of all of it. The one thing more than anything else is learning to pay attention. Because every year it's different; even during the period of a meet it will go through cycles or phases. It's real tough to put your finger on it, but the name of the game is to sense the upcoming tilt before anyone else does, to notice the particular combination that's beginning to gel before anyone else notices it. And to do that, you have to pay attention to everything."

I asked Bob if he saw his activity at the race track as principally logical or reasonable. "Well," he replied, "it's both. That's one of the things that's really interesting. There are certain kinds of information that reveal themselves in a logical manner, and there are certain kinds of information that don't reveal themselves in a logical manner at all.

"Let's say you're on your way up to the window to make a wager. The first area of information is like what you get out of the *Racing Form* or what you keep your charts for. (I used to keep charts on everything that moved, not only who won and against

whom but all of the fractions. Fractions were a tremendous advantage, because the way a race is won has more to do with the winner than any other single factor. And no one else kept those. I had all the figures on who was where, leading or trailing, at two, five, eight furlongs, and so forth, and it was a tremendous advantage. Now, of course, they print them up in the *Racing Form,* so anyone can use them; it's too bad.) Anyway, that kind of stuff is what you call hard fact information: a certain horse did win, he did win in a specific time over a particular group of horses on a particular grade of track, and so forth. All that information is true, and it's all useful, and you just stack it up. You derive logical conclusions from it; I mean, it has a solid characteristic, and you simply draw your conclusions from the character of its facts.

"And there are a number of those factual kinds of information. The betting, the money: you watch the tote board to see how the betting is going, how much is bet, how many people are betting, whether they're betting early or late, in large chunks or evenly, and so forth. And then you weigh that against what you know of the general habits of the public. And now you're starting to get into a slightly more theoretical area. In other words, what do you mean by 'the general habits of the public'? I mean, it's not something you could put a specific finger on, although, if pressed, I suppose you could give it some equation which you might use to derive logical conclusions.

"But then you get to the point where you're about to place your wager; the race is about to be run. You evaluate the sum total of the information, which has to do with how the money has been bet, what the horses looked like on the track, all this information—and *it's like you run your hand over the race*—I've had this happen so many times, it's the only way to explain it—you run your hand over the race. All this information is logically there, but there's something wrong. You don't know why something is wrong, but something is not correct. You can't put your finger on it, but say, like in this instance, I say to myself, 'Something in this race is suspect, it doesn't feel right.' So then I have to reevaluate everything in terms of this feeling I have about the thing, which is derived from information, but which is so complex and so intricate and so subtle that there's no way you can put a tag on it. But now you have to reweigh the character of your wager in the light of how you *feel* about it. See, what's happened now is you've come

up with an added factor, a factor which has no actual solid tangibility, but now it's changing your basic equation for the race. Your horse is three-to-one, say, and you've now got an added factor which forces you to four-to-one. In other words, this horse which was a good bet at three-to-one now no longer is, might be at four- or five-, but it's being offered at three. So now you have to weigh it in terms of how strong this feeling is, to what degree you might be able to substantiate it somehow. See, you've brought into play a kind of information which has a totally different characteristic. Now, you can dismiss that information, because it's very difficult information to put a handle on, and you want to, because you're about to make a fairly practical move in the world. You'd love to be able to put a stronger handle on the thing, but you can't. So sometimes you say, 'Well, Jesus, what the hell,' you don't trust yourself, and you bet it anyway. And the race blows up in your face: it just simply does not do what it was supposed to do.

"A lot of that has to do with a version of that thing of immanence: If a particular set of circumstances comes to a particular conclusion—okay?—and it does that let's say five times, about the fifth time you'd think you could say with some degree of certainty that it's going to happen a sixth time. But it doesn't work that way. And the reason is that there's the added piece of information that you've recognized it, and by recognizing it you've changed the character of the information. In fact, you've now set in motion a counterforce: let's say you now become ten people. Forget about you as a wagerer. The jockeys are sitting in their room and somebody's gotten away with something, a particular kind of move in a particular kind of situation, and they've gotten away with it, say, four or five times, and the jockeys, maybe not all of them, maybe one or two begin to sense it and maybe a little later to know it, that this situation has become visible in some way. And goddamn it, they will now react differently. When that situation arises again, they will respond differently. Man, that gets so subtle and complex, because you're talking about jockeys, you're talking about trainers; they're doing it almost intuitively sometimes, they're moving sooner, they're moving later, they're waiting, they're hesitating, what have you. That hesitation: you ask them why they hesitated, probably couldn't even tell you why they're hesitating. And you're sitting in the stands trying to anticipate the possibility of it all. You get the subtlety of the thing? I mean, it's spectacular!"

Get Bob talking about the races, and you might as well put your legs up on the table and lean back: you're not going anywhere for a while.

"So anyway, you get this feeling that this son-of-a-bitch race is not going to go that way. It's just a feeling in the air; it's beginning to be met by a countersituation. Within maybe two or three days, you'll read about it in the *Racing Form,* that a certain thing has won six times in a row under certain circumstances. Now, of course, it's public information, and everybody is definitely going to be betting on it. But by that time it's too late, it's over with: the situation may occur again once or twice because the conditions are just so strong, but that situation is no longer a live situation, it's a dead situation because now there are going to be so many counterforces operating against it. And the basic counterforce is that the moment people anticipate that something is going to happen, they've changed the character of the information on which they're basing their anticipations.

"That's incredible subtlety: it's so goddamned layered and complex. So at a certain point you begin to have a tremendous respect for the character of that kind of feeling. You respect the logical information, the hard fact information and all that—that's the basis for the other—but finally it is probably less critical to the final decision making than is the other."

Robert Irwin does not go to the races like you and I go to the races. I asked him whether intuition at the track was principally a negative thing, an early warning system.

"Oh, no. I just gave that as an example, that the race feels wrong. You can have just the opposite feeling: you get the sense that a particular situation is just absolutely immanent. You can hardly explain why, but you know damn well that this situation is simply going to take place. What you've done is catch the feel of a situation two jumps before it becomes a fact; once it becomes a fact, then it will be more attainable and it will immediately start producing a counterforce. So, on the affirmative side, intuition is about sensing facts before they materialize.

"But when you're standing there, the information is just coming in, and the texture of it, the amount, the kinds and variety—to be able to get it all together really takes an incredible amount of concentration. That's why I don't like to take anybody with me to the races, because it's like the ten minutes before post, you go into

a state of just poised suspension. And what you're doing is — you've gone through all the basic fact information, it isn't that anymore, you know who's who and what's doing what and all that—now you're simply weighing all these passing feelings and attitudes and senses about the thing, you're trying to pin it down. Maybe it's the way the horses looked in the post parade, you just didn't like the way that felt and you can hardly put your finger on it. Sometimes it's obvious: the horse was sweaty, he was acting up, and he doesn't have a history of that or something, which now changes everything else. But sometimes it's much subtler than that. It's an interesting feeling.

"And when you then go up to place the bet, you're betting the whole situation. Let's say there's twenty sets of information: one to do with the horse, one to do with past performance, one to do with works, one to do with the trainer's characteristics, jockey's characteristics, horse's characteristics, one having to do with whether the owner is there that day, whether he's got his best suit on (actually, that may not mean anything: most owners don't know shit about their horses). I mean, you name it: you can go on and on; who's betting, who's going to the window, all those things. They don't even have to be betting on the horse or against the horse. They can be betting on some fourth horse in the race who you haven't even given a thought to."

I begin to get the hang of this sensing stuff: I sense a story coming on.

"Let's say someone whose opinion you terrifically respect, say, he's a trainer who's training a horse in the race, and he bets this fourth horse, the horse that you basically don't give any chance. The horse has got early foot, that's all, but for some reason you doubt that he even has that, okay? You just sense that he's not on his game. You figure there's no way this lobster can cut it, all right? Now somebody comes in and makes a major wager on that horse. Now, that doesn't say in your mind the horse is going to win, but it certainly changes the calculation of whether or not he's got his foot. Let's say that piece of information tells you the horse has got his foot, okay? Now you have to go back and reexamine the whole race based on the fact that he's going to be a factor in it, which previously you didn't think.

"This horse is not going to win, mind you, he's going to have nothing to do with winning it at all, but he may affect the outcome

by what he does early on, just having to do with post position. Let's say your horse has got medium speed early and he's on the rail, and this horse has got good foot and he's going from the five hole, right? If he doesn't have his foot, maybe without having to use my horse into the first corner I can still be reserving the rail. But now what I've got is a spectrum where this horse is going to be showing early foot, somebody's telling me he's alive and away. Okay, so I have to count on the probability that when we hit the first corner he's going to cross over in front of me. Now, he's still not a winner, but now I have to face the prospect that three-quarters of the way home he's going to start backing up into my face, because I'm now locked in behind him, and I can anticipate now that clear over here at the top of the stretch that son-of-a-bitch is going to cause me racing problems. Now, I may be able to get around him, maybe he'll drift out, maybe he always drifts out, but let's say I don't know, I wasn't paying attention last time or I forget. I just don't know what he's going to do rounding that corner.

"Let's say there are two other speed horses in the race. Given that he's going to be moving early, I can almost tell you for a fact that now they're going to be there, too. See, I really want to save my move. But now I'm forced to move early myself so as to acquire position at that first corner, and I don't know if my horse has that kind of sustained drive in him. I don't know if he has two or three moves in him. So now the whole ball game's skewed. I mean, we're not talking about a horse that's even going to have anything to do with it, he's going to finish dead last in the race, but the son-of-a-bitch is going to cost me.

"So that's why I say you sit down, and you balance a race like that. This horse on the rail, let's say he's not some half-ass three-to-one, he's a twenty-five-to-one. I mean, ooh, that smarts. Just because this piece of shit has early foot, he's probably going to cock up this twenty-five-to-one shot. You can't not play the twenty-five-to-one, because the price is too big, I mean for a horse that's live and that you think is going to be there, but now he's going to get beat a head at the stretch. And you *know* it's going to happen.

"And not only do you lose the wager, which is not so bad. In the old days you used to be able to keep your mouth shut and come back. It was terrific: I would simply bet him again the next time. I knew I had a live horse, he was twenty-five this time, he'll

be thirty next time, terrific. It just added to the whole thing. But now they run the goddamn thing on television and every idiot at the race track gets to see it. They run it three times, and every moron there gets to see him being boxed at the corner. So the thing that hurts worst is not the loss but that the wager's no good anymore, it's gone down the drain. And it's gone down the drain because this piece of shit has foot. Let's say the shit doesn't even have foot, but the guy tells the jockey, he says, 'Just take him out for a half, he's not ready to run right now, but just take him out for a half and then let him relax.' The piece of shit goes for half a mile and cocks up your whole race.

"The point is you can handicap it, you can be absolutely dead right and lose. And the guy next to you does not understand why you've just given him a loser. All he knows is he's just lost his $30, and boy, he ain't happy with you. You've maybe done a brilliant job of putting the whole thing together and lost. Shit."

Bob pauses for a moment, savoring the loss, the irony. But only for a moment.

"But, you know, you have to maintain a very careful sense of equilibrium about yourself. In other words, when the race is over, there's a great tendency to say, 'My horse. . . .' You hear these guys, 'My horse was blocked, the goddamned jockey, if he'd moved earlier. . . .' They're jacking themselves off. After the race, to qualify why they didn't win—which 90 percent of the horse players do, qualify why they didn't win—they will exaggerate or elaborate on the information in such a way that it will cost them the next time the horse runs. Because the next time the horse runs, their memory of the last time will be incorrect. And you can't do that. You've got to look at the race and say, 'I made a good wager, I got beat, and these are the reasons I got beat.' You got to maintain your equilibrium; you got to pay attention."

Bob smiles fondly and starts spinning tales about his friends at the track, people he's known for thirty years. Few of them have any idea what he does outside the gates. They never discuss it: it's not germane.

And yet, if I've gone on at length about racing—if I've let Bob go on—it's because it has everything to do with his art, and especially his art of the seventies, as we shall presently see.

CHAPTER 13

The Room at the Museum of Modern Art (1970)

A passionate equivalence: attention to the incidental, the periph-
eral, everything that was beside the point. These were aspects of
the wisdom of the race track. They were also coming to constitute,
increasingly, the core of Irwin's artistic enterprise. Irwin was com-
ing to feel that just as everything had bearing at the race track, so
no single object could be isolated, transcendentally sheltered, in
the world of art.

"What I was becoming critically involved with, there in the
late sixties," Irwin explains, "was that whole mental structure
which allows one to separate or, in a sense, focus on particular
things as opposed to other things: why, for example, one focused

on objects rather than the light which reveals them. On what conditions, I started wondering, do we operate with art as a confined element in the world, in other words, an object or a painting as an isolated event in this world, surrounded by the world but somehow not totally or directly attached to it, actually somehow superior to it? It's a highly developed, raised rationale that this art object exists in. Indeed, we are oriented to look at such focal points as, in a sense, more real. And it's because of that that we're not really aware of what takes place otherwise, the so-called incidentals, the information that takes place between things, the kind of things that happen around, the multiple interactive relations.

"The art world is highly invested in the idea that you can take an object and set it in a room, and the internal relationships will be so strong and so meaningful that all the kinds of change that take place on the object as a result of its being in a new environment will not critically affect our perception of the object. If that is the given assumption, then the object can be moved from one environment to another without its being critically altered, which then gives rise to the illusion that it can be moved from culture to culture, that it has the ability to transcend its cultural specificity, which in turn gives rise to the ultimate illusion that the object can transcend time. Because what is being claimed is that there exist certain objects isolated and meaningful enough to be transcendent, that they have the power to go on and on, that they are, as it were, timeless.

"Well, one of the things that I was becoming involved in at that point in playing artist was the growing suspicion that this breaking down of the edge, the idea of the painting's moving into its environment, was putting the whole heightened rationale of the art object into doubt. There is simply no real separation line, only an intellectual one, between the object and its time environment. They are completely interlocking: nothing can exist in the world independent of all the other things in the world.

"To me, the whole history of contemporary art starts out as a highly informed and highly sophisticated pictorial activity. But by the time I arrive on the scene, as a post-abstract expressionist, there is at least the possibility of looking at the world as a kind of continuum, rather than as a collection of broken-up and isolated events."

The single experience that perhaps more than any other had raised Irwin's doubts about the transcendability of the art object had occurred in 1968 in New York, and we have already alluded to it. By way of preparing for an exhibition of his discs in two New York shows that year, Irwin had spent days neutralizing the exhibition spaces (in one case at the Jewish Museum, in the other at the Pace Gallery), meticulously repainting the walls, clearing the floors, squaring the corners, and so forth. This activity, which he had undertaken solely as a way of removing extraneous distractions from the viewing experience (something he had often done, and without problem, in Los Angeles) was, however, perceived by New York critics as an abrasive, fetishistic gesture, just too cool to be ignored, indeed in itself a distraction to any calm viewing of the pieces. Interestingly, rather than being angered by this response, Irwin became fascinated by it. Indeed, he came to feel that such critics were right; an activity that meant one thing in L.A. could mean something altogether different in New York.

"I mean," he explains, "I could see how if you spent your life in the confines of cluttered light, and thought of your existence in the maze of the city as an exercise in personal survival in which the prime requirement was a continuous mental toughness — sure, I could see how such subtleties might not seem real issues."

Context, then, was everything. But, if this were so, was it even possible to aspire to the creation of objects where this shift would not occur, especially when the shift seemed all the more pronounced in objects produced along the borderland of aesthetic inquiry? Or might some altogether different approach be called for?

This perplex consumed Irwin in his studio activity between 1968 and 1970. It was held in abeyance, but conspicuously so, in all of his experiments with sheet glass and acrylic columns. It was an implicit presence when, in early October 1970, Irwin opened his Venice gallery space for a showing of his "Skylights-Column" installation. Later that month, it became an explicit concern as he traveled cross-country to the Museum of Modern Art, where he made the first of two gestures that, taken together, would constitute the decisive break of his midcareer.

In 1970 most of the curators at the Museum of Modern Art were involved in researching and compiling large-scale historical retrospectives, but one young curator, Jennifer Licht, was haz-

arding a more adventuresome approach. She noticed that one small room on the museum's third floor, off to the side of the Brancusis, was going to be empty for several months, and she sought museum backing for an installation by the controversial Robert Irwin. She did not get it: she did, however, get confirmation that the room was going to be remaining empty. And so, more or less on her own authority, she invited Irwin to perform a transformation of the space.

"In other words," Bob was recalling the situation for me one afternoon, "the museum had not actually asked me to do it, nor had they appropriated any funds. They did not pay me to come to New York, and when I got there, there was no money to pay the painters, electricians, carpenters, and so forth; so there was to be no assistance of that kind. In fact it was worse than that: the painters, electricians, and carpenters were themselves not going to let me touch the room—you know, infringement on union prerogatives; it was their thing—so that I had to arrange with them privately on the side before they'd let me do it. Furthermore, I wasn't allowed to do anything during gallery hours. So what happened was that I began hanging around after hours along with my buddy Jack Brogan, who had been a technical consultant for me on several of my earlier projects. We'd walk in each night as the patrons were leaving, stay until the final guards were closing up, and come back the next morning even before the early birds arrived. And we just spent about a week there, trying out all sorts of different solutions."

There were no two ways about it: the room was an ugly room. It was jammed in one corner on the third floor, wrapped squat and L-shaped around a boxlike storage structure that protruded from one corner. Access was only possible from one side, a narrow floor-to-ceiling passage at one end of the base of the L. As Irwin recalls the space, the walls were "fat," the kind of walls you'd find in a basement, bowed as if by too much weight. "So that was all kind of interesting, because there was no way that room was ever going to be beautiful; it's basic properties were just too clumsy."

Irwin had arrived in New York with the intention of reproducing one of his Venice studio-type installations. He arrived, as it were, with his bag of conventional tricks, the sum of his two years of Venice explorations. None of them seemed to fit, or at any

rate they couldn't simply be applied to the new conditions. The awkwardness of the room itself forced him toward the next phase of his endeavor: each installation from there on would have to arise out of the unique configurations of each new site. As Irwin put it, "Instead of my overlaying my ideas onto that space, that space overlaid itself on me."

Irwin spent several nights just sitting there, taking in the situation. He cleaned the walls, repaired the floor. He tried this and that, put things up and took them down. As if at the races, he ran his hand over the whole situation. Finally he made his wager: it consisted of three major gestures.

The room was bisected by two banks of recessed fluorescent lights. "Actually they had once been part of a parallel set of sky-lights that ran the entire length of the museum, passing right over the various walls. They were about two feet wide and four feet deep with an old-fashioned egg-crate filter level with the ceil-ing, about two inches deep. They had long since stopped using them as skylights, so the egg crates were all dirty, and inside there were these fluorescent fixtures that simply, butt-ended, ran the entire length of the museum. Well, I cleaned the skylights and then took two colors of light, a warm and a cool, a pinkish and a greenish white. I mean, had you seen either by itself, it would have just seemed white, the way this bulb over here seems white, even though it's decidedly yellow. Anyway, there were eight shafts of light altogether in the two banks, and I interspersed them, warm-cool-warm-cool. And when you put them side by side like that, the pink one made the green look green and vice versa. The egg-crate filter tended to fracture the light through the room into very subtle bands of warm and cool; but these in turn naturally blended, and it was almost as if the room had a rainbow in it. It was all very strong, almost too strong, too romantic in a way; and yet, on the other hand, a lot of people didn't see it at all. So, go figure. Anyway, that was the decisive gesture; everything else merely complemented it."

The most awkward element in the room had been the far wall, the longest and most squat. Irwin addressed its presence by stretching a single strand of piano wire, taut, at eye level, parallel to and about a foot in front of the wall. He and Brogan devised a way of having the wire appear to pierce the walls at either end without any trace of incident. "Then we painted the first six

inches or so of the wire white," Irwin recalls, "so that even walking within a foot of it, you could not see the wire going into the wall. I daubed a little bit of white at various other places as well, so that the wire seemed to come and go. You had this visual element that you couldn't really hold in focus, no matter how hard you tried. It was just too slight. And yet, at the same time, you couldn't ever really look at the back wall either, because your eye was always getting caught up by this line. Your eye became suspended. And if you hadn't had the subtle colorations to orient yourself by—and they were very metastable—then it would have been hard to tell where the wall was. It could have been two, four, ten, fifteen feet back; your ability to focus on it or hold it in place had been destroyed."

Finally, Irwin stretched translucent white scrim, about four feet down from and parallel with the ceiling, about halfway across the room. (One bank of lights shimmered behind it, the other was clearly exposed.) As one entered the space from the room next door, one was thus confronted with two very distinct volumes of light (one, four feet above, and the other, eight feet below).

"That scrim material, like the wire, tended to affect the space as a kind of defocusing element," Irwin explains. "It's very hard to focus on that material; it sets up an ambiguity that makes every-thing do one of two things: either become ambiguous or razor sharp by comparison. Where a corner is will be very hard and extra clear, but where there's just surface will be very ambiguous.

"So that everything in that installation conspired to skew one's expectations, to raise some and lower others, so that your perceptual mechanism became tilted, and you perceived the room as you otherwise might not have. And that was all that was there. There was nothing else besides that."

There was not even a plaque with any attribution. The mu-seum kept putting one up, almost by force of habit, and Irwin kept having his friends at Pace come over and take it down. "I wanted to set it up as an opportunity which the spectator would have to deal with. In other words, you had to decide whether the room was there. Well, you knew the room was there, but you had to decide whether what was there was intended, whether or not it was finished, before you even got to the question of whether or not it was art. You had to deal with the simplest questions, which I felt was rather nice, because not only didn't we label it, we didn't

even announce it in any way. The museum, of course, cooperated in that, because they hadn't even been interested in having the thing there in the first place."

Ironically, the more sophisticated one was, it seemed, the less chance one had of "getting it." "A very naive audience could simply walk in, people who had no criteria as to whether it was art or not, and they could just like it or not, but they would immediately know what was going on and respond to it, one way or another. The more sophisticated person, with his or her expectations about what it was supposed to be, and about what art was and should be, tended to have a great deal of trouble with it."

Irwin had an opportunity to experience this peculiar phenomenon the very night he finished the room. "I was standing there that evening," he recalls, "and next to me were my friends, the people who were on my side, who were rooting for me in the situation, people like Jenny Licht and Arnold Glimcher. They were seeing it for the first time, and they were clearly rattled. They were trying to like it, trying in a sense to deal with it, but they just weren't sure: there was that nice awkward silence that's in the air when people don't quite know what to say or do. They were standing on one foot and then the other.

"Well, the museum was open that evening," continues Irwin, "and I still had the area closed off with a divider, but it was slightly ajar. And presently this black kid, about fifteen years old, peered around the corner and immediately said, 'Yeah, wow, man, okay, all right. Hey, baby, this is all right.' He just came in the room and spun around, sort of walked around in a revolving circle, turning as he went, just sort of really reacting and responding to it. And then he asked me if I'd done it, and I said yeah, and he said, 'That's just fine, man, that's all right, okay.' And then he shook my hand, said thanks, and walked out, leaving, as I say, my two friends there, a little bewildered as to what the hell to do."

Irwin notes that in time Licht and Glimcher warmed to the piece. He didn't have time, however; he left the next day, returning to Los Angeles. And then something very interesting happened: nothing. "It was kind of amazing," Irwin recalls. "There was no response at all. It was up there for two and a half months (they just left it up for a while). There was no official record made of it, but more curiously, no one even wrote about it, which is very interesting, considering that this was right in the middle of an art

milieu where if you just sneeze it gets recorded, dissected, and analyzed. Things like that are picked up automatically when you do something at the Museum of Modern Art. I mean, I know a great number of people saw it; you just have to assume they did. Whether they *saw* it, I don't know. But they were there, they went through it. And yet no one wrote a single word about it, which I found very interesting and, in a funny way, kind of flattering, because it really was not intended to lend itself to those kinds of methods. So, in effect, they responded without knowing they responded.

"But still, after about six months, I got a funny feeling at one point, a doubt as to whether I had done that piece at all. I had gotten no response, and the question of identity became very real."

Irwin paused. It is still a problem with his work these days, one that has never been completely worked out. "Now, interestingly enough," he continued, "maybe a year later, one artist, Richard Serra, said to me, 'That thing you did'—he didn't like it particularly, but it was bothering him. 'Why did you do that?' was the tenor of his question. It turned out, maybe a year later, that a lot of people had seen it, and a tremendous number of artists. Maybe other people saw it, too, but I started getting this feedback from all sorts of artists—and artists' opinions are, to me, the ones that count—artists who didn't necessarily like it, or who weren't necessarily convinced by it, but who were troubled by it, it was still going around in their heads. So, in a funny way it was recorded, and it did have its effect."

At any rate, it certainly had its effect on Irwin.

DEBOUCHEMENT

Irwin returned to Los Angeles, to his Venice studio, where the "Skylights-Column" installation was still up. It didn't make sense anymore. Something was wrong. For twelve years he had been pursuing a course of inquiry, each question opening out onto the next, the lines to the dots to the discs to the columns, but after the Modern Art piece, a fundamental transformation occurred. He had been following the questions through; now he was about to follow them straight out.

"It had been a long journey," Irwin summarizes, "starting out from my more or less naive approach as a painter to now be arriving at a point where, to some degree, I had dismantled the whole thing: image, line, frame, focus, transcendability. I'd dismantled the art endeavor, but in the process I'd dismantled myself. My questions had now become way in excess of any answers that I had, or even any possibilities. In fact, I arrived at this point with a real dilemma, and the dilemma was that all my questions now seemed external to my practice. The column not being successful is a good example. And it seemed to me that, if I continued doing what I was doing, I was simply never going to get to my questions. I would simply do those things, maybe better, or I'd extend them, maybe richer. So I really had a decision to make at that point, and it

was a fairly radical one in my life. See, I felt that if each day I got up and went down the street, the same street basically, and went into that studio, which was a particular scale and size, a room, and so on and so forth, and if I brought with me all my expertise—which is what you can't help but do in a situation like that, bring the things you've learned to be good at (and I'd learned a lot of techniques)—that I would essentially continue to do the same thing. And I didn't know exactly how to resolve that. But what I did was the simplest kind of thing—which was not an answer, but I think fairly reasonable given the dilemma—and that was to get rid of all those habits and practices altogether.

"I cut the knot. I got rid of the studio, sold all the things I owned, all the equipment, all my stuff; and without knowing what I was going to do with myself or how I was going to spend my time, I simply stopped being an artist in those senses. I just quit."

OCEANIC

Whoever you are, go out into the
evening, leaving your room, of
which you know every bit; your
house is the last before the infinite,
whoever you are.

Rainer Maria Rilke

CHAPTER 14

The Desert

He got rid of everything. The studio he sold to Doug Chrismas, who quickly turned it into the Ace Gallery. The supplies, he threw out. The collection of other artists' work, which he had built up over the years through a series of trades, he returned piece by piece to the respective artists. Then he went out on the Venice boardwalk, and for a long time, he just sat there.

Did nothing. Didn't even think about what to do next. In fact, began having a hard time thinking at all.

"You know what the biggest loss was in giving up the studio?" Irwin asked me one afternoon. "It wasn't the loss of my art world identity. It wasn't the scuttling of my economics. No, it was the loss

of a way of thinking, it was the loss of the physical things themselves. For twenty years I'd thought in terms of making objects; I'd worked out my ideas by working on physical things. I'm a very tactile person. I think by feel, and not having anything tangible to handle really threw me for a while. I mean, I understood how I'd gotten myself into that predicament — the questions simply mandated it — I just didn't know how to deal with it. I had to train myself to think in a new way."

He'd go to the races. He'd hang out at hamburger joints, idle about in his car. He'd leave town and head out into the desert . . . and it was in the desert that he picked up the trail once again.

"For some reason I started heading out into the Mojave, early morning drives out of the city to the end of the road. At first just a day at a time, and then later, on out into Arizona or south toward Mexico. I began pursuing a line of inquiry, or anyway retrieved the one I was already on.

"The Southwest desert attracted me, I think, because it was the area with the least kinds of identifications or connotations. It's a place where you can go along for a long while and nothing seems to be happening. It's all just flat desert, no particular events, no mountains or trees or rivers. And then, all of a sudden, it can just take on this sort of . . . I mean, it's hard to explain, but it takes on an almost magical quality. It just suddenly stands up and hums, it becomes so beautiful, incredibly, the presence is *so* strong. Then twenty minutes later, it will simply stop. And I began wondering why, what those events were really about, because they were so close to my interests, the quality of phenomena."

It was not that Irwin had suddenly become some sort of nature fanatic, à la Edward Abbey. He never packed a sleeping bag ("Who, me? Are you kidding?"). Come evening, he'd usually stop at a seedy, roadside motel. He seldom hiked too far off the road. He did not become obsessed by the spare adaptations of plants and creatures, nor did he start reading up on geckos and iguanas, or collecting Indian blankets and pots. It was just this thing of presence. And Irwin's only resources in that regard were still his own perceptions.

"In the beginning I proceeded in a very awkward and obvious way. Say, for example, there are a lot of things that just visually contradict your expectations; they just will not fall into perspective: foreground becomes background, background becomes fore-

ground, or the land seems to stand up on end rather than lay flat the way one logically knows it's supposed to be. So I began simply to mark those events, to put down sightlines, in a way. And I found that there were certain continuing situations: if I returned to them a year later, I could find the same place, and essentially the same energy would be there. I'm not talking about some sort of spiritual or mystical activity. I'm simply talking about my ability to perceive what was going on around me, that there was something very 'tactiley,' tangibly existent in this one particular area, say, which was simply not present two miles down the road.

"So originally I marked these places, quite literally. I laid a small concrete block flush to the ground at the place where I was standing and stretched a stainless steel piano wire out toward the horizon. It might go off a mile; it simply pointed in a direction. And that was the piece. All of which now seems really corny, and I don't do that anymore (although I do still head out to the desert occasionally). I understand why I did that at first, but it soon became clear to me that the mark was a distraction; it was about me, about my identity, my discovery. Whereas all that really mattered in such a situation was the place's presence. In other words, if I'd taken you out there to a place like that, what you would have perceived was yourself perceiving. You would have been the one dealing with it, and my hand would have been a distraction. Furthermore, I suddenly had this terrible fantasy of thousands of artists coming out and graffitoing the landscape with their art world initials. So I stopped leaving traces.

"Still, I had the problem of how any of this could be brought to bear on what we call art. How was I going to deal with these situations? Was I going to take photos? Well, that didn't really make any sense. Make plans, draw maps? That wasn't critical. How about loading people onto buses and dragging them out there to show it to them?" He couldn't do what, say, Michael Heizer was doing around that time, taking such situations and transformations back to New York in the form of giant photomurals in elegant galleries with written accounts and so forth. "Somehow, everything that was really important got lost in that kind of translation. And while I had a certain interest in some of the issues people like Robert Smithson, Michael Heizer, and Walter de Maria were beginning to explore around that time, I had no interest in most of the resultant "earth art," the big, ambitious

projects in which they applied massive technologies to several desert sites and transformed them into art—spiral jetties and carved buttes, that sort of thing—huge drawings, in effect, made out of packed dirt. Somehow to me such art in nature is completely arbitrary. I mean, nature is overwhelmingly beautiful and overwhelmingly aesthetic, and the necessity to change it or alter it is simply not there, except when we start talking about our own identities and our need to dominate and control."

What Irwin ended up doing with his desert situations was nothing. He didn't even take his friends out to see them. "I don't even describe them to anyone." He certainly did not try to transpose them to the galleries in the form of photo installations. Indeed, the comparison with some of Heizer's photomurals is particularly apt, because Irwin, too, was interested in how he might recreate that uncanny sense of presence in a gallery. But rather than literally pasting the desert vista to the walls of such spaces, Irwin chose to absorb the *lessons* of the desert and apply them, on a site by site basis, to each new room whose presence he would be confronting and trying to modulate during the coming years.

CHAPTER 15

Being Available
in Response

Although the desert offered Irwin lessons in presence, it had not solved his problem of how to proceed on a daily basis or how to continue thinking without the use of physical means. "So what I did," he recalled, "simply as a way of getting myself out of the dilemma I was in, was that I said I would go anywhere, anytime, for anybody, for anything. I made myself very available — and I made it for free.

"And I meant just that," he clarified for me the afternoon we spoke about what in the meantime has become known as his "project of general peripatetic availability," a posture he maintained in an active way up through 1976 and which he sustains in a more

limited fashion to this day. "I just sort of let it be known that I was available, in a way like I'm saying it to you. I mean, I didn't put out any ads or anything, but word got around. And you could be, let's say, up at UCLA, and you'd say, 'Well, let's take advantage of that. We'll have him come up and talk to the students.' And that's what I'd do. Or, 'We'll have him come up and do a piece in the patio.' And I would just come and do that.

"There's an important distinction to be made here," he continued, "between organizing and proselytizing, on the one hand, and responding to interest, on the other. I was and continue to be available *in response*. I mean, I don't stand on a corner and hand out leaflets. I'm not an evangelist. I'm not trying to sell anything. But on the other hand, if you ask me a question, you're going to get a half-hour answer. It doesn't make any difference whether or not it's a sophisticated question, only that you have a genuine interest in its properties."

Irwin was available in response, but for a long time nobody asked. Nobody knew what to make of the offer, and Irwin was no help: he didn't have a clue. "Curators would ask me, 'If we invite you, what are you going to do?' and I would have to say, 'Well, I don't know what I'm going to do; I'll just spend some time there and then decide.' They'd say, 'Well, could you send us a plan? What's it going to cost?' Well, I wasn't going to charge them anything for my time (sometimes I'd ask them to pay my fare), but there was still the question of how much materials would come to. In other words, we had no connection, because they kept needing something tangible, and I kept saying, 'I don't know,' which also put into these situations the possibility of failure. I could go to the Walker Museum, let's say, and they'd set up an exhibition with all their catalogues and press releases and everything, and there was a risk that when I got there, I wouldn't be able to come up with anything."

The initial invitations, when they came at all, were primarily for Irwin's presence as a speaker. Slowly, however, interest grew, and by 1972 – 73, enthusiasm had soared to such an extent that Irwin was almost continually on the road, wending his way through labyrinthine tours, traveling weeks on end, for example, from one small midwestern college to another: Iowa, Oklahoma, Nebraska, Missouri, Kentucky, Tennessee, and then on up the Atlantic seaboard and back over to the Northwest. At each stop he

might stay a week, talk with students, contrive an installation, stir things up, and then be gone. For many young art students in the vast middle reaches of this continent during the pale middle reaches of the past decade, Irwin's roadshow constituted a first exposure to significant strains of modernism and minimalism.

As useful as Irwin's appearances were to those exposed to them, they were perhaps more useful to the artist himself. For one thing, they helped keep him grounded—in the world—during a period when his primary researches were becoming increasingly abstract and ethereal. "The ideas I came to be dealing with during that period were getting real obscure, even for me, to the point where I was beginning to wonder exactly what and how I practiced in the world. There were some critics who from a political perspective attacked that obscurity as a kind of elitism. That charge bothered me, and I tried to address it through this posture of availability. To me, the crucial difference between obscurantism and elitism is availability. Elitism is the private use of ideas for personal gain or power. And although the kind of inquiry I was doing at times seemed fairly rarefied, I made every effort to anchor it back in the world by staying open to every possible invitation.

"The thing about what I do is that I allow myself total excess in a way: I'm totally self-indulgent in terms of my art, and I'm becoming more so. I do things which from any social or political view are utterly outrageous. I mean, they absolutely ignore all the social issues of the day. And there are times when I feel the discomfort of that, too. But my way of balancing that out is that there's one thing I can do that has immediate social value, and that has been this kind of running talking with people. So I do that for free. Because I don't want to put economics on it at all. That was a particular issue on campuses when I first started traveling, because those were the years of all that tension, and the first thing people wanted to know was what you were doing there and how much you were making: 'Oh, they're giving you $1,000, well. . . .' So I simply eliminated that: 'I'm just here, period. You can either ask questions or not ask questions, I'm not getting paid, and I've got no ambitions for you other than to encourage you to do what you're doing.'

"That's the one thing I can contribute socially at this point. So I do it. The art I am pursuing gets very obscure, the kinds of

questions I'm asking may not have any tangibility in my lifetime. Yet I still live in the world, and I have feelings and concerns and interests. So this is a way of bridging that gap. But I've done it in a way that hasn't compromised the art."

It's not just Irwin's sociopolitical conscience that gets salved through this peripatetic project; although he's loath to admit it, Irwin is sometimes troubled by the isolation his project of inquiry requires. Through these forays, he is allowed a sense that his work has a certain immediate resonance in the world, that he is not just spinning in some vacant metaphysical corner. He does not need much of that kind of resonance, but he does need some, and these travels give him all he needs.

Moreover, sometimes it is through the conversations which his talks provoke that Irwin achieves breakthroughs in his own inquiries. For although his researches have drifted into zones of ever greater complexity and sophistication, in another sense he has stayed in the same region ever since he began, which is to say right at the frontier of everybody's common sense and simple perception. It is a dialogue that anyone can enter, a research in which every perception is useful. Often Irwin's audiences include curious onlookers from all sorts of tangential disciplines, and a simple comment from one of them can redirect the course of Irwin's thinking for weeks. And vice versa. Irwin now finds himself being invited to symposia on medicine, psychology, nuclear physics, systems analysis, and any number of arcane interdisciplinary pursuits. These meetings in turn lead to correspondences (principally telephonic) which last for years and form a central component of Irwin's ongoing researches.

A central concern of the installations Irwin attempted most places he visited was presence; each could only be experienced in person. This, too, required Irwin's widespread availability. "The kinds of things I'm doing now don't exist secondhand; you either get to see them firsthand, or you don't get to see them at all. I can't talk to people in Iowa City about what I did in Minneapolis; I have to do it in Iowa City. Of course, the flipside is I can't do in Iowa City exactly what I did in Minneapolis."

Indeed, the kind of work Irwin now wanted to produce could only be done "in response." He was no longer manufacturing objects that Iowa City or Minneapolis could subsequently choose to display. "That was the difference. When you set out to make an

object, you sit down and make this new thing from scratch, whereas what I was now interested in was the nature of things as they already were. Given any new site, I would respond to it, modulate its presence; but first I had to be invited in. Although part of my work on the road thus fulfilled a communicative and social function, at another level I was picking up all kinds of impressions which I was then feeding directly back into my ongoing research."

CHAPTER 16

Some Situations
(1970 — 76)

There are at least two problems in writing about Irwin's art since 1970. To begin with, if the driving, focused progression of Irwin's aesthetic development between 1957 and 1970 could be likened to the narrows of a surging river, the work after 1970 is instead oceanic. One loses the sense of dynamic evolution and transformation from year to year. By 1970 Irwin had arrived at his lifethemes — the explication of presence, an awareness of perception — and everything since then has consisted in an ongoing charting of those waters. Yet we can no longer rely on chronology to order the development of thinking. There is a certain evenness of curiosity; the ocean is vast, and Irwin's explorations

move through wide, recirculating sweeps. There are dozens of installations, and, taken together, they limn a consistent concern. They don't so much lead one to the next as they fold, one inside the other, like nothing so much as the very process of thinking.

The other problem in describing Irwin's installations of this period is that you had to be there. Perhaps the central concern of all these installations has been their presence—temporal, spatial—such that any descriptive report of their character or intention necessarily betrays their essential nature. That which in its most fundamental essence was *here-now* in the reporting undergoes the inevitable fall into *there-then*. By even descending into the past tense—and as I write, virtually none of Irwin's pieces from the past decade still exists—I find myself caught up in a syntactical contradiction. Irwin would only smile at my dilemma, since it constitutes the writerly analogue to the core paradox that he himself has been living on a daily basis ever since he abandoned his studio.

"There are such sophisticated systems of orthodoxy," Irwin said to me one afternoon, "and they're so beautifully developed—not just the orthodoxies of painting and sculpture but the superstructures of museums, galleries, collecting, criticism, and so forth—that when you decide to try and operate outside of those systems you really have a problem, because everything is set up to induct that which is already within the paradigm or within the orthodoxy. And if you should ever actually question these orthodoxies, the first thing you have to face is that there actually is no process by which your information can in fact be inducted. So you're forced to operate in a contradiction, which means that if you want to deal with the culture at all, you will have to deal at least in part with its present currency. Thus, for example, I'll go out and engage people in dialogue, although on another level dialogue is a complete contradiction to what I'm really interested in, which is the process of unmediated perception. Or I'll use a museum space to try and show the irrelevancy of the museum situation. You have to use all the currencies, all the processes that are already operative and argue against their inclusiveness even while you're using them, which is a funny place to be. And it's not always a convincing argument, since you're contradicting yourself even as you're making your case."

It is part of the peculiarity of Irwin's current situation that he

contaminates anyone who tries to write about his activities with an equivalent contradiction. Critical language flounders in a comedy of inadequacy; as with Irwin's work, it can only be hoped that such internal riddles give rise to pause.

Having said that, it is still possible to attempt a survey of some of the types of work Irwin has engaged in over the past decade. This is perhaps best accomplished by considering in detail a few specific situations (not necessarily in chronological order).

In a whole series of situations throughout these years, Irwin had recourse to what might be seen as his favorite medium of the period: whitish, translucent scrim. He'd first encountered the material in Holland, while supervising installation of some of his discs for a show at the Stedlijk Museum. "You walk down the streets in Amsterdam," Irwin recounts, "and they're all lined with these terrific windows which they take incredible care of. And it seems like every lady in Holland makes curtains out of the stuff."

What particularly fascinated Irwin in the scrim material was its capacity to give shape, as it were, to light. The material was transparent and yet not quite—light seemed to catch in the interstices, to catch and hold, to take on volume. Irwin ordered bolts of the material, and over the next several years there was a regular traffic in scrim, Amsterdam to Los Angeles, and then from Los Angeles to wherever Irwin was working.

Its possibilities seemed unlimited. For a show at the Pace Gallery in New York, for example, Irwin stretched a taut "soft wall" of the material, floor to ceiling, twenty-four inches in front of and parallel to the rear gallery wall. At the Walker Art Center in Minneapolis, Irwin contrived a "Slant Light Volume" at the far end of a low and wide, dark hall by stretching a sheer scrim at an angle of roughly 45 degrees from the ceiling, away from the viewer, toward the floor, and then allowing an intense white light to fall on the far side. There were countless other scrim modulations, but they all shared in this eerie effect of somehow rendering light palpable.

But Irwin's seventies' repertory was far from limited to the deployment of scrim. Often the effects he sought were more subtle, and his transformations, less obvious. One such case occurred in 1971 when Irwin was invited to participate in a four-artist show at the UCLA art galleries entitled "Transparency, Reflection, Light, Space."

"In preparation for that show," Irwin recalls, "I spent a lot of time looking around the gallery, and for some reason I couldn't figure out anything to do in the formal spaces. Not that anything was wrong with them; I just couldn't get a handle on what was unique about those rooms, if anything. Then I ran into a utility stairwell which presented a very interesting situation. There were a couple things that were very nice about it. One was that while the front stairwell was very formal, with floating steps and everything, and was the architect's attempt to be very 'designed,' very artistic, in a way—I didn't like it particularly—this utility stairwell was simply that, a utility stairwell. It had the minimum. It met all the legal requirements, period, and nothing else. How steep it was—I don't think it could have been any steeper. It had those kind of institutional railings. The corners had an angle on them. It was the simplest kind of concrete shaft; I mean, in terms of architecture, there was no attempt to modify or make that space interesting at all. Institutional light fixtures, the whole thing, just by the book.

"But there was one funny thing about it: the architect, in wanting to continue his illusions about the building from an architectural point of view, did not want the exterior facade of the building to stop at a certain point; so he continued it on to include this utility stairwell, which was very funny, in a way, because it had nothing to do with the stairwell at all; it had all to do with this idea about facade. In other words, he ran this series of windows the entire length of the building so as to fit his modular conception.

"But the unintended result of all of that was that that utility stairwell was quite a nice place. One of the things that was very nice about it was that all the light in there was reflected light. Only in the morning was there a little slit of direct light, but most of the light was reflected. And interestingly enough, in this situation it was reflected off an awful lot of different kinds of surfaces—a very red building across the way, some very strong green grass; it depended on the time of day you were there as to the color the stairwell was. I mean, it was subtle. Most people would have probably said it was white all the time; but to me, you'd walk in there, and at a certain time of day it was violet, and another time of day it was green, and another time of day it was a subtle mixture of colors. It was a very loaded kind of situation.

"So I did a lot of things in that stairwell. I changed a lot of

things. I neutralized things and blocked things and removed things. I fooled around with the covering of the baseboard; there was a situation in terms of one of the windows where I made it look as though it continued where in fact it didn't. I covered up one section of one window so that the far corner looked as if it were angled as all the other corners were angled. All sorts of things like that, which no one really saw—which, by the way, they weren't intended to see; it was just the presence of the situation which I liked.

"Then, I think, I probably made an error, and it probably had a little bit to do with my not being on top of the situation. I put a piece of scrim material up near the second floor, up high, and stretched it out flat. It did a nice thing; I mean, it did work in the room in a way. But in a way it also defeated me in the sense that the few people who did deal with the stairwell at all finally said, 'Oh, that's it,' and pointed, dealt with the scrim as though it were the art; whereas it was simply a device that I had used hopefully to try and get the situation maybe a little more strongly identified. Without the scrim I don't know if anybody would have seen it— maybe one or two people. And a curious thing, when the show eventually came down, I went back there and found a number of the things which I had done had not been removed. For some reason they either didn't notice them or didn't know that I had put them there. But in a funny way, even with a lot of the things removed, that stairwell still was doing exactly what it did so well. It didn't need my scrim. And in a funny way, maybe it didn't need any of the details I added. What was really essential was going on there anyway."

The point of these exercises, it sometimes seemed, was to achieve the maximum transformation with the minimum alteration. Or, at any rate, it was on that basis that Irwin often came to gauge the success of his installations, and on that basis that he cites his 1975 show at the Chicago Museum of Contemporary Art as one of his most accomplished.

The Chicago show included a retrospective selection from Irwin's entire oeuvre as well as two on-site installations. One of these comprised a gorgeous, complex scrim modulation, running (V-shaped) the length of a large hall; the other, tucked away in an unpromising space in the back, was considerably simpler.

"We had pretty much finished installing the show," Irwin

recalls, "when on that last day I began to try and figure out what could be done with this awkward space in the back. Basically, it was a three-walled, rectangular space, which you entered at one end where there was simply no wall; it was just an open-ended room. And the space had three fairly interesting qualities. First of all, the light diffused out of this bright, hivelike modular ceiling, which was actually kind of ugly. Secondly, in the center of the space was this square post left over from the previous uses of the building (it had been a bakery and as such was not particularly designed for aesthetic appeal, and this column was just a structural support). That post was totally arbitrary; it sat dead in the center of the room and pretty much blocked any view that you might have of the walls. Any time you hung a show, for instance, you had to look around this column to look at the paintings. So this room had a white ceiling, white walls, a whitish floor, and a white pole in the middle, and the only other element in the room was the kickboard, a molding which skirted the edge of the three walls, the kind of thing they have in most museums so that when the janitors mop the place they don't get the wall dirty; and this baseboard was painted jet black. So you had white and white and white and white, and one very strong six-inch black line going around and dividing the space, which is about as powerful an element as you're going to find.

"What I did in that situation is that about six feet into the space I took a piece of black tape, about five inches wide, and laid it out across the floor, horizontally, so that it picked up the black line and created a rectangle, using the three sides of the kickboard and then drawing it across the front. And that was it."

Roberta Smith, an excellent art writer who experienced the Chicago installation in person, tried to describe its impact:

The resultant black rectangle was not what you "looked at"— there was actually nothing to focus on—but soon it brought the space into focus with a distinct visual snap. From inside, the light in the area seemed different, more substantial, and the wall color began to shift ambiguously. From outside the area, the tape seemed to lift the plane of the floor upward in your field of vision, and it also made the room seem wider and shallower than it really was. Consequently, a person moving toward the back wall was soon out of whack perspectively, because the figure receded faster than the room. The area was transformed into a separate volume; it seemed to lift out of the museum and

become so exclusively visual that it could have been almost any size: it could even have been a small boxlike model of Renaissance space. It is hard to know whether the tape was actually doing all of this or whether, having become visually conscious enough to see the black rectangle, you simply continued to experience the room with this heightened awareness.*

Irwin, for his part, recalls how, perhaps because of the inclusion of his earlier works in the Chicago retrospective, "people approached that room in the back very unsure of the ground they were on. Some people would not cross the line; many people weren't sure what the line physically represented—a lot of people actually stuck their hand out to make sure they weren't going to bump into something, as if there were a glass pane there, or as if the room space were somehow solid. The fact of that single swath of tape having that much impact was very interesting.

"Also, when you watched someone walk across the line into this space, it was very interesting to see how aware you were that they diminished in size, which is something that of course goes on all the time with our vision. Most of the time we don't cognate on it; there are too many other distractions. But here you become really conscious of the people changing in size. And when you were inside the space, you were very conscious of just that, of really being inside a very specially defined situation.

"I think probably the best definition of how the piece worked, though, is that of the ten people who worked there, and who had been working there for five years or more, four of those people asked me if I'd built the post, this post that had been in the room all along. Which is simply saying that they were seeing this room for the first time."

Irwin smiled, glowed, relishing his triumph. "Now, what I did," he continued, "had a minimal physical or intellectual being, no literate meanings, no symbolic references, and no art world contents; and yet you were clearly conscious of a presence. When you turned around to walk out of the space, you suddenly became aware of the post in the next room, which you hadn't been aware of before. The point is you became aware of all those so-called incidentals or those things which were real aspects of the room but which you had canceled out by some mental process such as we've talked about before, on a scale of some kind of meaning. So

*"Robert Irwin: The Subject is Sight," *Art in America* (March 1976): 68–73.

that one strip of black tape, I think probably almost more than anything I've ever done —because it had so little being on a physical level; it had so little importance in terms of objectness, and so little demand in terms of an idea (there was nothing really interesting or clever or complicated or difficult in terms of the act itself, but the act had a tremendous effect on what went on around it, a tremendous effect on the area that it acted in, and a tremendous effect on the people that came and participated in the situation)—that was, I think, maybe the best trade-off that I've had so far."

Compared to some of the work he was doing a few months later, even the spare swath of black tape in Chicago seemed heavy-handed. As his principal contribution to the United States Pavilion at the 1976 Venice Biennale, Irwin merely outlined, with a piece of string stretched into a taut rectangle, the dapple of tree-filtered light on a patch of ground. At that point he still felt he needed the string, not so much because he needed to leave a trace of himself as because he needed to mark that particular corner of ground as in some sense a heightened field. But many people mistook the string itself for the work of art ("When I point my finger at the moon, don't mistake my finger for the moon" is a Zen aphorism that Irwin is fond of citing). By mid-1976 Irwin himself was prepared to jettison —along with figure, line, focus, permanence, and signature —the very requirement of any overt activity of making as a necessary prerequisite for artistic viability.

CHAPTER 17

Reading and Writing

Not too long ago, I was speaking with a woman who had had occasion to interview Irwin during the mid-sixties, and she mockingly recalled what she referred to as his "macho ignorance," the way, for example, he would have had her believe that, despite the accomplished minimalism of his dot canvases, he had never heard of Kasimar Malevich. She didn't accept the pose then, and she still doesn't. Another critic who spent time with Irwin during the late sixties (Jan Butterfield, whose valuable transcripts were subsequently published in *Arts Magazine*) recently related to me how she and Irwin had once gone several rounds over her attempt to defend the validity of philosophic and critical speculation.

"Look," she told the headstrong artist, "there are other ways to explore this field of inquiry which you are probing—philosophy, aesthetics, criticism. . . . They may not have value for you, but they are not without value." Irwin, she claims, dismissed her contention out of hand.

The fact is that it is entirely plausible that as late as 1965 Irwin was still utterly oblivious to the legacy of Russian suprematism. And, indeed, it wasn't until the early seventies that Irwin began to entertain the possibility that the tradition of philosophic speculation might have any bearing on his own concerns. Once this tendril of possibility drifted into his purview, however, he grasped it with singleminded enthusiasm.*

Descartes, Hegel, Kant, James, Merleau-Ponty. . . . During the mid-seventies, whenever he was not responding to lecture invitations or contriving on-site installations, Irwin was in Westwood, poring over the classics of the modern Western tradition: *The Phenomenology of Mind, The Primacy of Perception.* . . . One afternoon a friend told Irwin the story of how Sartre first heard about Edmund Husserl's phenomenology: it was early in the thirties, and Sartre, fresh out of graduate school, was at a cocktail party conversing with a friend who had just returned from Berlin. "You see, my dear fellow," this friend explained to Sartre, pointing to the glass of apricot brandy that he had just procured, "if you were a phenomenologist, you could take that cocktail and make philosophy out of it." Sartre was on the next train to Berlin. Irwin's friend pointed to the Coke Irwin was cradling in his hands and assured him that Husserl could help show him how to transform it into aesthetics. Irwin got up and headed straight for the library. Several months later, at the opening of one of his finest installations, a philosophy professor walked over to Irwin and whispered, "This place is crawling with Wittgenstein." The next morning Irwin was delving into the *Tractatus.*

*The rest of this chapter, perhaps the most technical section of this book, makes extensive use of a vocabulary and outlook derived from phenomenology, the philosophy of human experience that has grown in large part out of the work of Edmund Husserl (1859–1938) and his followers. Some of the terms that arise tangentially in my exposition of Irwin's thinking, words like *originary, bracketing, typification, lifeworld,* and *precogito,* draw on a rich set of layered associations in the work of such phenomenologists as Husserl, Alfred Schütz, Jean-Paul Sartre, and Maurice Merleau-Ponty. Readers who might wish to pursue some of these associations are invited to consult the bibliographic note at the conclusion of this book.

The thing that first attracted Irwin to these thinkers was not so much the content of their arguments as the scale of their ambition. "The idea of being reasonable," he rhapsodized one afternoon, "to me that's the real jewel in the human crown. And part of being reasonable is being responsible. To think something through thoroughly without the compromises of personal ambition or the comforts of personal bias. To tackle something mammoth and then to accomplish something of real consequence, that's the only thing that matters: fame, money, position, none of that stuff comes near. And when I see someone accomplish that, or when I see someone make that kind of commitment, whether they succeed or not, I'm touched by that. I'm touched by somebody who really puts it on the line in terms of making that kind of contribution and taking that kind of responsibility. When I first read Hegel, that was my first take on the thing. I was really touched by the aspiration, *sentimentally touched* by the fact that somebody would aspire to something so huge. Or like Kant: I mean, what a spectacular effort!"

The ambition lured him, the reasoning held him. He became increasingly rapt. For months at a time he abandoned his art-world interactions altogether. You could find him, almost any day, either by the falafel stand in the village or in a shady alcove on the UCLA campus, a pile of well-thumbed volumes arrayed by his side. He read with heartrendering deliberation. Five, six, eight hours a day: two, three pages. He stubbornly puzzled over each turn of phrase, never giving an inch, evaluating each move—"I'm not going to let him get away with that," he crowed to me one afternoon, catching Wittgenstein in an apparent inconsistency, "no way. This guy's real crafty: you really gotta be careful"—as if it were a poker game. Next to the opened volume he kept a notebook; in his right hand he clutched two felt-tip pens, a black and a red. The black was for recording what the philosopher said, the red for his own comments—often for his refutations.

"Ed Wortz once made me conscious of how I handle information," Irwin commented to me one afternoon, recalling days of their collaboration during the Art and Technology period, "how I hold it all in a state of suspense while I examine it before I select what I will let into my life. Because for me, ideas are very potent elements that can radically change your life. Nothing is the same once you accept an idea, and you can never return to the place

you left. So I proceed very cautiously in the realm of ideas and information."

Husserl, Wittgenstein, Sartre, Schütz. . . . It was not the most elegant dialogue. The style of discourse was utterly foreign to Irwin, and his steps were often clumsy, lurching, leaden. He mistook passages, shaved nuances, mauled subtleties. But progressively he improved—and more fundamentally than that, like a craftsman at his lathe, he honed his own thinking. His grappling with these books was not so much an occasion for the correct elucidation of the course of Western philosophy as an adjunct in the continued refining of his own inquiry. In this context it did not matter that he continually called positivists and behaviorists "structuralists" or Maurice Merleau-Ponty, "Ponty." What mattered was how he distilled a particular tenor of thinking into his own.

Fired by his reading, Irwin began to try to articulate his concerns through writing of his own. The texts that resulted, notably the intricate "Notes Toward a Model," which he offered as the core of the catalogue for his 1977 show at the Whitney, were often as dense and turgid as his talks could be swift and clear. Indeed, many observers marveled at the curious transformation. Irwin's prose occasionally gleams with aphoristic insight (for instance, "Human beings living in and through structures become structures living in and through human beings"*), but more often the writing labors under the exquisite care that Irwin brings to the task. Formulas are offered, then modified, confounded, convoluted. Irwin is not easy to read, whereas he is an unmitigated delight to listen to. One explanation for this contrast may lie in the character of Irwin's presence in each situation. When he speaks, he speaks in response, to a particular audience, within a specific context. When he writes, by contrast, he must avail himself of an utterly anonymous, typified medium—indeed, typography. He earnestly buttresses every assertion with his anticipations of every conceivable objection. His sentences clot. Addressed to no one in particular, his language tends to become disembodied. Ironically, his passionate defense of the experiential becomes mired in his intellectualizing style — something that seldom happens with his speech.

*"Notes Toward a Model" (New York: Whitney Museum of Art, 1977), p. 29.

Problems of style notwithstanding, however, it was during this period of intensive reading and writing that Irwin began to frame the intellectual superstructure for the argument he had heretofore pursued across the naive, purely intuitive terrain of his art. The most fundamental assertion remained that of the primacy of perception. Irwin has become increasingly convinced that perception precedes conception, that every thought or idea arises within the *context* of an infinite field of perceptual presence which it thereupon rushes to delimit. In this conviction, Irwin conspicuously dissents from a central tenet of Cartesian philosophy. Descartes argued that the fundamental, originary moment, when everything else had been stripped away, occurred in the *cogito: Cogito ergo sum.* I think therefore I am. Thinking preceded and defined being: mind preceded and defined experience. For Descartes, it is the thinking mind that perceives. Irwin, by contrast, feels that prior to the Cartesian cogito there is, as it were, a "precogito," which is the originary *pre*mediated perceptual field, and that all thinking has designs, lays designs, as it were, across this field. Irwin's perplexing challenge to us is that we think about that endless moment of precognitive perception.

Irwin's most sustained theoretical exposition to date of the foundations for this contention comes in the middle portion of his Whitney essay, "The Process of a Compounded Abstraction." Over five densely articulated pages, Irwin traces a sixfold progression from perception through conception, form, formful, formal, and on to formalized. The text requires a more careful consideration than this context allows, but the six stages can be summarized: Irwin defines *perception* as the individual's originary, direct interface with the phenomenally given. We are speaking here of the overbrimming synesthesia of undifferentiated sensations—they are not even defined yet as sounds versus colors, and so forth—they exist as the plenum of experience. With the next stage, *conception*, the individual (who now, for the first time, arises as a being differentiated from his surroundings, a cogito, an "I") through the operations of his mind isolates zones of focus: this splash, that tree, that horizon, this car, and so forth; and yet, at this stage, though isolated, these zones remain unnamed. Naming comes at the next stage, *form*, where that isolated zone of focus, that tree, now becomes "that tree." With naming, and myriad parallel operations, it now becomes possible for the

first time for individuals to communicate with each other; community comes into being. At the next stage, *formful*, these named things begin to be deployed through relational patterns: day and night, hot and cool, loud and soft, and so forth. At the next stage, *formal*, these patterns in turn begin to be reified, to become standardized into the more efficient deployments of social usage: clock time, calendars, color wheels, temperature readings, and so forth. At the final stage, *formalized*, it is these standardized measures that begin to dictate our behavior, a behavior that has now become utterly estranged from direct perceptual experience. Thus, for example, we shuttle ourselves through a world of nine-to-five jobs, daylight saving time, thermostatic controls, and so forth.

This process of compounding abstraction is not so much a temporal progression as a phenomenological one. At any given moment, for any given individual, all six phases are operating simultaneously, and yet the earlier phases exist prior to the later ones in the sense that they ground them, they constitute the source out of which the more compound stages emerge. In this sense, perception is originary, the foundation of everything. And yet, like the bottommost stratum at an archeological dig, perception is the hardest to reach.

But Irwin's theory of compounding abstraction is more than a descriptive epistemology: indeed, it grounds his entire aesthetics and accounts for the destiny of his art. In exploring the movement from an immediate perception of chaotic sensations through their conception and formation, for example, as a palisade at sunset, and then finally to their formalized characterization as this particular palisade at 7:52 P.M. Pacific Daylight Saving Time, Irwin sees a complete re-presentation of the whole at every stage. He further argues, invoking Wortz's law, that "Each new whole is *less* than the sum of its parts," that what is perhaps gained in practical efficiency and social utility is lost in real information. It is precisely because Irwin insists that each progressive abstraction from perception to formalized truth implies a loss rather than a gain that he sees his own progressive deletions of the formalized requirements of the art object as a gain rather than a loss.

With his retrospective at the Whitney in 1977, Irwin was to take that progression to Point Zero . . . or, as he might have preferred to characterize it, to Point Infinity.

CHAPTER 18

The Whitney
Retrospective:
Down to Point Zero
(1977)

As the elevator doors eased open onto the vast, empty room on the fourth floor of the Whitney, you were immediately in the thick of it, the thin of it. For a fragile moment, all your expectations were suspended, and the world itself seeped in. Already as you walked out of the elevator, you were triangulating, calibrating, trying to get a fix, to mend the tear in the fabric of your mundane anticipations. But even as you were doing so, you were newly aware of the way in which that is something you do all the time. Nor was the room all that easy to put back together again: the optics were slightly skewed, such that just as you began to figure out how the effect had been achieved, your calculations were

melting in the uncanny undertow of immediate perceptions. The only light was the natural light of day streaming in from that large, peculiar window over to the side and spreading the length of the hauntingly sheer scrim that, suspended from the ceiling down to eye level, bisected the room longitudinally. Also at eye level, a thin black line skirted the walls of the room, describing a huge rectangle and then flashing out along the base of the bisecting scrim. The pristine scrim was by turns utterly transparent and then utterly opaque, both at the same time, but then neither at once. As you walked around the space, under the scrim, into the corners, along the walls, the room itself seemed to stand up and hum. Things that had always been there—the even, modular hive of the ceiling; the dark, rectangular grid of the floor—you noticed as if for the first time. There was a sense of great excitement in all of this, but at the same time, an evenness, a lightness, almost a serenity.

Yet, some people did not get it at all. The elevator doors slid open; they peered out, stepped back in, pushed the button, and were gone. "When people walk into a gallery where I've installed some of the kinds of things I've been doing recently," Irwin commented to me over Cokes in the Whitney's basement coffee shop the morning after the show opened, "a lot of people just say, 'Oh, it's an empty room.' The question then, of course, is emptied of what? What they do is come into this room with expectations and deal with whatever it is they think the room is supposed to be occupied by. What they are indicating by saying that it's an empty room is that all the things going on in that room, all that physicality in that room, somehow does not exist for them. For actually the room is not empty at all. On any kind of perceptual level, it's very complex. It's loaded with shapes, edges, corners, shadows, surfaces, textural changes. . . . What I'm really trying to do with these things is draw their attention to, my attention to looking at and seeing all of those things that have been going on all along but which previously have been too incidental or too meaningless to really seriously enter into our visual structure, our picture of the world."

Many critics did not get it at all, either. As had been the case with most of Irwin's work since he undertook his sequence of progressive reductions, there was an unfortunate tendency among some art cognoscenti to misread the empty room as either

a nihilistic dadaist gesture or a whimsical conceptual stunt. In his somewhat high-strung review in the *New York Times*, Hilton Kramer blasted the Irwin show as "a repudiation of art and life."* And almost everyone who wasn't misreading the room as a nihilist affront was mistaking it for the focal point of the retrospective (in a few cases, critics restricted their reviews entirely to an analysis and celebration of the room).

For Irwin, however, the room on the fourth floor was intended as only one stage in a progression of aesthetic discovery. The Whitney had been offering him a retrospective for some years, but Irwin had deferred until it became possible to transform the usual ritual of historical documentation into a fresh opportunity for aesthetic praxis.

Over to one side, to be sure, there were the retrospective rooms (actually arrayed beyond the wall on the far side of the large scrim room) with representative offerings of abstract expressionist canvases, early and late lines, dots, discs, and columns. Out of this progression emerged the large empty space. But, as Irwin observed to me that morning, "That fourth floor room, that room for me is seven years ago. That room is merely a recapitulation of the piece at the Modern. It's maybe a little better realized, because I've had more practice, and it sets up some interesting thematic parameters for the rest of the show, but the only thing I'm interested in *now* is the stuff it opens out onto."

Irwin's true aspiration for the Whitney project was laid out in one tight paragraph that he placed innocuously on the wall on the ground floor opposite the elevator (most visitors noticed it, if at all, on their way out):

New York Projections, this Whitney Museum project, is intended to act out (in on-site installations), illustrate (in aerial photographs of New York), and develop the argumentation (in the catalog essay) for perception as the essential subject of art. Assuming that context is not only the bond of knowledge, but the basis of perception/conception, this exhibition has been developed contextually. By holding the most essential contextual thread (those elements taken from perception and used in "art," i.e., line, shape, and color, etc.) and removing in turn each of the additional contextual threads (imagery, permanence, method, painting, sculpture, etc.) which have come to be

*"A Career That Rejected Studio Art," *New York Times*, 8 May 1977, Section D, p. 25.

thought of as usual in the recognition of what is art, we arrive at the essential subject of art. In effect, this is accomplished by a principal change in the relationship of the indicator (object of art) and what is indicated (subject of art), from their acting as one in the art object to their being one in the aesthetic perception of the individual observer.

The Whitney show invited the viewer to recapitulate the process (the progressive removal of contextual threads) which had brought Irwin to his current phase and then invited that viewer to join the artist in taking the process to its next stage. For years already, Irwin had harbored doubts about the compromise of working in museums, because, in effect, all that happened in such situations was an expansion of the frame—from the canvas to the entire room, or even the entire museum—without a truly fundamental suspension of the posture of focus or frame itself.

Therefore, early in 1977 in Fort Worth and now at the Whitney in New York, Irwin used his museum pieces to raise questions that were then aimed at the surrounding world into which the major work had already broken out. Lovely as it was, Irwin's Whitney installation was primarily intended to function as a catalyst, and a catalyst in two ways, one thematic and the other attitudinal. The great floating rectangle and the way it in turn brought out the modulation of the ceiling and the reticulation of the floor established the predominant theme of the *grid;* and just as many museum visitors experienced, as if for the first time, the hegemony of right angles within the room, so they were now invited to translate this reclaimed vision out into a city where the grid of clean horizontals and verticals is so pervasive as to have become almost invisible. Beyond that, the room seduced the sympathetic observer into a certain attitude of perception, a posture of heightened attention, and this heightened vision was in turn available for transposition into the world. Walking out of the museum onto Madison Avenue, Sotheby Parke Bernet diagonally across the street looked different from the way it ever had before; both it and the look had been reclaimed.

This movement outside was not just implicit, however; Irwin himself led the way with his two on-site installations and a sequence of highly suggestive aerial photographs of Manhattan Island. Once again, the two on-site installations were not so much interesting in themselves as they were as penultimate steps in a

line of aesthetic argumentation. This fact was made especially clear in the sequence of unfolding images in the catalogue to the show. The photograph of Irwin's "Black plane—Fifth Avenue and 42nd Street" (Irwin spread black paint over the entire square defined by the crosswalks at that intersection) was immediately followed by an extraordinary helicopter shot entitled "Black planes—Shadows, Park Avenue" (in which Park Avenue is revealed as a succession of black building shadows and thin strips of intervening sunlight). The photograph of the "Line rectangle—World Trade Center" (a ground view looking up at Irwin's rope rectangle defining the space between two buildings and the sleek skyscraper bracketed beyond them) was in turn followed by an aerial photograph of "Rectangle—Mercury-vapor lamps, Central Park" (an image of the vast luminous rectangle of street lamps bordering the park at night). It was difficult to spend too much time considering Irwin's two on-site installations. They were metastable, instantaneous pieces. It was as if Irwin were saying, "I can paint this square here at Fifth Avenue and Forty-second Street, and doing so creates a remarkable perceptual space, but why bother? There are hundreds of shadow squares just as remarkable all up and down the block. The point is to attend to *them*."

And that, of course, was just about as far as you could go on a particular line of aesthetic inquiry, for it implied not only the dematerialization of the art object, but the virtual evaporation of the artist's role qua artist. And Irwin was willing to say as much. Sitting there in the Whitney's coffee shop, Irwin pointed through the glass wall up at the play of shadows on a building facade across the street. "That the light strikes a certain wall at a particular time of day in a particular way and it's beautiful," he commented, "that, as far as I'm concerned, now fits all my criteria for art." At the terminus of Irwin's trajectory, when all the nonessentials had been stripped away, came the core assertion that aesthetic perception itself was the pure subject of art. Art existed not in objects but in a way of seeing.

And that, for a man who had spent twenty-five years honing his vocation as a practicing artist, had some fairly profound implications.

A few months before the Whitney show, Irwin described his situation in terms of a tense, if coy, analogy. "It's like I'm on the

trapeze now, and I'm swinging in the dark. Everything feels correct, and I'm telling myself that at the top of my swing, if I let go and reach out, there'll be another rung out there, and I'll just swing off on that one. But only a fool lets go and reaches out until he's somehow thoroughly weighed the consequences of letting go."

A few days after the Whitney show opened, back in Los Angeles, Irwin seemed satisfied with the weighing. He seemed entirely at ease, mildly curious as to what would come next, but content with the possibility that he might have just staged his last gesture as an artist.

"The issue of my possibly no longer being involved in the art world is not a really complicated one for me," he said. "I don't like the art world very much anymore; it's not what I thought it was; it's not nearly as interesting as I thought. I'm not faulting anyone or anything. It's just how I've come to feel. I don't know what else I would do exactly at this point, but I'm not wedded to that world at all anymore."

At one point in our conversation I asked Irwin, given all of that, why he had gone to so much trouble preparing and realizing his Whitney project, and he smiled in reply: "Let's just say that show provided me with an opportunity to mark an x at the point where I jumped off."

CHAPTER 19

Since the Whitney: Return to the World (1977 – 81)

Almost three years had passed since the Whitney opening, and we were talking in his Westwood study. His work table was brimming over with architectural plans, aerial photographs, topographical maps. Mailing tubes were arrayed along the back wall, prepared for dispatch to places like Dallas, Columbus, Berkeley, Lake Placid, Cincinnati, Lawrence, New York City, and Seattle. Irwin was only in town for a few days; then he was going to survey a new site in Houston. Our conversation was interrupted by calls from Washington and San Francisco. Over the past six months, he had submitted proposals for massive, permanent on-site installations at over a dozen locations, easily the most ambitious undertakings

of his career. I asked him what had happened, I thought he had been preparing to jump off the ledge. "Ha!" he laughed. "Let's just say I hit an outcropping about ten feet down." He was palpably pleased with the image. "It was great—real dramatic and everything. I looked good going over the edge, looked good to everybody behind me, but I hit this rock ledge about ten feet down, and all that happened was I scratched myself up a little. . . ."

The question, though, was a serious one, and one Irwin had been thinking about a good deal. In trying to account for the transformation, Irwin recalled the example of Marcel Duchamp. ("Duchamp bluntly illustrated that any object could be art if so called," Roberta Smith wrote back in 1976. "Irwin's work has been suggesting, with increasing insistence, that any situation is art, *if so experienced.*")

"When Duchamp reached a certain point," Irwin explained, "he just stopped, and theoretically everybody had the presence of Duchamp having stopped. In one sense we two were very similar at that point. Actually, of course, as we now know, Duchamp didn't in fact stop, he couldn't; secretly he continued doing things in his closet, right up to the very end. But even taking Duchamp's cessation seriously, there are other possibilities at that point. And one of them is that that thrust, that progression, is something which, like a wave, comes again and again and again. You step back and you start over and you do it another way, taking it down to the same point, and then repeating. And each time it's articulated, it becomes more visible.

"After the Whitney, I might have just disappeared, and in a way that would have been nice. But as it turns out, I couldn't. And maybe it's for the same reason I've never been comfortable with the argument from certain spiritual quarters about enlightenment. I don't doubt that those people devoted to Zen and yoga, the krishnas and all of them, do attain an altered state of consciousness, that they are in a different place, and in a sense a nicer place. *But this is not an enlightened world.* And the world always draws you back.

"The fact that I can go off and stand there by myself just thinking for two hours or two days or two months doesn't negate the fact that in two minutes I'm going to have to drive a car, listen to the news, buy a Coke, and every one of those things draws me back into the world.

"There's a tendency to think that the ordinary has been weighted down by all the biases which ensnare it, but in another sense, it was never part of those biases. The presence of something, anything, everything, is untainted. The ordinary, could we but see it, is just as extraordinary as the highest consciousness imaginable.

"And in a way, the Whitney, far from launching my disappearance, poured me back *into* the world. It gave me more work than ever."

Actually, for about nine months after the Whitney show, Irwin continued to entertain the possibility of performing no further art activities. He returned to his books—Wittgenstein, Kant, and for the first time Plato—and he tried to elaborate on the writing in his catalogue essay. "But somehow," he explained, "there wasn't the urgency. I was having ideas, but there wasn't the *bang*, where they just have to be expressed. The past few years have been a take-in time for me. Even though all of these things I'm doing appear to be outgoing, they're really just allowing me to participate in the world and to take things in. Maybe later on they'll gel into some writing or some philosophical model building, but not now."

Irwin paused and considered his formulation. "Actually," he resumed, "to tell you the truth, I don't have the slightest idea why I'm doing these things now. I'm doing them because right now they seem like the right thing for me to be doing."

All through the months after the Whitney, Irwin continued to receive invitations to come examine sites and propose installations. After a fallow period, he simply started accepting them.

Basically Irwin's renewed activities took up where the Whitney had left off: outside. Irwin would be invited to come visit a site where a certain amount of funding had been set aside for a piece of public sculpture. (In this context, the increasingly common practice of specifying a certain small percentage of the budget of each new public building project for artistic purposes was particularly useful.) One way or another Irwin would hear of these opportunities and visit the sites. Thus, for example, the city fathers in Cincinnati opened a competition for a piece of commemorative sculpture in a park along the Ohio River waterfront. What they apparently had in mind was a bronze grouping of some pioneer family gazing out west. Irwin visited the park. "And it's an inter-

esting place," he explained to me at the time. "Within a half mile
or so, four bridges span the river, a freeway, a train, a few
others — one's yellow, another's blue — and I just wanted to arch a
thin, say three-foot, bright red arch out over the water, 800 to
1,000 feet, soaring low in a gentle curve, and anchoring down into
the shore on the other side. Nothing else: just this arc. I mean,
that'd be real clean and entertaining."

For Fort Worth's Trinity Park, Irwin proposed another river
piece. There a sequence of parallel freeway bridges similarly span
a river, which in this case is negotiating a soft, lazy S-curve. Irwin
proposed a piece that would be visible principally to the people in
the cars crossing the bridges, and then only peripherally so. As
Irwin conceived it, at a point along one shore near one of the
bridges, a thin gleaming aluminum bar would rise about one
hundred feet vertically, straight into the air. A few dozen yards
downshore, a similar bar would rise, but flexed slightly toward the
middle of the river, held taut by an invisible guy wire. Further
still, another bar would rise, curved even more. And so forth,
until one bar arched clear across the river and tapped the other
shore. On that shore, another sequence of bars would reverse the
progression, ending up with a straight, gleaming vertical. Drivers
speeding across the bridges would be only momentarily aware of
a peripheral snap, at the edge of their consciousness — almost like
a cartoon of a pole vaulting across river. Once aware, they might
try to focus on it, but the experience would already be past. What
would be left, Irwin hoped, would be that shiver of perception
perceiving itself.

For a snowbound slope at the Winter Olympics in Lake
Placid, Irwin proposed a tumble of large, rectangular glass panes
(six by eight feet, each plate cemented to the ground at one corner
and seeming to fall forward toward the next, which it over-
lapped). For downtown Los Angeles, Irwin proposed seeding all
the vacant lots in a ten-square-block area of partial redevelop-
ment with a deliriously colorful array of wildflowers. For the
surface of a claustrophobic Seattle square, an awkward space sur-
rounded on all sides by tall municipal buildings, Irwin proposed a
maze of raised, circular grass troughs.

For a gently sloping, forested, dell fronting the shores of
Lake Waban at Wellesley College in Massachusetts, Irwin pro-
posed a 120-foot long, 2-foot high, half-inch thick stainless steel

screen, polished with abstract swirls à la David Smith and intercut with lyrical leafshapes à la Matisse. "That Wellesley site was so lovely and pastoral," Irwin explains, "it really didn't require anything additional from me. All I was trying to do with my gesture, in the most subliminal fashion I could manage — and thanks to the reflectivity of the steel and the shimmer of the pond beyond it, the screen often did seem to just disappear — was to in a sense underline the beauty and perceptual vitality of the site as it already existed."

At one point, Irwin was contacted by a group of citizens in San Francisco who were trying to figure out what to do with a tract of land in the Embarcadero which the city had purchased and cleared in preparation for an extension of the double-decker elevated highway that skirts the city's waterfront. Through a marathon political battle, the local residents had fought off the highway project, and now people were entertaining proposals for what to do with the entire dock district. Irwin visited the site and came away feeling that its most compelling feature was the truncated highway. "They were going to spend a lot of money to tear down that obsolete spur of freeway," Irwin explains, "but I suggested that for the same amount of money, they could erect a monument, as it were, to their triumph. I proposed that they extend the supporting buttresses one span beyond the halted freeway, but then, rather than extending the concrete highway to reach that next span, they instead arch the double-decker roadway gently skyward, as if some huge hand had simply come down and peeled the highway back, bringing the whole project to a halt. Which is, in effect, what had happened."

More recently, in New Orleans, the city fathers sponsored a competition for proposals on what to do with a large, flat, dilapidated, triangular wedge of city park in the middle of the town's civic center, surrounded on all sides by government buildings. They wanted something big, something with real snap, something that could serve as a civic symbol, something like . . . the Saint Louis Arch. Irwin came in with his biggest proposal yet, winning the competition but completely baffling the city leaders. Basically, Irwin proposed a gently angled pyramid, rising above the entire triangular wedge, consisting of compacted, grass-covered earth toward the base and then close-knit metal screening for the upper two-thirds. The base would be landscaped with

very formal, French garden-style promenades. The pyramid would be hollow: inside, visitors would find a lush, tropical rain forest and an aviary populated by a dazzling array of birds: flamingos, parrots, hummingbirds, birds of paradise. From the other side of the city hall, a pedestrian skyway would vault out from the nearby sports arena, across parking lots and city streets, angling gently downward, piercing the city hall itself at the level of the second floor (just to the side of the mayor's office, which would be visible through a window), emerging from the municipal building and continuing across the street and into the upper reaches of the aviary, then slowly angling to ground level at the far end of the pyramid. "Now, that," Irwin smiled delightedly, "would be real entertaining." The mayor, however, was not amused, and the proposal currently languishes.

Birds, pavement, glass panes, wildflowers, grass troughs, aluminum walls. . . . At one point, in the spring of 1979, following a particularly prolific period, Irwin had pieces installed at four institutions simultaneously, and he took special pride in the conspicuous variety of the media he had deployed. At one he had set up a scrim; at another the principal media were contact paper and transparent colored film; the third consisted of bricks and plaster. Finally, and perhaps most successfully, at the University Art Museum in Berkeley, Irwin succeeded in mastering the exceptionally assertive character of the interior space, with its projecting fan of rising concrete overhangs, by shooting banks of long, parallel fluorescent light shafts, at three separate levels, cantilevered in a separate direction at each level, spanning out across the yawning chasm (the light banks even pierced the glass walls and continued into the world outside).

"I'm no longer concerned with the art world context," Irwin insisted at the time of the Berkeley show. "I'll use any materials, any techniques (I don't care if somebody else is using them or seems to have them earmarked; I don't care if they're thought of as art or nonart), *anything that references against the specific conditions of the site*. Whether it works is my only criterion."

Irwin felt, for example, that in general the Berkeley piece did work. The light banks, which required extensive technical innovations (as have components in many of the other projects), did succeed in heightening the extraordinary ambience of the interior vault. And it was the space that intrigued Irwin, not the lights.

Although he took a certain mischievous satisfaction in his choice of media ("That piece made Dan Flavin, who is ordinarily thought of as pretty far out, man, it made Flavin look like a painter"), at another level, as he reported, "I don't like the fluorescent lights; I don't even look at them. I don't care about the design pattern and the varying geometric mesh or anything like that. I am only interested in how the lights articulate the space. And I don't want people focusing on the lights either. That's why I don't like the piece being shown at night. Of course, naturally, the museum insisted that the opening, like every other opening they'd ever had, take place at night. I suppose it was just one more case of art coming last."

(Irwin had faced the same problem at the Whitney opening in 1977, with somewhat more comic results. Whereas the Berkeley installation had been made up of artificial light banks, the whole point of the fourth floor Whitney installation was the natural daylight streaming in from the window. To heighten the grid context, Irwin had in fact removed all the artificial light sources from the central room. Notwithstanding this, in the middle of April, the Whitney administrators insisted on holding one of their traditional 7:00 P.M. openings. Hundreds of trustees, patrons, and guests gathered in a hall that at the outset was at best dim and by party's end had gone pitch black: people huddled frozen, stranded, champagne glasses in hand, waiting for the elevator to surface with its welcome spray of light.)

One afternoon Irwin and I were discussing the extraordinary range of his recent proposals, and he began talking about the historic relationships between site and art. "Traditionally," he explained, "the art object was thought to be 'site-dominant.' It could be transplanted anywhere: in its transcendent significance it would dominate any location of placement. A recent representative of that tradition would be someone like Henry Moore. During the sixties, many artists began to think in terms of 'site-adjusted' works. Mark Di Suvero, for example, will vary the scale and adjust the direction of placement (the compass coordinates) depending on the particulars of the site where he is placing one of his large pieces. By the seventies, people like Bob Morris were beginning to talk about 'site-specific' art: that is, they would visit a site and tailor their proposal to the particular character of the site;

but it was still very much their ideas overlaid onto this particular new site; or perhaps, phrased differently, their ideas in the version allowed by this site. What I'm moving toward in my recent work is something I would call, by contrast, 'site-generated.' The site in its absolute particularity dictates to me the possibilities of response.

"What's funny about all this is that the various agencies and councils which are announcing competitions and extending invitations these days are all quite up to date. They've got the language down: how, for example, the proposal needs to be 'integrated' with the 'particular character of the site.' Trouble is, when you come in with that kind of proposal, something which is site-specific or site-generated, it turns out what they really wanted deep down in their heart of hearts was a Henry Moore.

"So you can make a lot of proposals and get very few commissions."

Of the dozens of proposals Irwin submitted during the past five years, only a small number of his large-scale conceptions were actually being realized: Lake Placid, Wellesley, Berkeley. And realization usually seemed to hinge on somewhat capricious factors.

In Dallas, for example, Irwin was invited to submit a proposal for a small, circular park between a freeway and a new hotel development. He went, surveyed the site, came home, worked up his proposal, and returned to Texas with his presentation, only to discover that the government agency that had solicited the proposal had no authority in the matter, and that actually the park was entirely the domain of the hotel's two developers.

"And one of the developers already knew what he wanted," Irwin recounted upon his return to L.A. "He's been sponsoring this artist who is off in Spain right now hacking up horses to learn about their anatomy 'cause he wants him to do a sculpture of a mustang. To this guy, Mustangs . . . are . . . Texas. Right? And he's already got his artist.

"So along comes me, this guy from California who's suddenly been thrown in bed with the two of them, not because they want me but because of some complication with federal financing, and they're going to have to at least listen. I walk into the room, and these guys are just businessmen, and they don't give a damn about art, for two reasons: they don't know art, and furthermore this is

business and has nothing to do with art. They're building a hotel and they need a park between the hotel and the freeway and the park needs a sculpture.

"I walk in the room and they've already made up their minds. They're going to give me a little time 'cause they're stuck with me, they've got no alternative, but it shouldn't take more than ten minutes."

Irwin quickly unfurled his maps and drawings and placed his clay model on the table in front of the two businessmen. Basically he was proposing that a thin, level wall of Cor-Ten steel slice through the park, about eight feet high (although the rising and falling slopes in the park would vary the actual height of the wall relative to the ground), pierced at a few points by the various walkways, a clean, simple gesture that would serve to heighten the dynamic surge of traffic and cross-purposes swirling all around the park.

"The two developers looked at my model for about three minutes," Irwin continued his account of the meeting, "and then they said, 'Yeah, hey, that's all right, okay, fine.'

"And I was really surprised. I couldn't believe it. I mean, to me it was simply an exercise: you show up because that's what you do. I no more thought they were going to go along with it than . . . I wouldn't have given you a nickel for a dollar. As far as I was concerned, it was off the boards in Vegas: no way this project was going to get off the ground. But they just said, 'Yeah, okay, that sounds real interesting.' Somehow they didn't have any trouble with it at all. Now, if I'd gone in there talking art, there would have been no way we could have made a connection. But I wasn't talking art. I was talking that particular little park, and somehow it all seemed okay to them."

Even so, Irwin's *Park Wall* almost ran afoul of subsequent complications. One of the new realities with which his recent aesthetic confronts him, as we have begun to see, is the requirement that he mesh his perceptual imagination with the concerns of bureaucrats, contractors, architects, and engineers. In this case, the contractor who had been hired by the city and the business people to supervise erection of the *Park Wall* turned out to be defrauding everybody of thousands of dollars. With the case stalled in court, the Cor-Ten steel sheets piled at the site baked and warped in the glare of a particularly gruesome Texas heat

wave. Following more than a year's delay, everything had to be started afresh. But Irwin, undaunted, was back on the road, surveying sites and parceling out proposals.

One way of viewing Irwin's career is as an hourglass, gradually narrowing to a point at the Whitney show and then widening on the other side. The work after 1977 thus begins to reintroduce many of the elements that had been progressively deleted before that year: objecthood, permanence, line, and so forth. In some senses, these elements are reintroduced with a vengeance: the post-Whitney works are substantially more imposing than their pre-Whitney counterparts; they're more extensive, more expensive, and far more complex objects.

But there is another way of viewing Irwin's career, one in which the recent work may be seen as part of a continually developing mastery along an uninterrupted curve.

To understand this second perspective, we might digress for a moment and consider comments Frank Stella once made concerning his aspirations as a painter. "I always get into arguments," Stella told an interviewer in 1968, "with people who want to retain the old values in painting—the humanistic values they always find on the canvas. If you pin them down, they always end up asserting that there is something besides the paint on the canvas. My painting is based on the fact that only what can be seen there *is* there . . . If the painting were lean enough, accurate enough, or right enough, you would be able to just look at it. . . ."*

Commenting on this kind of formulation by Stella, philosopher Karsten Harries has written, "Stella projects the ideal of an art that would not allow us 'to avoid the fact that it's supposed to be entirely visual.' . . . It is significant however that Stella does not claim his art succeeds in being entirely visual. What the work of art is, is not what it is supposed to be. Instead of being fully present, it is only a metaphor of presence No matter how radical the pursuit of presence, the work of art will always fall short of that purer art that is its telos. It points beyond itself and lacks the plenitude it demands."**

*Frank Stella quoted by Bruce Glaser in "Questions to Stella and Judd," *Minimal Art: A Critical Anthology*, ed. Gregory Battock (New York: Dutton, 1968), pp. 157–158.

**"Metaphor and Transcendence," *On Metaphor*, ed. Sheldon Sacks (Chicago: University of Chicago Press, 1979), p. 75.

Instead of being fully present, it is only a metaphor of presence. With this phrase, Harries summons the passion of Irwin's career, the ghost he tries to shake. In everything Irwin has done since the abstract expressionist canvases in the late fifties, he has been try-ing to approach—and slowly getting closer and closer to his goal—that presence that would not be metaphorical. For Irwin sees presence and metaphor as polar opposites. Presence de-mands presence, whereas metaphor allows, indeed requires, ab-sence—evasion. When the one who experiences the object expe-riences it as *like* something else, or as like something that could be accounted for in such and such a way, then he no longer experi-ences *it* but rather experiences his abstractions—and presently his compounded abstractions—*of* it. Across the lines, the dots, and the discs, in calibrating presence, Irwin was still creating objects that were metaphors of presence. Even the room at the Whitney and its two accompanying on-site installations were more about what it might be like to be present than about pres-ence. They were, however, getting closer to the quarry, and in his most recent work, Irwin has gotten closer still.

Irwin feels that perhaps his most successful piece to date, again one that has never been realized, was a proposal he made in response to a site at Ohio State University in Columbus. Listen to how he describes it:

"The site was a large oval in the center of the university, an oval of grass surrounded by buildings. There were a series of formal concrete paths which had been laid out there initially so as to get people from one building to another. But as these things happen, and as other buildings were added, people walked their own paths into the grass oval. And what the authorities did, which was very wise, was simply to let people walk the paths and after they were really established, they concreted them in. So now this thing has an interweaving of paths which is geometric and yet informal.

"Once an hour, because of the schedule of the school, classes break and people come traversing all of these paths. You can just stand there, and the oval is so large that you cannot really sort out why people are coming and going. So there's all kinds of nice imagery in there and kind of a surreal landscape.

"So, to me it was already a piece of sculpture. It had all the dimensions and all the properties of a piece of sculpture: physical

divisions, both organic and geometric, participation of people, the kinetics of the movement. It was already operative in that way.

"Now, contextually speaking, no one but someone like myself who was preoccupied with it would even recognize that idea. Not too many people pay attention to that sort of thing.

"So what I tried to do with the alteration I proposed was simply to heighten the involvement to the point where there was some recognition of one's participation, but not to heighten it to the point where you looked at the gesture as art.

"What I suggested was that they take the existing planes of grass—some of them, about a fourth—and tilt them slightly in various directions. From one to the next it might go from zero to 18 inches, then a path, then from 18 to 30 inches, path, then back from 30 to 18, path, and on down. The planes would just be tilted very slightly. Zero to 18 inches might happen over 100 feet. You'd shore up the sides by using Cor-Ten steel, because Cor-Ten looks brown and almost earthlike. We wouldn't be making an issue of the physical structure at all. The grass would still be grass, just tilted. That was all.

"What I really liked about that idea was that—well, first of all, it was really engaging. It was a natural confrontation: nobody had to assume a special posture of attention, to go to an art place, or to go out of their way. It was literally on their way.

"The piece was gentle enough not to make any issues about its existence. And it was as close as I've been able to get to simple presence. The metaphor, the means were minimal. The intellectual connotation that it was about art was just about as minimal as I've ever gotten it, and yet it still did something. It was integrated and yet active."

There is almost nothing in the Columbus piece that could be subsumed to metaphor. It simply presents the plenitude of its presence.

Interestingly, Irwin had now made a quantum leap in his pursuit of presence precisely by jettisoning the technique that until recently had formed the principal mode of that pursuit: the discipline of sequential reduction. The Columbus piece is positively brimming with extraneous detail. (It is, indeed, this very wealth of detail that renders the metaphorical evasion impossible.)

"Remember when we talked about the early paintings?" he

asked me one morning. "The thing to realize is that the reduction was a reduction of imagery to get at physicality, a reduction of metaphor to get at presence. I did it within the painting. I had to restrict my means, because the more complex the painting was, the more it became, for me and other people, metaphor. We had to drain it of metaphor so that we'd see the presence. But, at another level, the presence is always there. You can see it in the most restricted things, but you can see it in the most elaborate things, too, so long as you're attending to it.

"The kinds of things I'm doing now are things which, on the basis of their gross physicality, a lot of people will see as sculpture again. And they're not that different. But in my mind, I've learned to deal with the presence without the reductiveness. I'm getting more and more of all of that stuff in there, but still keying it on presence. I mean, it might even get baroque at some point, just loaded with richness of detail and tactileness. It can become tremendously rich, as rich as the world.

"Restriction can be a discipline to break habits, but it need not be a final state, and it's no state of grace."

To be present to the world the way Irwin invites us to be present involves some far-reaching implications, not only for art but for everyday life as well. Sometimes Irwin insists that his activity need not in any way jeopardize the activities of other artists, that there is room in the art world for infinite approaches. But this benign equanimity is fraught with irony (an irony that, of course, he would deny), and within moments of such protestations of innocuousness he can just as easily be speaking in the most incendiary of terms: "What we're really talking about is changing the whole visual structure of how you look at the world. Because now when I walk down the street, I no longer, at least to the same degree, bring the world into focus in the same way. My whole visual structure is changed by the fact that I'm now using an entirely different process of going at it. So the implications of that kind of art are very rash; I mean, in time they have the ability to change every single thing in the culture itself, because all of our systems — social systems, political systems, all our institutions — are simply reasonable reflections of how our mind organizes. So we're talking about a different mental organization, which ultimately, in time, has to result in different social, political, and cultural organizations, because they're the same thing."

Or, as he told a recent lecture audience, "Even revolutions don't cause change: change causes revolutions."

Irwin's playing for all the marbles. And that may be one of the reasons his work is still so elusive to most people. Irving Blum, Irwin's former dealer, expressed a common exasperation one afternoon when he commented, "There's such a thing as having too high an ambition, so that it's unrealizable. But whose fault is that? Society's for not being ready to understand? *No:* it's the artist's for aiming too high *and not realizing*. Hell, Irwin wants to transform entire cities! There's such a thing as a question being so huge that it's impossible to encompass, and I think Irwin's questions have attained that scale. They're so complex and so extensive that for the moment at least, they seem unanswerable, and hence they have no resonance in the world."

"It's said there's no longer any avant-garde operating in the art world today," Irwin's other former dealer, Arnold Glimcher of New York's Pace Gallery, commented one afternoon. "But I don't think that's quite true. The avant-garde today may persist in the life and work of only one man—and that's Bob Irwin." Glimcher's is a tremendously prestigious gallery. His artists include Lucas Samaras, Chuck Close, Jim Dine, and Louise Nevelson; he has now been chosen to represent the much-litigated estate of Mark Rothko. He continued, "Bob's may be the most extended perception working in the world today; we're not talking about ten years ahead of its time, maybe more like ten decades. And it's a pity that it's not being shared. But that's as much Irwin's fault as the world's. He simply refuses to play by the art world's rules—to politic for commissions, to attend to documentation, and so forth—and so he's become invisible."

Irwin's composure notwithstanding, that invisibility sometimes irritates him. After six or seven proposals without a single realized commission, he begins to wonder. For a few months he drifts without a rudder. One afternoon I mentioned to him the titles I'd chosen for the sections of this book—Lifesource, Narrows, Delta, and Oceanic—and he laughingly suggested I might need to add a coda: Whirlpool.

"He's a guy who likes to run risks and experiment on the edge of what he knows, on the edge of what can be accepted or interpreted or communicated," his friend Ed Wortz once said to me. "Sure he's been scared. He's scared of the prospects of his disap-

pearance as an artist, that what he's doing might get sufficiently far enough away from the expectations of artists and fellow inquirers that he disappears. That's of concern to him. But it's of interest as well. And face it: it's real exciting having one foot on a banana peel and the other hanging over the edge of an abyss."

"There are things I've undertaken as an artist that I will never accomplish in my lifetime," Irwin told me one afternoon. "It's just not possible. The kind of change I'm envisioning, the ideas I'm entertaining, simply don't enter society whole. There's always a process of mediation, overlapping, intermeshing, threading into the fabric. But we're headed there: the complexity of consciousness, its capacity to sustain being in presence in all its rich variety will be growing with each generation. Sometimes I feel on the verge of that."

Irwin paused for a moment, lost in thought—this man who shuns metaphors and yet is so gifted by them: "It's like you're on a swing," he finally said, "and you swing way up to the top and for a split second you can see over the wall, you can see all that light, but you're already on your way back into the world. So you swing harder and you get a little higher and you see a little more, but back down into the world you go. To recognize something and then live there takes a tremendous conversion of your being. You don't just swing up there and say, 'Oh, that's nice,' and stay there, hanging in midair. Hanging in midair can be nice — I did it at the Whitney, I did it in the desert, for a moment with the dots. But the world always draws you back."

The metaphor is strikingly resonant with a passage Irwin has recently been studying, the cave allegory in Plato's *Republic*. The philosopher returns from the sun-drenched surface back to the everyday lifeworld of the cave.

Various reviewers in New York have referred, sometimes pejoratively, to Irwin as a southern California guru. But that characterization is inadequate even by way of neutral description. Irwin is not interested in garnering disciples to a systematic world view. The image of the Zen master is perhaps a bit closer to the mark, with his capacity for presence and his insistence on the immediate. But even that is not quite the right model. Rather, Irwin's presence in the art community is Socratic. He is perception's gadfly, annoyingly prodding the taken-for-granted, relentlessly combing the ordinary and uncovering its hidden wonders.

("All I try to do for people is to reinvoke the sheer wonder that they perceive anything at all!") He disarmingly denies any special knowledge, except for his certainty that he is still searching; and by the very scandal of his obstinate perplex he upends the false certainties of others. He is a master of irony and a devotee of serious play. He has an extraordinary tolerance for ambiguity: he asks questions that seem by their very nature unanswerable, but he maintains his interest because the questions are legitimate — and are themselves probably more interesting than any answer they might summon. In short, he is an artist who one day got hooked on his own curiosity and decided to live it.

To see
is to forget
the name
of
the thing
one sees.

Paul Valery

BIBLIOGRAPHIC NOTE

The catalog for the Robert Irwin show at the Whitney Museum of American Art in New York City (April 16 – May 29, 1977) provides the most thorough documentation to date on Irwin's career, including 18 pages of photographs of late works, an adequate chronology, an excellent checklist of selected exhibitions, and a useful bibliography. (A more thorough bibliography on Irwin's early career, along with a fine essay by Jane Livingston, can be found in the catalog of the Fort Worth Art Center Museum's 1969 Robert Irwin-Doug Wheeler show, an exhibition that also traveled to the Corcoran Gallery in Washington, D.C., and the Stedelijk Museum in Amsterdam.) The Whitney catalog also includes the most comprehensive philosophical statement that Irwin has published thus far, "Notes Toward a Model: The Process of Compounded Abstraction."

Other published statements by and interviews with Irwin include:

Robert Irwin, "Preview of the United States Section, São Paulo Bienal, 1965," *Artforum* 3 (June 1965):23; statement of his position on the photographic reproduction of his art.

Robert Irwin, letter to the editor, *Artforum* 6 (February 1968): 4.

Frederick S. Wight, *Transparency, Reflections, Light, Space: Four Artists* (Los Angeles: University of California, Art Galleries, 1971).

Alistair Mackintosh, "Robert Irwin: An interview with Alistair Mackintosh," *Art and Artists* 6 (March 1972): 24 – 27.

Jan Butterfield, "Part I. The State of the Real: Robert Irwin Discusses the Art of an Extended Consciousness," *Arts Magazine* 46 (June 1972): 47 – 49. "Part II. Reshaping the Shape of Things," *Arts Magazine* 46 (Sept. – Oct. 1972): 30 – 32.

"Projects for PCA," (Symposium conducted by Marcia Tucker at the Philadelphia College of Art, 1976).

Robert Irwin, "Some Notes on the Nature of Abstraction" in *Perception and Pictorial Representation,* ed. Calvin F. Nodine and Dennis Fisher (New York: Praeger, 1979), pp. 217 – 227.

Of recent writing in periodicals on Robert Irwin's work (not covered above), three articles stand out: Edward Levine's "Robert Irwin's Recent Work," *Artforum* 16 (December 1977): 24 – 29; and Jan Butterfield's "The Enigma Suffices," a report on Irwin's "Room with Twin Skylights" instal-

lation at the Malinda Wyatt Gallery (Venice, California), published in *Images and Issues* 1 (Winter 1980–81): 38–40; and Malinda Wortz's "Surrendering to Presence: Robert Irwin's Esthetic Integration," *Artforum* 20 (November 1981): 63–69. An earlier, condensed version of some of the material in this book appeared in my own report, "Robert Irwin's Whitney Project: Retrospects and Prospects," in the *Los Angeles Institute of Contemporary Art Journal*, no. 15 (July–August 1977): 14–20.

Until recently, Peter Plagens's *Sunshine Muse: Contemporary Art on the West Coast* (New York: Praeger, 1974) provided one of the few general surveys on the subject, a somewhat glib account, which is currently out of print. The Ferus group benefited from a particularly lovely retrospective survey in the catalog to the Newport Harbor Art Museum's 1976 "The Last Time I Saw Ferus" show (curated by Betty Turnbull). The "Report on the Art and Technology Program of the Los Angeles County Museum of Art (1967–71)," a project curated by Maurice Tuchman, has an exceptionally thorough documentation of the Robert Irwin-James Turrell-Ed Wortz collaboration, compiled by Jane Livingston (pp. 127–143). The catalog to the Los Angeles County Museum of Art's 1981 "Art in Los Angeles, Seventeen Artists of the Sixties" show (also curated by Tuchman) includes several useful essays and a particularly suggestive "Chronology of Exhibitions (1959–70)," compiled by Stella Paul. Later this year (1982), Harper & Row will be publishing Jan Butterfield's *Context: Light and Space as Art*, a richly illustrated survey of works by Irwin, Doug Wheeler, Maria Nordman, James Turrell, Michael Asher, Eric Orr, Larry Bell, and several others.

One of the best introductory texts on phenomenology is Maurice Natanson's wonderfully congenial *Edmund Husserl: Philosopher of Infinite Tasks* (Evanston, Illinois: Northwestern University Press, 1973). The winner of the National Book Award, Natanson's study also includes a thorough bibliography on Husserl and phenomenology. Also useful is James Edie's collection of essays by various writers, *An Invitation to Phenomenology: Studies in the Philosophy of Experience* (Chicago: Quadrangle, 1965). A fascinating, although highly technical case for the significance of the *precogito* (or, as he calls it, the *prereflective cogito*) can be found in Jean-Paul Sartre's early volume, *The Transcendence of the Ego: An Existentialist Theory of Consciousness*. (One might also sample the seminal "Introduction" to Sartre's *Being and Nothingness*).

Irwin and I recently had a conversation about some of the books that had mattered to him. Among art books he singled out Ad Reinhardt's collection of essays, *Art-as-Art* (New York: Viking, The Documents of 20th-Century Art series, 1975). In the area of philosophy, he cited Maurice Merleau-Ponty's *The Primacy of Perception* (Evanston, Illinois: Northwestern University Press, 1964); Alfred Schutz's *The Phenomenology of the Social World* (Evanston, Illinois: Northwestern University Press, 1967); Ludwig Wittgenstein's *Philosophical Investigations*, translated by G. E. M. Anscombe (New York: MacMillan Publishing Co., Inc., 1958); Thomas Kuhn's *The Structure of Scientific Revolutions* (Chicago: University

of Chicago Press, 1962); Michael Polanyi's *The Tacit Dimension* (Garden City, New York: Doubleday, 1966); and Robert Heiss's *Hegel, Kierkegaard, Marx; Three Great Philosophers Whose Ideas Changed the Course of Civilization* (New York: Delacorte Press/S. Lawrence, 1975). Two classics in particular—Immanuel Kant's *The Critique of Pure Reason* and G. W. F. Hegel's *The Phenomenology of Mind*—he found profoundly moving, not only in terms of what they had to say about perception but also in terms of the sheer scale of the ambition they displayed. In the area of science, Irwin cited a long article by Gordon G. Globus, "Consciousness and Brain," *Arch. Gen. Psychiatry* 29 (August 1973) and then referred me to his old Art and Technology friend, Dr. Ed Wortz.

Dr. Wortz, formerly with the Garrett Aerospace Corporation and now a practicing psychotherapist, mentioned Polanyi's *The Tacit Dimension*, along with the same author's *Personal Knowledge; Towards a Post-Critical Philosophy* (London: Routledge, 1958). "From the Old Days," Wortz cited NASA's *Aeronautics Data Book* and Stanley Smith Stevens's *Handbook of Experimental Psychology* (New York: Wiley, 1951). He also recommended William T. Powers's *Behavior: The Control of Perception* (Chicago: Aldine Publishing Company, 1973). Since his collaboration with Irwin in the late sixties and early seventies, Wortz's own thinking has drawn increasingly on several Zen sources. He cites, in particular, D. T. Suzuki's *Zen and Bergson* and his *The Lankāvatāra Sūtra* (London: G. Routledge and Sons, Ltd., 1968); John Blofeld's *The Zen Teaching of Huang Po* on the Transmission of Mind (New York: Grove Press, 1958); and Garma C. C. Chang's *The Buddhist Teaching of Totality; The Philosophy of Hwa Yen Buddhism* (University Park: Pennsylvania State University Press, 1971).

Just as Wortz hears Zen resonances in Irwin's work, I've been struck by parallels within the Jewish mystical tradition. No other tradition, perhaps, has dwelt so suggestively on the nature of questions and questioning: human existence as a question, the relationship between questions and answers, questioning as questing. Gershom Sholem's *Major Trends in Jewish Mysticism* (New York: Schocken, 1946) provides a masterfully evocative introduction.

Another relevant tradition might be consulted: Søren Kierkegaard is the Master of Irony (his first book was entitled *The Concept of Irony*), a man for whom existence was always in question. *Purity of Heart Is To Will One Thing* is the title of one of his later books, a devoutly Christian tract, which seems surprisingly relevant to Irwin's passion. His *Either/Or, Fear and Trembling, Philosophical Fragments* and *Repetition* are similarly resonant.

"Whereof one cannot speak, thereof one must be silent." With these words, so remarkably resonant with the title and theme of this Irwin biography, Ludwig Wittgenstein concludes one of his earliest meditations, *The Tractatus Logicus-Philosophicus* (London: Routledge & Kegan Paul, Ltd., 1922, 1971). Of even more interest in our context are some of Wittgenstein's later works—works where his research into logic begins to become haunted by phenomenological implications. In addition to the

Philosophical Investigations (previously cited), one might sample Wittgenstein's *Zettel* (Berkeley and Los Angeles: University of California Press, 1967) and *Remarks on Color* (Berkeley, Los Angeles, London: University of California Press, 1977). Several valuable elucidations of Wittgenstein's later thought have been published, including Henry Finch's *Wittgenstein: The Later Philosophy* (Atlantic Heights, New Jersey: Humanities Press, 1977) and P. M. S. Hacker's *Insight and Illusion: An Investigation of Wittgenstein's Later Philosophy* (Oxford: Clarendon Press, 1972).

The question of photographic reproduction of art works—the problem, that is, of the presence of the image—has received some interesting treatment in recent years. The seminal text, Walter Benjamin's brilliant essay "The Work of Art in the Age of Mechanical Reproduction" (1936) is available in a volume of selected Benjamin essays entitled *Illuminations* (New York: Schocken, 1969). The intellectual progeny of that essay include John Berger's *Ways of Seeing* (London: Penguin, 1972) and *About Looking* (New York: Pantheon, 1980); Susan Sontag's *About Photography* (New York: Farrar, Straus and Giroux, 1977); and Roland Barthes's posthumous *Camera Lucida: Reflections on Photography* (New York: Hill & Wang, 1981).

Much of the material in this book derives from conversations, some of which were taped. The University of California, Los Angeles Oral History Program (a research unit of the University Library's Department of Special Collections) has compiled "Los Angeles Art Community: Group Portrait," an exceptionally useful archive of transcribed interviews with over thirty artists, collectors, and dealers (including Irving Blum, Edward Kienholz, and Craig Kauffman). The Robert Irwin interview in that series, conducted by Frederick S. Wight, is almost 300 pages long and is a seminal document. In addition, I have deposited with the Oral History Program my own tapes and transcripts from over twenty hours of supplemental conversations with Irwin, as well as shorter talks with Mrs. Goldie Irwin and Arnold Glimcher.

Finally, concerning the Search. Many novels describe its extraordinary epiphany in the middle of a particular character's everyday life. One novel that was with me a good deal as I composed this biography was Walker Percy's *The Moviegoer*.

INDEX

Index : 211

Designer: Sandra Drooker
Compositor: Innovative Media, Inc.
Printer: Vail-Ballou, Inc.
Binder: Vail-Ballou, Inc.
Text: 10/13 Baskerville
Display: Baskerville